# The Pattern Companion:
# Mosaics

# The Pattern Companion: Mosaics

Edited by Cassandra Case

*With material by*
Leslie Dierks, Elizabeth DuVal,
Reham Aarti Jacobsen,
Jill MacKay, Connie Sheerin

Sterling Publishing Co., Inc.
New York

**Library of Congress Cataloging-in-Publication Data Available**

2  4  6  8  10  9  7  5  3  1

Material in this collection was adapted from:
*Making Mosaics,* by Leslie Dierks © 1997 by Altamont Press
*Mosaics in an Afternoon®,* by Connie Sheerin © 1999, by Prolific Impressions, Inc.
*Creative Garden Mosaics,* by Jill MacKay © 2003 by Jill MacKay
*Beyond the Basics Mosaics,* by Elizabeth DuVal © 2004 by Elizabeth DuVal
*Mosaics for the First Time®,* by Reham Aarti Jacobsen © 2004 by Reham Aarti Jacobsen

*Detailed rights information on page 192.*

Book design by Alan Barnett

Published by Sterling Publishing Co., Inc.
387 Park Avenue South, New York, NY 10016
© 2005, Sterling Publishing Co., Inc.
Distributed in Canada by Sterling Publishing
*c/o* Canadian Manda Group, 165 Dufferin Street
Toronto, Ontario, Canada M6K 3H6
Distributed in Great Britain and Europe by Chrysalis Books Group PLC
The Chrysalis Building, Bramley Road, London W10 6SP, England
Distributed in Australia by Capricorn Link (Australia) Pty. Ltd.
P.O. Box 704, Windsor, NSW 2756, Australia

*Manufactured in China*
*All rights reserved*

Sterling ISBN 1-4027-1273-1

# Contents

# Introduction

Mosaic art was first used by the Sumerians in Mesopotamia some 5,000 years ago. They used semi-precious stones (lapis lazuli, onyx, turquoise, etc.), shells, gold, and terracotta to decorate furnishings, tools, weapons, and dwellings. It is striking that these same types of materials were also used in similar ways by the Aztecs in Meso-America, although their culture flourished half a world away between the 13th and 16th centuries A.D.

The ancient Greeks made mosaics with pebbles of contrasting colors. They achieved extraordinary detail by using smaller and smaller stones, eventually cutting small cubes from stone for their mosaics.

The Romans also decorated their shops, baths, and other communal areas with mosaics, though they preferred a much simpler, monochromatic style. As the mosaic art spread with the Roman Empire, it began to take on local flavors, resulting in distinct styles that were easily identifiable by region.

Those responsible for "lifting" mosaics from the floor to the ceiling were the Byzantines. They also pioneered the making of smalti—a specialized glass created by pouring molten glass, colored with metallic oxides into slabs and allowing it to anneal. It was then split by hand into small rectangles, producing brilliant surfaces unparalleled by other materials. Gold and silver smalti were made by fusing metal leaf between layers of glass. The making of smalti became a classic Venetian tradition, still in practice to the present day.

Islamic mosaics, in accordance with the rules of Islam, totally lack human representations. Rather, they are characterized by a profusion of geometric and plant-like designs as well as calligraphy, intended to inspire both awe and contemplation.

Although the finished product looks complex, making a mosaic is quite simple and requires only a minimum of tools and materials. Today, new materials are easy to work with, inexpensive, and widely available. You may find that many of your favorite materials are even free.

The patterns you will find in the following pages range in difficulty from very easy to quite challenging. There are motifs that can be adapted to other forms as desired. Also included are a variety of techniques, which may be applied to different projects as you become inspired. On the next page can be found a brief description of mosaic methods covered in the sections.

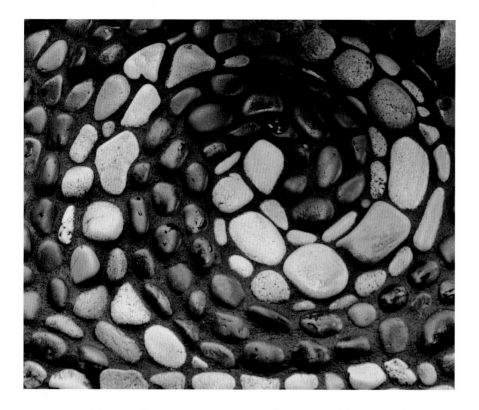

placing old china in intricate patterns. It has been said, "Picasiette is where all broken things want to go when they die."

**Garden projects**—provides intriguing projects to grace the outdoors, and covers special methods to make pieces more weather resistant.

**Armatures and constructed bases**—gives step-by-step demonstrations within specific project directions to familiarize you with a number of structural options for creating sculptural mosaics.

Making mosaics has become a true form of artistic expression. Everyone who comes to the craft will eventually settle into a "rhythm" with mosaics and develop a personal style. You will most likely come to favor certain adhesives, tesserae, and bases as you experiment. Almost anyone with a sense of imagination and creativity can put together a beautiful and long-lasting work of mosaic art.

In recycling items that might otherwise be discarded, making mosaics can also be earth-friendly. Beginners and professionals alike can create exquisite designs with broken tiles, pieces of stone, and other castoffs.

There are so many ways to express oneself in this art. Tradition can be a source of inspiration, but do not be limited by it. Pieces that do not turn out as planned should be considered valuable lessons. Keep going. You will be amazed how often today's mistake becomes tomorrow's innovative technique. Be safe—read labels, understand how to use your tools, and wear protective gear as suggested—and above all, have fun!

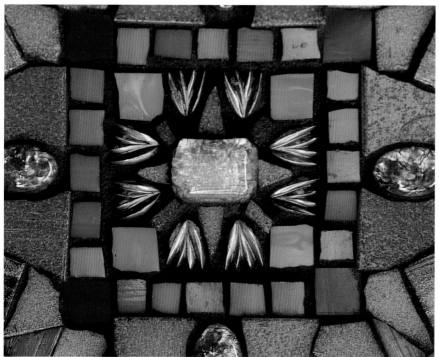

**Direct method**—when the tesserae are applied directly onto a surface.

**Indirect method**—for when you need to mosaic evenly onto an uneven or slightly curved surface. It also allows you to create the mosaic in your workshop and move it to its final location.

**Picasiette**—or *pique assiette* (translated as "broken plate," "stolen plate," or "plate stealer") is a wonderful way to reclaim heirlooms that have met with misfortune. Shards of ceramics and other found objects can be used in the original form, adhered randomly. However, more formal, quilt-like designs can be achieved by hand-cutting and

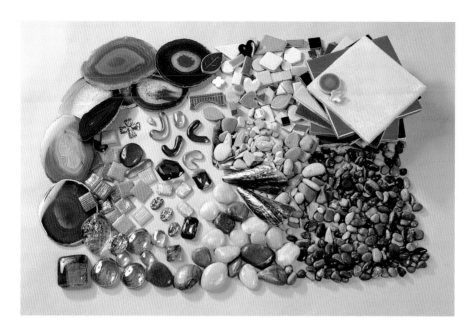

## TESSERAE

Tesserae are the many small units that are assembled to make up the mosaic "picture." The words tessera (a single unit) and tesserae (more than one) are Latin for "cube(s)," and were derived from the Greek word tesseres, meaning "four-cornered." Originally used to describe the small cubes of stone or glass that composed ancient mosaics, these terms have come to be used as labels for any mosaic unit, such as marble, ceramic tile, broken crockery, or found objects. Many of the commonly used materials are described here, but don't let this list limit your creative instincts. By their very nature, mosaics encourage experimentation with all manner of materials and designs.

## Ceramic

Ceramic boasts many qualities that make it ideal for mosaics. It can range in color from pale pastels to fully saturated primaries and can include many variations. Ceramic can be glazed (shiny or matte) or unglazed, some suggesting stone or other natural materials.

**Glazed tiles** have a thin coating of color—from subtle to stunning, glossy or matte, solid or patterned —over an off-white base.

**Picasiette**, or *pique assiette* is a style of mosaic that recycles old ceramic elements. Also referred to as "memory ware," "whatnot," "bits-and-pieces mosaic," or "shardware"—chipped, cracked, or damaged china, crockery, or tiles are shattered into random pieces or cut by hand into specific shapes. Many of the resulting tesserae are curved, and some contain three-dimensional decorative elements (spouts, handles, etc.) that can produce highly textured surfaces that often contain elements of humor.

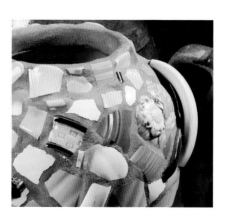

**Unglazed tiles** look earthy, carry their color all the way through, and are especially convenient because they can be oriented however desired.

Prefabricated tiles are readily available in a multitude of sizes and shapes. A good way to build up a collection of tiles is to buy closeout pieces, discontinued pieces, remnants, or samples that are available at flooring and hardware stores. However, be aware that this may not be the best way to acquire tiles for every project, as you may find that you do not have enough of a particular type or color that is required to complete your mosaic. When calculating a project, always plan carefully and allow for waste and for pieces that may get broken.

Different tiles are made for different applications. Each type of tile is classified by specific characteristics that determine where and how it should be used. Be certain to assess your needs before choosing tile for a project. For example, does it need to be frostproof, nonslip, or hard-wearing? You will be better prepared to make your selection after studying the following rating systems, used by tile manufacturers:

### Ability to Withstand Abrasion

Class I: Walls only

Class II: Very light foot traffic

Class III: Medium residential use

Class IV: Heavy residential use

Class V: Commercial, durable, stain-resistant

### Water Absorption/Vitrification

Nonvitreous: 7%+; prone to stains even when sealed; not suitable for wet areas or heavy traffic

Semivitreous: 3%–7%; can be sealed, indoor, minimal outdoor, available in frostproof

Vitreous: 0.5%–3%; okay for wet, high-traffic, or outdoor/cold climate

Impervious: Below .05%; i.e., porcelain; very hard, stain-resistant, does not require sealing, withstands use in wet and freezing conditions

## Found Objects

This category is also known by its French term, *objets trouvé,* and is a catch-all containing such things as beads, buttons, marbles, shells, pebbles, bottle caps, toys, various food items—in short, almost anything you can imagine varnishing and gluing down. For the most part these objects are only suitable for decorative projects that will not be subjected to foot traffic or weather conditions, although there are exceptions. Use your judgment or experiment on test pieces if you are considering including found objects in a piece.

## Glass

Glass tesserae are some of the most highly prized mosaic materials due to their reflective qualities and the wide range of available colors. Stained glass and other types of translucent colored glass make handsome mosaics, especially when applied to a surface that allows the light to shine through. More common, though, are opaque glass tiles that are prefabricated specifically for mosaics.

**Clear glass/marbles** used as tesserae can produce wonderful visual effects. The variations are

many, and include such treatments as attaching clear glass tesserae over a picture or piece of patterned paper on a base; attaching an image directly to the backs of clear glass tesserae, then segmenting the image by trimming the paper close to the edges of the tesserae; painting or applying gold leaf to the backs of clear glass, then breaking or cutting the glass to obtain tesserae; or painting a base, then adhering clear glass tesserae over the paint.

**Mirrors** can add spark and contrast to a mosaic, simply by placing a few pieces here and there. A three-dimensional piece covered entirely in mirror can also be quite striking. Now that you can purchase colored mirror, textured mirror, and van Gogh (mottled mirror), the possibilities seem endless. Mirrors are easy to cut and shape using glass cutters or nippers. Use a light touch with grout to avoid scratching the mirror. Mirror is sold by glass suppliers and online retailers. It is available in a range of sheets from several feet square down to ½" hand-cut squares; it may also be purchased in precut shapes and strips, or as scraps.

**Smalti** are brilliant glass tesserae designed specifically for mosaics. They are produced in relatively small quantities according to classic traditions. In addition to a full range of colors, smalti are available in gold and silver.

The same characteristics that give smalti their unique look (uneven texture and small visible bubbles) make them unsuitable for floors or other surfaces that require an even or flat surface. Grouting will also ruin the look of smalti; therefore most artists use the self-grouting method. Smalti are sold in bulk or face-mounted on kraft paper, and, although sizes vary, the most common are ⅜" x ½".

**Smalti filati** are made by pulling the molten glass into threads or

Mirrors

Smalti

rods and cutting them into tiny pieces. Smalti filati are approximately 1mm square and are used to make "micro mosaics."

**Stained glass** is a wonderful material for mosaics; with all the colors and textures available, it can be manipulated in many ways and used in many interesting variations. The only downside to working with stained glass is the potential for injury; it must be handled carefully and safely. Stained glass comes flat or textured in many colors—clear, opaque, iridescent, mottled, and multicolored—and is available in sheets of varying sizes, ranging from several feet square to hand-cut ½" squares; also in strips, scraps, or remnants.

**Vitreous glass** (also called Venetian glass) is machine-molded into thin square tiles—the small colorful glass tiles most commonly used to line swimming pools. They

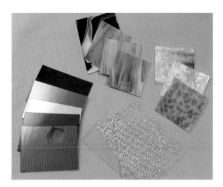

Stained glass

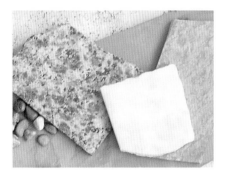

Stone

can also be used on floors, walls, counters, and decorative pieces. Used full size, the grooves and beveled edges provide additional adhesion, but sometimes they can be a hindrance when you want to cut the tiles into smaller sizes. They are usually placed textured-side down for better grip, but with the stronger adhesives now available, the textured side can be used uppermost to create a different effect.

Vitreous glass tiles come pasted onto sheets of paper or plastic mesh but can be ordered unmounted. They are available in various sizes but are most common in ¼" or ¾" squares about ⅛" thick. Vitreous glass—available in a wide range of colors, including some with metallic veins of gold or copper—is frostproof, extremely durable, and stain-resistant.

## Stone

Stone was once the dominant material for making mosaics, beginning with the uncut pebbles used thousands of years ago by the Greeks. Although their palette was limited to earth tones, the ancient Greeks were able to create pebble mosaics of astounding beauty and refinement. Pebbles are still used today, but by relatively few artists. It's not easy to find (and handle) large quantities of well-shaped pebbles in uniform sizes and in a range of tones. By strolling along a beach or riverbank, however, you can accumulate a collection of interesting pebbles fairly quickly. Judicious use of even a small batch of pebbles together with some cut stone can result in a stunning composition.

In addition to collecting your own stones or cutting chunks from the thick slabs sold for landscaping purposes, you can purchase some of the most popular types of stone in easy-to-use precut tiles.

**Granite** is a dense stone with regular mottled patterns. It comes in a range of earth colors. When used in concert, marble and granite complement each other nicely. Granite has a greater tendency to shatter when cut, however, and isn't as easy to use as marble for making mosaics.

**Marble** is available in a wide assortment of earth tones plus shades of white and black. Because of its many variations in color and random veining, no two pieces are identical. Unpolished marble is more natural looking, but is quite porous and susceptible to damage from moisture if left unsealed. Large pieces of green marble have been known to warp after prolonged exposure to dampness.

**Slate**, another type of stone tile, is used mainly for floors, patios, and walkways. Although it has a color range limited to black and gray tones, its strong linear quality can be useful in some applications. It is not as durable as marble and granite.

**Limestone** is available in lighter earth shades, and is easier to cut and shape because it is much more porous and less durable than marble and granite. Because of this, it can stain or erode if used in outdoor projects.

Stone often falls under the tile heading as the two materials are often packaged and used in the same manner. Marble and granite tiles are available in small squares, ranging from ⅝" to nearly 2", and in larger sizes up to 12" square. Slate tiles come in both square and rectangular formats of various sizes. One appealing aspect of stone is that it can also be purchased in uncut slabs or large pieces; however, it requires the use of stronger tools than would be used for tile. (See pages 16–17.)

## BASES

You can create a mosaic on almost any flat or three-dimensional surface as long as it has been properly prepared. First, it must be sealed to prevent the tesserae from falling off over time. Then it must be "keyed" or roughened to give it a "tooth" to aid the grip between the base and tesserae.

**Backerboard** is made specifically for tile and is an excellent choice for mosaics that must be water-resistant, as it remains rigid when wet. It is a bit more expensive than plywood, and comes in two types: cement-based panels (require a saw to cut) and lightweight panels of cement with fiberglass mesh (only need a razor to score and cut). Both are available in various thicknesses.

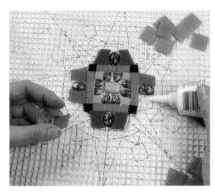

Building a mosaic on mesh so it can be transported to another site for installation.

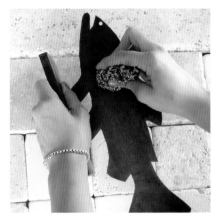

Preparing a metal surface by keying with rough steel wool.

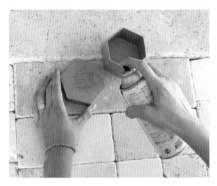

Spray-sealing a cardboard surface.

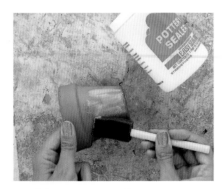

Applying pottery sealant to terracotta.

**Concrete** should only be used as a base when dry and in perfect repair. Minor defects may be fixable with a leveling compound. However, do not try to disguise a problem, as it will only make it worse.

**Glass** bases should be clean and dry. Remove any residue by going over the glass once with denatured alcohol. Clear or semi-clear stained-glass tesserae work wonderfully when applied to a glass base with clear silicone adhesive, as the combination allows light to shine through.

**Mesh** backing comes in many forms—fiber netting, scrim, gauze, and wire mesh are all names you will encounter when choosing a mesh backing. Mesh is useful for creating a slight even curve in a mosaic. It can be cut into any shape and is available in sheets or rolls.

Mesh also provides a way to do an entire mosaic or parts of a mosaic at a location other than the final site. Upon completion, the mosaic (or its parts) can be carefully transported to the final site and permanently attached with epoxy or cement.

**Metal** can be a good, strong base for mosaic. To "key" a metal surface, use a rough grade of sandpaper or steel wool. Make certain to wipe down all surfaces that have been keyed with a clean dry cloth before adhering tesserae, as keying a surface will leave small flakes or particles that will interfere with the adhesive grip between the tesserae and the base. Use a multipurpose adhesive when attaching tesserae onto a metal base, as it will give you a much better bond.

**Papier-mâché/cardboard** must be sealed to prevent the moisture in the adhesive or the grout from damaging them beyond repair.

**Terracotta** needs to be sealed before adhering any tesserae. Make certain to seal your grout, especially lighter colors, to avoid water

damage that may occur with use or as a result of being outdoors.

**Walls/floors**, as with concrete, make certain any existing finishes are sound and keyed when utilizing plaster or painted walls. If you decide to use new materials, use cement-based backerboard. You will need to make certain the wall is strong enough to hold the final mosaic; when in doubt, consult a professional. When working on an outside wall or stone, use a sand or cement level to create a good bond. Wood floors must be reinforced with plywood.

**Wood** is a logical choice for bases that involve curving or complex contours because it is easy to cut. Use a jigsaw or scroll saw to cut curving contours in wood. Be sure to choose rot-resistant wood—the most commonly used woods are plywood, MDF (medium-density fiberboard), hardboard, or a naturally resistant wood such as cedar.

Hardboard works best for intricate cutouts; however, it must be sealed completely. Marine-grade MDF should be used for outdoor applications. Both materials are available in various thicknesses. The rule of thumb is, "the larger your piece, the thicker the wood must be to keep it from warping under pressure." Use the following as a guide:

- ⅛" thick for a project of 18" or less
- ½" thick for a project up to 36"
- ¾" thick for a project larger than 36"

To further reduce the chances of damage from rotting and warping, brush two coats of outdoor wood sealer onto the wood—including the edges—before tiling the surface. Use a nontoxic water-based sealer and allow drying time between coats. Some sealers leave a slick coating that keeps adhesive from sticking. If your sealer leaves such a finish, sand, "key" or score

it. The scoring need not be deep—just roughen it a bit.

# ADHESIVES

There are many different types of adhesives that can be used for attaching tesserae onto a base. Each has its own set of characteristics that determines how and where it can best be applied. The following adhesives are most often used for creating mosaics.

**Cement-based adhesive** is economical, is available in premixed or powdered form, and can be colored with additives. It is available in fast- and slow-setting formulas, and requires water cleanup while still moist. Used in the Direct method.

*Note: The premixed form tends to dry out in its container.*

**Epoxy** is available in gel or liquid form, is suitable for outdoor and wet applications, and is a strong adhesive; however, two-part mixing may be messy and time consuming. Epoxy is available in fast- and slow-setting formulas, causes strong fumes, and requires use in a ventilated area. Used in the Direct method.

**EVA (ethylene vinyl acetate)** is a water-resistant version of PVA, but it is not waterproof. It is suitable for use in areas that may get wet, but not for use in pieces that will be submerged regularly. Used in the Direct method.

**Gum adhesive (gum Arabic, gum mucilage)** is ideal for pieces that must be transported; however, it is expensive, more difficult to remove than PVA/paste, and is unsuitable for outdoor or wet applications. Used in the Indirect method.

**Mastic paste** is latex- or petrochemical-based, and is available in premixed-form. It is economical, though not as strong as cement-based adhesive. It is suitable for use in dry, low-traffic areas. Used in the Direct method.

**Multipurpose adhesive**, a strong adhesive that is available in some basic colors, can also be colored with additives. It is almost always paintable and is thick enough for three-dimensional or vertical applications. Read package labels for indoor/outdoor and wet compatibility. Used in the Direct method.

**PVA (polyvinyl acetate)** comes in a liquid form, dries clear, and requires water cleanup; however it is unsuitable for outdoor or wet applications. PVA adhesive is used as a sealer for porous mosaic bases such as hardboard, terracotta, and papier-mâché. When diluted 1:1 with water and brushed onto the base surface, it gives a good tooth to help the tesserae grip better. Used in the Indirect method.

**Silicone** is available in gel or thick adhesive form. It works well on almost any surface, is thick enough for use on three-dimensional or vertical applications, and is available in clear, white, and almond in small tubes—other colors are available for use with a caulking gun. It will expand and contract with weather conditions, and dries to a rubbery finish, but it is not paintable. Used in the Direct method.

Silicone is an excellent adhesive to use on glass and mirrors, but take care to minimize air bubbles that may result when placing the tesserae. Although it is a little time consuming, it is a good idea to make certain the adhesive covers the entire back side of each glass tessera for a more finished look.

**Wallpaper paste** is inexpensive. It is available in powdered or liquid form, and requires water cleanup, but is unsuitable for outdoor or wet applications. Used in the Indirect method.

**Sealing a wood surface**
Dilute PVA adhesive 1:1 with water and brush onto the wood surface to seal it.

**Sanding a wood surface**
You can use sandpaper to roughen the surface.

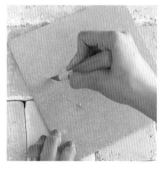

**Keying a wood surface**
To "key" a wood surface, score it with a hacksaw or a box cutter.

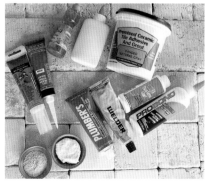

Adhesives

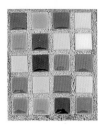

Black grout tends to make the tesserae seem more vivid and makes the piece "pop" (top left).

White grout has the opposite effect of "mellowing" the piece (top right).

Gray grout blends the colors in the piece together (bottom left).

Colored grout can give a piece a "zany," fun, or more artistic look (bottom right).

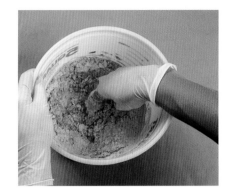

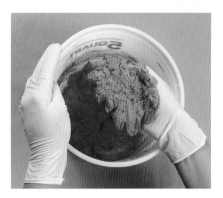

# GROUT

Grout is the mortar that fills the spaces between the attached tesserae. It is an extra source of strength to the finished mosaic. More importantly, it is the element that pulls your mosaic together visually—it is quite amazing how different your piece will look once it is grouted.

## Sanded vs. Non-sanded Grout

There are two basic types of grout: cement-based and epoxy-based, both of which are available in either sanded and non-sanded formulas. The common use for non-sanded grout is for filling spaces less than $\frac{1}{16}$" wide, while sanded grout is used in wider spaces. However, even for these smaller spaces it is not necessary to use non-sanded grout. In fact, most artists prefer the finished look of sanded grout and use it on all their pieces regardless of the space between the tesserae. Both sanded and non-sanded grouts are available in many colors and can also be colored with additives.

*Note: Use a light touch when grouting over china and mirrors with sanded grout. Avoid rubbing too hard when spreading the grout and when cleaning up, as you can scratch the mirror or damage the china pattern.*

**Cement-based grout** is the most commonly used grout. Often, you can find cement-based grout containing powdered polymer or liquid latex additives, which give it increased strength and resilience.

**Epoxy-based grout** is resistant to chemicals, mildew, water, and stains, and does not require sealing. It is, however, more expensive and difficult to work with and can take two to seven days to cure. When dry, it has a dense, slick-looking finish that may not be suitable for "earthy" or rustic applications. It requires special safety precautions, application, and finishing. If it is not cleaned off the tile quickly and as directed by the manufacturer, it is very difficult to correct. Using epoxy-based grout takes practice. Try it out on a small test piece first before attempting to use it on a large piece.

*Note: Due to the level of difficulty involved in working with this type of grout, most of the projects in this book do not call for epoxy-based grout. This information has been included to give you a broader understanding of the grouts that are available.*

## Grout Color

Grout color in creative or decorative mosaics is a personal choice. Each yields a different visual and aesthetic effect.

## WORK AREA

If you have no permanent studio space and are setting up a temporary work area, it is recommended to cover your work surface with paper or, preferably, plastic (a trash bag taped tightly to the table will do). Select a room that has a hard floor, not carpet—glass and ceramic shards, adhesive cement, and grout are virtually impossible to fully remove from carpet pile. Make certain to cut tesserae in a location away from people, pets, and food. Cutting into a large cardboard box will help contain the waste pieces.

When grouting, cover your floor area thoroughly, as grout has a way of getting everywhere. Have a bucket or bowl of water on hand for washing grout off tools, gloves, or skin. Simply dip in water and wash off. When you have finished grouting, let the water stand until it is mostly clear. The grout will settle in the bottom and you can gently pour off the water. Then tap the sides of the bucket/bowl to loosen the deposit of grout so you can dump it in the trash.

The essential items, or those that should be included as part of your starter set, are highlighted in the green box at right.

## SAFETY TOOLS

An **air-filter mask** is essential for respiratory protection when working with "mix your own" adhesives, grout, and concrete. One is also recommended when sanding or using a saw, or when breaking or cutting glass and ceramic.

**Apple cider vinegar** should be kept available. If you get grout on your hands (from a hole in your

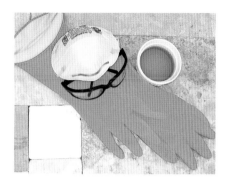

glove, for example), rinse your hands with the vinegar. It will neutralize the chemicals and prevent damage to your skin.

**Rubber gloves** should be regularly stocked if you do mosaics. Purchase several pairs that fit well. You may want more durable ones for breaking and cutting tesserae, and a supply of latex ones to protect your hands from the caustic

### BASIC MOSAIC SUPPLY KIT

A list of the basic supplies you'll need for virtually every project in this book:

- Plastic for covering work surface
- Paper plates for holding tesserae
- Craft sticks
- Tweezers
- Containers for mixing grout
- Container for water
- Sponge
- Polishing cloth
- Razor blades
- Cleaning tools (dental picks, etc.)
- Plastic or kraft paper for wrapping object
- Latex gloves
- Safety goggles
- Dust mask

effects of grout while still affording you more tactile sensitivity. Vinyl gloves are useful when working with solvents and spray paints.

**Safety goggles** are a must every time you cut tesserae, as it only takes one stray shard of glass in the eye to cause serious damage. It is worth splurging on higher-end goggles or safety glasses. Keep in mind when selecting your pair that if you do not like them because of bulkiness or awkwardness, you will be less likely to wear them.

## DRAWING AND DESIGN TOOLS

Before you rush out and buy everything on the following lists, you should know that these tools are provided mainly to give an overview of the ones that you may use while creating a mosaic. Some of these tools are nice to have, but not always essential. You will find that a particular tool may be absolutely vital when working on one mosaic project and completely unnecessary for another.

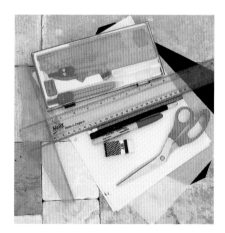

**Geometry set** (compass, protractor, set-square, ruler) is useful for drawing designs and measuring accurately.

**Pencils, erasers, felt pens,** and **permanent markers** are necessary as you work out the design of your mosaic.

**T-square** ensures 90° angles and helps you measure and draw straight lines.

**Carbon paper, tracing paper, graphite paper,** and **drawing paper** are used to transfer mosaic designs or pictures.

**Templates** can be used if you are uncomfortable with your freehand skills. There are almost unlimited templates available that would be suitable for use in mosaic design.

**Craft scissors** are useful for cutting paper or template materials.

## SURFACE PREPARATION TOOLS

**Box cutter, craft knife,** or **rough-grit sandpaper** are used to key wood or metal surfaces.

**Denatured alcohol and a clean cloth** are used to remove any residue from glass.

**Latex primer (self-leveling)** helps correct a surface that is not quite level.

**PVA or EVA adhesive** is necessary for sealing porous surfaces before attaching tesserae. Apply with an old brush.

## CUTTING TOOLS

**Ceramic tile cutter** is used for cutting larger tiles. This tool makes quick work out of cutting several strips or small squares.

**Chisel** is used with a hammer to break stone or tile.

**Glass cutter** is used to score straight or curved lines.

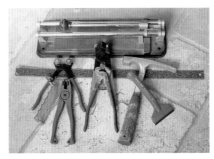
Cutting tools

**Hammer, mosaic** or **masonry,** breaks tesserae with its sharp end, and can be used with a chisel with its flat end.

**Rubber mallet,** an alternative to a hammer, breaks china and crockery for picasiette.

**Ruler (cork-backed metal)** is used with a glass cutter to score tesserae. The cork prevents the ruler from scratching the tesserae while you cut.

**Running pliers** help break glass when your strips are too small or thin to break by hand.

**Tile nippers** are invaluable for cutting and shaping tile, china, and crockery.

**Wheel glass cutter/** are used to cut and shape glass, smalti, china, and more. This is an indispensable, versatile tool.

## ATTACHING TOOLS

**100% silicone sealant/adhesive** is used to attach mirrors and works well with glass. It is also thick

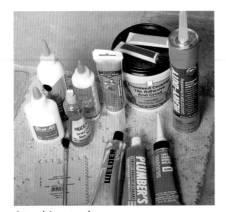
Attaching tools

enough to use with three-dimensional or vertical applications, as it keeps the tesserae from sliding.

**Adhesive spreader** is used to apply an even layer of adhesive.

**Disposable brushes** are used to spread adhesive.

**Heavy welding compound** is an epoxy adhesive. It is very strong—use sparingly. This material is available at auto-supply stores.

**Mastic** is a setting adhesive that works well for tile. It is available in indoor- and outdoor-compatible formulas, but is not appropriate for all surfaces.

**Multipurpose adhesive** is used to attach tesserae onto many surfaces.

**Premixed grout/adhesive** is used when dealing with tesserae that must be self-grouted.

**PVA adhesive** is used to attach tesserae onto brown kraft paper when working in the Indirect, or Reverse, method.

**Tweezers (long craft model)** for manipulating and positioning tesserae that are too small to handle with your fingers.

## GROUTING TOOLS

*Note: All food-oriented tools must be "dedicated" once used for grouting.*

**Bowl or disposable container** for mixing grout.

**Brushes (old toothbrushes or vegetable brushes)** for clearing away grout and defining details.

**Clean cloth rags** (not shown) for wiping down and buffing finished piece. Soft cotton works best.

**Float** for spreading grout.

**Grout additive** fortifyies or provides more resistance to grout; for projects made to be subjected to traffic, water, or weather.

Grouting tools

**Grout sealer** for extending the life of your mosaic.

**Mixing stick** for stirring or mixing grout.

**Pallet knives (disposable)** for spreading grout in small spaces.

**Pointing trowel** for working grout into smaller spaces between tesserae.

**Sponges** for wiping off excess grout.

**Squeegee** for spreading grout across a large surface such as a floor.

**Trash can** for disposing of old grout and other unusable items.

**Water container** for rinsing and cleanup.

## EXTRA TOOLS

**Benchtop grinder** or multipurpose tool with a grinding wheel attachment is valuable for smoothing rough edges. This tool is available at stained-glass suppliers or hardware stores.

**Cutting system** (e.g. Morton®) is useful if you cut large quantities of glass. This tool is usually available from stained-glass suppliers.

**Hammer and hardi** (small anvil) are used for cutting stone and smalti. These tools can often be found at stone masonry stores.

**Tile stone** is a rectangular stone that works as a file to smooth edges and shape tesserae; works well with tile, stone and china.

# Techniques

## SAFETY FIRST

*Never scrimp or take shortcuts when it comes to safety.*
*Always protect yourself by following the simple procedures outlined below.*

- Always keep your work area well-ventilated, especially when working with polymer clay and solvent-based adhesives. Fumes and dust from adhesives and grout can be very harmful—both to you and others, including pets, in or around your work space.

- Since tesserae can be serious choking hazards, keep children and pets out of your work area. Shards from broken glass and ceramics can cause injuries. Use good judgment when making exceptions for children—supervise them closely and make sure they wear closed shoes. Children will also need goggles and gloves, even if they are just observing. As for pets, however, bear in mind that their eyes and paws can't be protected, and that the dust, chemicals, and shards can be harmful to them.

- Don't keep food or open drinks near you when you're working with glass or tile; you could end up eating or drinking tiny splinters or grout dust.

- Safety goggles are a must when cutting any material, especially glass and tile, or when operating power tools because small particles and splinters fly when cutting and nipping. Goggles are also recommended when mixing dry materials, such as fiber cement or grout, to protect eyes from the dust. Store goggles in a sealed plastic bag when not in use to keep them

clean. If others are near you while you are cutting or nipping, make sure that they also wear eye protection.

- A quality air-filter mask is essential. Wear it every time you do anything that creates airborne particles, which includes cutting and breaking tiles. Remember that inhaling the dust when mixing grout, fiber cement, etc., can cause serious damage to your lungs and sinuses over time. Keep your mask in a sealed plastic bag when not in use so dust won't build up on it.

- Always wear good-quality latex or rubber gloves when using adhesives or grouting. The harsh chemicals found in grout will eat away at the skin on your hands with prolonged exposure. If you do get grout on your hands, rinse them with apple cider vinegar to neutralize the chemicals, then wash them thoroughly with soap and water.

- Maintain your tools with care. Wash and dry them after use and spray metal tools with a protective lubricant so they won't rust. Keep them in a designated place in your work area for easy access. If a tool looks like it might be broken, discard it and replace it with a new one.

- Once you have used them for making mosaics, tools such as bowls, spoons, pans, trays, and

sieves should be dedicated to your craft and never again used for food.

- Read and follow all product manufacturer's directions and project instructions carefully and completely. Be aware that every product behaves in its own unique way.

- Be careful when working with cut tesserae; they have sharp edges after cutting.

- Make a habit of cleaning up after every work session. Bits of glass, tile, and other materials accumulate quickly. Wear protective gear when sweeping the floor and counters, as glass can break down into particles tiny enough to become airborne.

- Never, ever, rinse grout or cement down your drains. These materials will set up, or harden, damaging your pipes in a big way. Instead, use a "slop" container—a large bucket or plastic garbage pail filled with water—to collect cement residue for disposal. Submerge and rinse off grout and cement mixing containers in the slop bucket. Rinse your hands and tools in a separate bucket filled with clean water, then empty that bucket into the slop container. To clean out the slop container, let the contents settle overnight, then pour off the water and dump the sludge at the bottom into a plastic garbage bag for disposal.

# ANDAMENTO

Andamento refers to the "flow" of the tesserae—how you arrange a background in relation to the focal point. It has been described as the mosaic equivalent of the brush stroke. The word that refers to these "brush strokes" in mosaic is "opus." To achieve different looks, you can choose one opus for your focal point, or central design, a contrasting opus for the background, and sometimes even a third opus for a border.

**Opus circumactum** is the name for a circular or fan-shaped pattern. It is important when using this opus to make certain that the curves mirror each other; if the proportions vary, the imbalance will pull the eye away from the effect and ruin the finished look.

**Opus musivum** is a pattern that outlines the focal point, then continues to outline the outline, over and over until the whole background is filled. This gives the piece a very lively look, which is full of movement.

**Opus palladianum** refers to irregularly cut or broken tesserae laid out in a "crazy paving" style. The trick to creating a nice effect is to keep the spaces relatively equal between the tesserae. This is a great way to use up bits and pieces of tesserae; however, be careful about using too many different sizes, colors, patterns, or textures as the project can become cluttered and lose its charm.

**Opus regulatum** is a pattern in which tesserae are laid out in a grid. This pattern is very plain but can provide a dramatic background with a look of simple strength.

**Opus sectile** is a technique often used by stained-glass artists. This opus uses tesserae that are individually cut into shapes specifically fitted to each other.

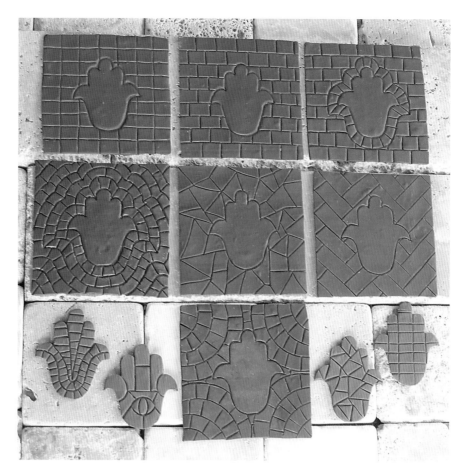

Top left: Background in opus regulatum. Top center: Background in opus tessellatum. Top right: Background in opus vermiculatum with opus tessellatum. Middle left: Background in opus musivum. Middle center: Background in opus palladianum. Middle right: Background in opus spicatum. Bottom left: Focal points in opus musivum and opus sectile. Bottom center: Background in opus sectile. Bottom right: Focal points in opus palladianum and opus regulatum.

**Opus spicatum** yields a weave done in the herringbone effect. This is not the easiest choice to work with as a background; you must make sure that your focal point is well defined.

**Opus tessellatum** is similar to a brickwork design, with the rows of tesserae laid out in a staggered, rectilinear arrangement. In this pattern, it is essential that the pieces do not match up or the effect can be ruined.

**Opus vermiculatum** is a pattern whose main purpose is to outline the focal point or design with a single row. The rest of the background is then completed using a contrasting opus, such as opus regulatum or tessellatum.

# LAYING OUT A MOSAIC

Planning ahead eliminates many potential problems that may arise during the creative process. Before you lay out a mosaic, ask yourself a few key questions.

*Example: You want to make a clock with an abstract design to hang on the kitchen wall.*

**What is the mosaic's purpose**?

To hang on the kitchen wall and show the time. Since the mosaic will hang on the wall, it must be a suitable weight for the wall; if it is too heavy, either scale down the project or reinforce the wall.

**Is the mosaic decorative or functional**?

Functional—the clock hands must glide smoothly above the surface, so the clock's design should be as uniform as possible.

**Will the mosaic be permanent or movable?**

Movable—plan on sealing the grout and edges so the grout will not slough off or crumble when touched.

**What style will you use for the mosaic (traditional, abstract, modern)?**

Abstract—start sketching or hunting for layout ideas. When selecting the tesserae and grout, keep in mind the theme and colors of the kitchen, and choose an appropriate base and adhesive.

## Planning the Layout

A common ways to lay out a mosaic is with a motif or picture in the center, then a background and a border. Use the background to frame the central motif as you would use a mat board to frame a picture, then use your border as you would use a picture frame. Choose an andamento to complement the central motif.

Put your design on paper. A rough sketch is a good start, but for best results use exact measurements in your drawing. With a full-scale drawing or pattern you will be able to work out any problems ahead of time. It can be helpful to use colored pencils to work out color schemes and measurements beforehand. If a particular piece is not coming together the way you anticipated, try changing colors or measurements.

You can also use found art. Photocopy the piece of found art and use carbon paper to transfer the design onto your base. Use an entire picture or merely focus on a small portion of the picture and expand or enlarge that part. Inspiration can also come from design sources such as fabric and wallpaper. Be flexible when planning out a mosaic; sometimes the mosaic lays itself out despite what you plan. Just go with it and see where it takes you.

To transfer a pattern, you'll need the materials listed for the Pattern Transfer Kit below. Note that black graphite paper is not the same as carbon paper for typing, but a special, wax-free paper sold in crafts and art-supply stores specifically for transferring designs.

For many of the project patterns in this book, you will need to enlarge the design by the percentage indicated in order to produce a full-size template. If the design is particularly large—larger than the photocopier's paper—you may need to copy the pattern in sections, and then tape the enlarged copies together. In some cases you may also need to enlarge the design a second time, as indicated on the template.

---

### PATTERN TRANSFER KIT

- Tracing paper
- Pencil (2B)
- Black graphite paper (if indicated in project)
- Masking or cellophane tape
- Black permanent marking pen.

---

## Transferring Patterns onto Flat Objects

1. Trace the pattern template using tracing paper slightly larger than the pattern itself. Be sure to make good, solid lines as you trace.

2. Tape the tracing paper pencil-side up against the back (non-graphite side) of a matching-size or larger piece of graphite paper. (See Photo 1.)

3. Put the joined papers graphite-side down on the surface of the object to which you want to transfer the pattern. With the template properly aligned, tape the papers in place to keep them from slipping. (See Photo 2.)

4. Carefully go over all of the lines on the tracing paper with a pencil. Apply enough pressure to transfer the image through the graphite, but not so much that you rip or tear the papers. Begin in one clearly defined spot and move methodically through the pattern, paying attention to where you are and making sure to cover every line. (See Photo 3.) Try not to stop midway though the process because you may not be able to tell where you were when you stopped. If you remove the graphite paper and discover that part of the design wasn't transferred, you'll have to try to put the graphite paper back on the object in the same place—a difficult task because you can't see through the graphite paper to align the pattern.

5. Once you've finished transferring the design, carefully remove the papers. (See Photo 4.) Go over the graphite lines with a permanent marker so that the pattern can't be smudged or erased. (See Photo 5.)

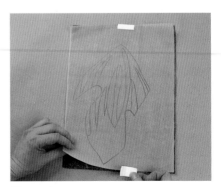

Photo 1

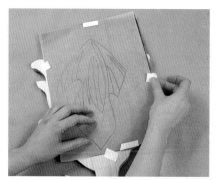

Photo 2

Photo 3

Photo 4

Photo 5

## Transferring Patterns onto Three-Dimensional Objects

On more complicated surfaces you can't always position and trace over an entire pattern all at once. Instead, you'll have to work in sections. For instance, to transfer a pattern to the curved surface of a flowerpot:

1. Tape the top of the joined tracing/graphite papers to a portion of the top edge of the flowerpot, leaving the sides and bottom of the paper loose but making sure that the pattern would be aligned evenly if it were wrapped all the way around.

2. Smooth down the paper in the center of the section facing you, where the flowerpot contacts the graphite paper directly. Trace the lines in that section.

3. Turn the flowerpot slightly, smooth down and trace over the next section (which is now facing you), and so on. Reposition the tape along the top edge as needed to keep the section you're working on in place.

4. Continue turning, smoothing, and tracing until the entire design has been transferred. Then remove the paper and go over the lines with permanent marker.

## CUTTING TECHNIQUES

Whether you choose to use a cutter or nippers, it is the pressure of squeezing the tesserae between the "jaws" of the tool that cuts or breaks it into pieces. With practice you can control this breaking to achieve shapes. One basic difference to remember: with a tile nipper, only ⅛" of the jaws of the tool should be on the tesserae. With a wheel glass cutter, you place the cutting wheels in the center of the line you want to cut.

Spend some time experimenting with various cutting techniques and tools. Never mind if you ruin some tiles or glass along the way. Of course, remember *always* to wear safety goggles when cutting.

### TILE MAKING KIT

- Glass cutter
- Running pliers
- Ruler
- Safety goggles

## Making Tiles from Glass and Mirror

When vitreous glass tiles don't offer the color or look you want, you can cut your own square or rectangular tiles from stained glass or mirror. Cut them to whatever size you wish. Use them as they are, or nip and shape them just as you would store-bought tiles.

1. Determine the width of the tiles you wish to cut. Place a ruler at that width along one edge of the glass and use the glass cutter to score a line across the surface of the glass by pulling it once along one edge of the ruler. (See Photo 6.)

*Note: When using a glass cutter, never go over a score line twice, as this can cause problems when you are making the break—make certain of your cut the first time.*

Photo 6

2. Make additional score lines parallel to the first, spaced to match the first strip's width. Using running pliers, snap the entire scored section off the main piece of glass at the last score line. Turn the scored section and cut a second set of score lines with the glass cutter, perpendicular to the first set, creating a grid. (See Photo 7.)

3. Align the running pliers with the first lengthwise score line you made and snap off the first strip. Then snap off the rest of the long strips. (See Photo 8.)

4. Turn each strip and use running pliers along the second set of score lines to snap off individual tiles one at a time. (See Photo 9.)

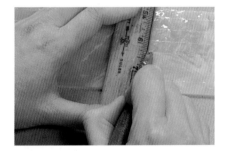

Photo 7

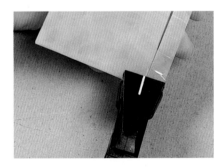

Photo 8

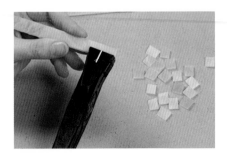

Photo 9

## Cutting Smalti

Although the traditional way to cut smalti is with a hammer and hardi, use a wheel glass cutter for more control and a cleaner cut. (See Photo 10.)

Photo 10

## Cutting Shapes

For some projects you'll want to cut tesserae into distinct shapes such as circles, triangles, or crescents. Using glass mosaic cutters, you can cut these shapes from vitreous glass tiles or from stained-glass or mirror tiles you've made yourself.

To make rectangles, cut a square straight in half. (See Photo 11.)

To make tiny squares, cut those rectangles in half. (See Photo 12.)

Make triangles by cutting a tile in half diagonally; then cut the two halves diagonally in the opposite direction to make small equilateral triangles. (See Photo 13.)

To create curved shapes, use glass mosaic cutters to nip a series of slight angles at the corners and along the edges of tiles. To make crescent moon shapes, nibble away the outside corners and middle of triangles. (See Photo 14.)

To create a circle, nip a series of angles around a square tile, removing small bits at a time to form a smooth, even curve. (See Photos 15 and 16.)

Photo 11

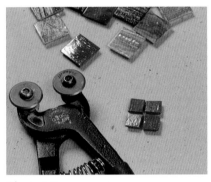

Photo 12

Photo 13

Photo 14

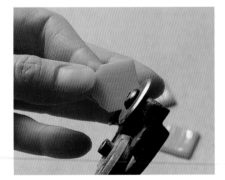

Photo 15

Photo 16

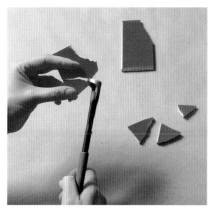

Photo 17

You can also use these techniques with ceramic tile nippers to shape vitreous glass tiles. The cut edges will be somewhat more ragged, creating tesserae with a looser look. Of course, tile nippers are the tool to use when shaping pieces of ceramic tile. By carefully lining up the jaws in the direction of the cuts you want to make, you can create basic shapes such as triangles. (See Photo 17.)

*Note: Break 4" x 4" tiles into shards with a hammer, then nip them into smaller, more precise shapes to fill available space.*

## Cutting a Simple Leaf Shape

1. Start with a piece of glass as long as and slightly wider than the leaf you want to create. Using a glass cutter, score an arc from the middle of one narrow end to the middle of the other. Then score a matching arc on the other side. (See Photo 18.)
2. Use running pliers to break the glass at the scores, creating the basic leaf shape. (See Photo 19.)
3. Score and snap the leaf shape in half lengthwise. (See Photo 20.)
4. Using glass mosaic cutters, nip each side evenly into diagonal sections. With the sections spaced slightly apart, the grout lines between will simulate leaf veins. (See Photo 21.)

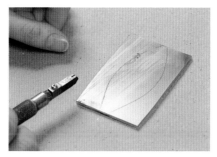

Photo 18

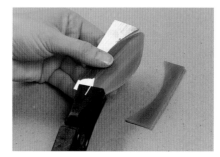

Photo 19

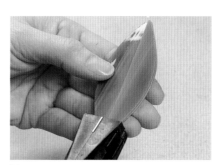

Photo 20

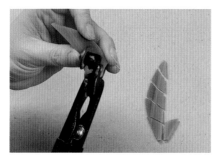

Photo 21

## Cutting Irregular Tesserae

Irregular tesserae or shards with interesting curves or angles add visual impact because the eye is usually more attracted to slight imperfections and to irregular shapes. Therefore, you may want to vary the widths of the strips you score and break off, and/or snip

them with glass mosaic cutters into slightly angled pieces of varying size, each unique. (See Photo 22.)

1. A glass cutter is great for creating shards with long, sweeping curves. First, score the glass or mirror freehand. (See Photo 23.)
2. Apply running pliers to one edge of the score line to break off the pieces. (See Photo 24.)

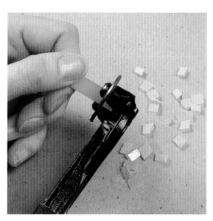

Photo 22

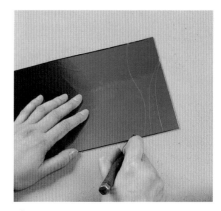

Photo 23

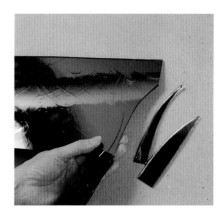

Photo 24

3. Glass mosaic cutters are best for cutting and shaping irregular, fractured-looking shards of stained glass. You can cut pieces to the approximate sizes needed. (See Photo 25.)

4. Cutting and adding irregular tesserae to a surface is like doing a jigsaw puzzle, only you get to shape the pieces as you go, and make them fit together however you wish. (See Photo 26.)

5. Glass mosaic cutters can create slight curves in the shards as well as angled cuts, which allow you to shape them to conform to the space you want to fill while maintaining their overall fractured appearance. (See Photo 27.)

Photo 25

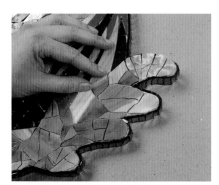

Photo 26

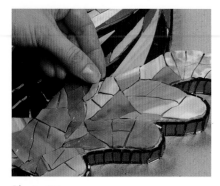

Photo 27

You can also use this technique with vitreous glass and ceramic tiles. The irregular shards you get from vitreous tiles will have a more angular look and feel, simply because you start with perfect squares. Ceramic tile, dinnerware, and china cut into shards with nippers have a heavier, broken-plate appearance.

## Make Your Own Gold-Leaf Glass

You can use double-thickness clear glass to make an affordable substitute for the world's most expensive mosaic material: handmade gold-leaf tesserae. Authentic gold-leaf tesserae are made by sandwiching gold leaf between fused layers of glass. They're strikingly beautiful. The cost, however, makes genuine gold-leaf tesserae impractical for many projects.

Inexpensive composite gold leaf, which is sold along with a special adhesive in crafts stores, may be applied to double-thickness clear glass, then cut into squares or shards for tesserae. The only disadvantage is that the gold leaf can scratch easily—so before placing the tesserae, paint the surface with metallic gold enamel. This will help hide any scratches.

### Materials

• Composite gold leaf and adhesive
• Double-thickness clear glass

1. Following the manufacturer's instructions, brush a coat of gold-leaf adhesive onto the glass. The glass should be as big as or slightly smaller than a sheet of gold leaf, typically 5" square. (See Photo 28.)

2. Let the adhesive dry clear. Then carefully lay a sheet of gold leaf onto the glass. Because gold leaf is feather-light and less than paper thin, it can be difficult to handle and position. Just get as

much on the glass as possible. (See Photo 29.)

3. Smooth the gold leaf carefully over the surface. (See Photo 30.)

4. Trim excess gold leaf from the edges and smooth it onto remaining clear areas. (See Photo 31.)

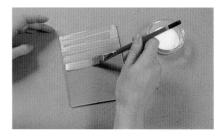

Photo 28

Photo 29

Photo 30

Photo 31

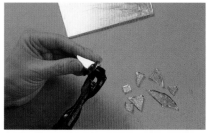

Photo 32

5. Cut the glass into shards, gold-leaf-side up, to minimize scratching the gold leaf; or, follow the instructions on page 00 for making square and rectangular tiles. (See Photo 32.)

## Cutting Tile

### Cutting Tile with Tile Nippers

As with pliers or a wheel glass cutter/nipper, position the tile nippers no more than ⅛" onto the tesserae when making a cut. To cut triangles, do the same, but position the nippers at the corners. (See Photo 33.)

### Cutting Shapes with Tile Nippers

To cut shapes, use the nibbling technique to nip away the edges of the tile with the nippers. Nip only to the outside of the shape as you can always cut more off. If you cut into the shape and get too much, you can't undo it. (See Photo 34.)

### Smoothing Tile Edges

After cutting shapes, use a small tile stone to smooth the edges. The stone works just like a file. Make certain that you always file in one direction. (See Photo 35.)

### Cutting Tile with a Tile Cutter

1. Place the tile in the cutter, flush with the top edge. Hold the tile with one hand as you score the top by pulling the handle and dragging the scorer across the tile surface.
2. Return the handle to the starting position. This will remove the scorer from the surface and position the break piece. Firmly pull straight down; the tile will snap.

*Note: The tile should remain in the same position the entire time. As with glass cutting, only score a line once.*

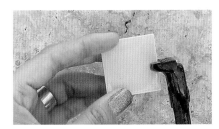

Photo 33

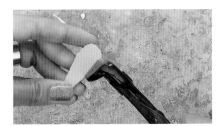

Photo 34

Photo 35

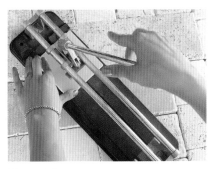

Photo 36

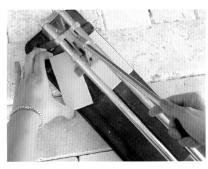

Photo 37

### Breaking China/Crockery

To break china or crockery into random pieces, use the "safety smash," as outlined below.

1. Place one or two folded bath towels on concrete or another hard surface so you have two to four thicknesses of toweling. Place the plate upside down on the towels. (See Photo 38.)
2. Place one towel over the top of the plate to keep chips from flying out. Use your hands to feel through the towel and locate where the ridge is on the bottom of the plate. (See Photo 39.)
3. Put on safety goggles. Imagine that the ridge on the back of the plate is a clock face, and hit the ridge at 12, 3, 6, and 9 o'clock with a mallet or gently with a hammer, to break the plate into manageable pieces. Try not to begin the break by hitting the plate in the center, as you can end up with a large hole in the middle of the plate and a plate border that is fully intact. If you begin at the plate edge, you are likely either to chip the plate, marring the

Photo 38

Photo 39

usable surface, or shatter the border into pieces too small to use. (See Photo 40.)

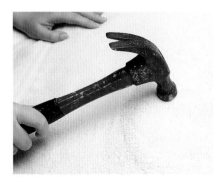

Photo 40

4. Lift the top towel periodically to see how the breaks are progressing. China will not break predictably, so do not get too upset if the breaks are not as you had envisioned. Be flexible; however the broken pieces turn out, let your eye guide you to their best placement. (See Photo 41.)

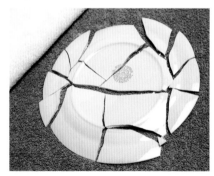

Photo 41

5. If you choose to continue with a hammer, always keep the plate covered with the top towel. Continue hitting the plate all over until the desired size pieces are achieved. Be aware that all these pieces will have sharp edges, so be careful and watch for small slivers and shards.

## Cutting China/Crockery with Tile Nippers

You may decide to stop using a mallet or hammer and begin using nippers to "clean up" the pieces. You could also do all the breaking with tile nippers, which would give

you a bit more control. Keep in mind that with china, you will always have to overcome two obstacles—slope and ridge. When using nippers to make cuts, place the blades only about ⅛" over the edge of the plate.

1. Using the nippers, break the plate in half. (See Photo 42.)
2. Break each half into quarters, then break each quarter into eighths. (See Photo 43.)
3. Separate the plate's border from its center, cutting away the curved portion between border and center. (See Photo 44.)

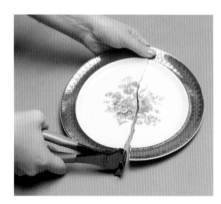

Photo 42

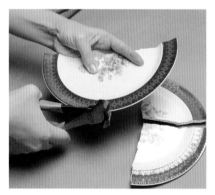

Photo 43

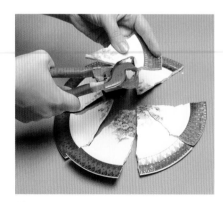

Photo 44

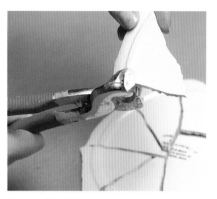

Photo 45

*Note: Experiment with the angle at which you hold the tile nippers. You will see that this often determines the outcome of the cut more than you might think. Try to be consistent when making cuts on pieces that will be placed near each other on the mosaic project.*

4. To flatten pieces, such as the ridge at the back of the plate, place the nippers as close to the ridge as possible and nip away a little bit at a time. Remember to use only the very edge of the nipper. You may have to make two or three attempts from each side until the ridge is removed entirely. (See Photo 45.)
5. Repeat the process with several more plates to obtain patterned pieces and solid colors. For your own convenience later, sort pieces according to color. Save details such as rounded pieces, edge pieces, spouts, and handles for possible features in projects.

## Cutting China/Crockery with a Wheel Glass Cutter

You can use a wheel glass cutter with china and crockery, just as

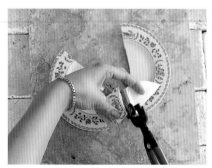

Photo 46

easily as with glass. However, china does not always break predictably because of the many variables in how and with what it was made. Be prepared for the possibility of your cut going awry. Remember that a random quality is one of the charms of picasiette. (See Photo 46.)

### Cutting Stone

Lay your stone on the work surface. Use either a chisel and hammer, or the sharp end of a mason's hammer, to strike the piece; this will cause the break. (See Photo 47.)

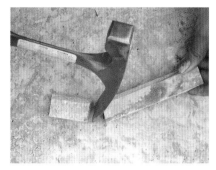

Photo 47

# ATTACHING TESSERAE

### Direct Method

Adhering tesserae directly to an object is called, quite sensibly, the Direct method.

### Buttering the Adhesive

To apply adhesive, many mosaic artists use a flat knife or craft stick to spread glue or mortar onto the back of each piece before placing it—a technique called buttering (like spreading butter on a cracker).

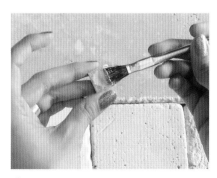

Photo 48

When using silicone glue, butter only very large pieces, as buttering smaller tesserae with glue can be messy and time-consuming. (See Photo 48.)

### Applying a Bead of Adhesive

For gluing small areas, use the tube's applicator tip to apply and spread the adhesive directly onto the base. (See Photo 49.) You may also use a craft stick to spread the glue before positioning the tile and pressing it into place. (See Photo 50.)

Keep the adhesive's thickness consistent—about $\frac{1}{16}$" when working with stained glass or mirror; about $\frac{1}{8}$" for other materials. It's difficult to spread the glue evenly, so inevitably, the glue in some areas will fill the spaces between tesserae. Use a dental tool or craft stick to remove excess glue while it's wet.

Be careful not to spread glue over an area larger than you can tile before the adhesive dries. If that happens, the tiles won't stick. Placing another layer of glue on top will create an uneven surface.

Photo 49

Photo 50

Your only option then is to scrape off the dried adhesive and start over. Silicone glue dries in about 5 to 10 minutes.

When working with thin-set mortar and ceramic tile, butter each piece before placing it. Be sure to cover the entire bottom surface with adhesive, then press it into place. Use a craft stick to remove any excess mortar that oozes out.

Regardless of the adhesive, when tiling vertical surfaces, work from the bottom up. Apply the adhesive, then tile upward, so that the first and lowest pieces you position will help keep the higher pieces from slipping down before their adhesive sets.

### Indirect Method

Creating a mosaic on a portable surface material that will then be moved and installed elsewhere in a permanent location is known as using the Indirect method. This method is a bit more difficult, but it gives you the freedom to put mosaics in all kinds of places—indoors or out—allowing you to make them in the convenience of your work space.

To do an Indirect mosaic, draw or transfer your picture in reverse onto brown kraft paper. Attach the tesserae, face down, onto the drawing with a 1:1 solution of PVA (water-soluble glue) and water. (See Photo 51.) Allow the glue to dry. Spread adhesive onto your permanent base, then flip the design over

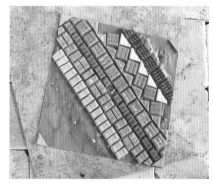

Photo 51

and attach the back side of the tesserae onto the base (the brown paper is now uppermost). Allow the mosaic to set. Dampen the brown paper to break down the water-soluble glue and peel it off to reveal your design. You are then ready to grout the mosaic.

## Double-reverse Method

When you are working with tesserae that have a different color on the back from what you see on the front, such as ceramic tiles, you may wish to use clear contact paper to work the Double-reverse method.

*Note: When your mosaic must be perfectly flat for its application, such as on a tabletop, countertop, or floor, use the Double-reverse method.*

In this method, you lay out your mosaic on a picture as in the Direct method, then attach the contact paper onto the top; flip, and cover with another piece of contact paper. The best way to flip the mosaic is to "sandwich" it between two pieces of wood, flip it over, then remove the top piece of wood. (See Photo 52.)

Photo 52

The advantage of using contact paper is that you are able to look at your picture to check the progress of the design—just take care when flipping back and forth. You also need not use a glue-and-water solution to attach the tesserae onto the paper, since it is already sticky.

## Indirect Mosaic on Mesh

Tape plastic sheeting or cling wrap over your design or pattern. (See Photo 53.)

Center mesh over the plastic-topped design and tape it in place. Attach tiles in the center first and work outward. Glue mosaic materials in place one at a time. (See Photo 54.)

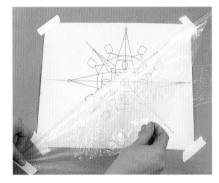

Photo 53

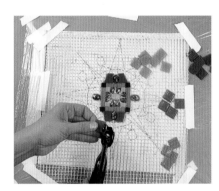

Photo 54

When the glue on the completed mosaic is completely dry, carefully lift the tiled mesh off the cling wrap. Hold the mesh-backed mosaic in place on the surface where you'll be installing it and trace around it with a pencil. Spread an even layer of adhesive within the tracing. (If the surface is painted or especially smooth, rough it up with sandpaper first.) Press the mesh-backed mosaic into position in the glue, getting it properly aligned right away, before the adhesive dries too much.

Place a flat board over the mosaic, and with a hammer tap lightly all over the surface to ensure that the entire piece is securely embedded

and level. Using dental picks or a razor blade, clean away any adhesive that has come up through the mesh onto the tiles. Let the glue dry for 24 hours. Proceed with grouting.

## Placing and Spacing

Keep the spaces between tiles (the gaps that will be filled with grout) consistent as you place them. Narrow grout lines give a piece a tight, controlled look; wider grout lines produce a looser feel. As a rule of thumb, use the following:

- Stained glass or vitreous glass tiles: leave between ¹⁄₁₆" and ⅛"
- Ceramic tiles or picasiette: leave between ⅛" and ³⁄₁₆"

For small objects, use proportionately small tesserae, spacing and positioning them carefully with tweezers.

When tiling a curved or rounded area, cut or nip the pieces small enough to rest flat on the surface. The greater the curve, the smaller the piece must be cut. If you can rock a piece back and forth, it's too big. Remove it and cut it smaller until, when you reposition it, no movement can be detected.

When tiling adjacent to an edge, place the tesserae flush to the edge, not short of it or extending slightly beyond it. This will create a stronger edge, allowing you to handle the mosaic object more easily, and will also help produce a more even and attractive edge grout line.

## Tiling Edges

Although some mosaic artists recommend otherwise, if you tile and grout the edge properly and handle the object carefully (see page 00), you won't have problems with the edge tiles popping off—the main reason why some prefer not to mosaic edges.

1. To tile an edge, measure the thickness of the base and cut several strips of material to

precisely that width. If you make them any larger there won't be enough space for grout in the gap where the edge and surface tiles meet. Use a glass cutter and running pliers if you're cutting glass or mirror. Use a tile cutter if you're working with ceramic tile. (See Photo 55.)

2. Snip the strips into smaller pieces, placing them on your work surface in the order that you cut them. Again, use whichever tool is appropriate to the material: glass mosaic cutters for glass or mirror, tile nippers for ceramic tile. You can cut the pieces into regular shapes or, as shown here, irregular ones. (See Photo 56.)

3. If the edge you are tiling is curved, cut some pieces narrower than others, for tiling along the curves. Spread adhesive onto a section of edge. (See Photo 57.)

4. Press pieces into place, spacing them consistently. Take care to position them flush to both sides of the edge. Make sure that the pieces along curves are narrow enough to lie flat. (See Photo 58.)

5. If the pieces are not narrow enough, cut them smaller. Use tweezers when tiling tight areas. (See Photo 59.)

6. Continue tiling—cutting and snipping additional strips of material as needed—until the entire edge is finished. (See Photo 60.)

7. Apply similar techniques to tile the lip and inside edge of flowerpots, vases, and other containers. You can carry a design detail and its color from the side of an object over onto the lip and inside edge. This takes time and patience, but produces a more sophisticated, finished look. (See Photo 61.)

*Note: When tiling the edges of a flat project, keep it flat on the work surface so freshly glued tiles will be supported from underneath, preventing them from sliding downward. Once you start tiling edges, do not move the piece too soon, or you may knock off some of the tiles. When you need to turn the object midway through tiling, let the adhesive dry first. Grasp the piece on the portions of edge that are not yet tiled, lift it straight up, turn it, and let it down flat. Do not slide the piece.*

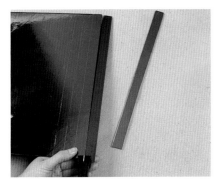
Photo 55

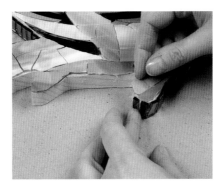
Photo 58

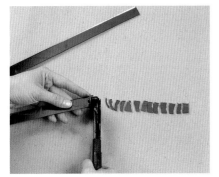
Photo 56

Photo 59

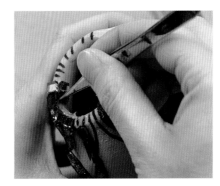
Photo 61

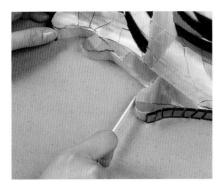
Photo 57

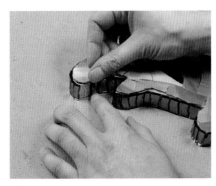
Photo 60

**Cleaning Adhesive**

1. Before grouting the mosaic, carefully clean away all excess adhesive. Use a craft knife or razor blade to scrape residue from the surface. (See Photo 62.)

2. Adhesive in the cracks between tiles will prevent you from filling the gaps properly with grout. Use a craft knife or dental pick to remove the material. This is

an important step, so take your time and be careful not to miss any areas. (See Photo 63.)

Photo 62

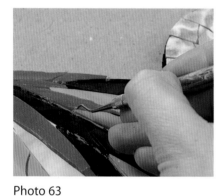

Photo 63

# GROUTING

Grout must be mixed just before you apply it to the mosaic, so prepare for both mixing and grouting in advance. Try to avoid grouting at night, unless you have excellent lighting; mistakes are much easier to spot in the daylight. Allow sufficient time; once you start grouting you can't stop midway—you must complete the process.

Cover your work surface with plastic or kraft paper. Assemble the materials you'll need—grout, acrylic grout fortifier, and pigment (if you intend to custom-color your grout)—along with the necessary tools and supplies. Never rinse any grout down the drain. If you feel it is too difficult or time-consuming to clean a grout container, mix the grout in a disposable container.

You must wear latex or rubber gloves during the grouting process. Be aware that you can easily go

through two or three pairs of gloves during one project. Grout is nontoxic, but very caustic; it will dry out your hands and nails.

Grout is available in a wide array of premixed colors. However, if you want a specific color and you cannot find it premixed, there are a few ways to mix your own colors.

- Add colored grout to white grout to get a lighter color than the original.
- Blend two different colored grouts together to create a new color.
- Mix acrylic paint or powdered tempera into white grout to customize a new color.

### Grouting with Cement-based Sanded Grout

1. Pour the determined amount of powdered grout into a dedicated mixing container—one cup per square foot of mosaic is an average amount.

*Note: It is better to have a bit more grout than you need. It can be a real problem to have too little and need to mix more, especially if you are custom-mixing your color.*

2. Add liquid pigment or other colorant next if you're custom-

coloring the grout. Pigment amounts are included in many of the projects that call for custom-colored grout, but use your own judgment. Eventually, you will develop a feel for how much color to add. (See Photo 64.)

3. Following the manufacturer's directions, add water or grout additive, stirring in a little at a time. Mix well, making certain to scrape the bottom and sides of the container. (See Photo 65.)

4. Use only enough liquid so that, when mixed, the grout has the consistency of thick oatmeal or peanut butter. If the mixture is too wet when applied it will crack as it dries; if it is too dry it will be difficult to work with and can flake off in the drying process. If too much water is added, allow it to sit for a few minutes until it thickens up, or add a bit more dry grout and stir until smooth. When you scoop up a handful (wearing gloves!) and turn your hand over, the grout should slowly glop off. (See Photo 66.)

5. Allow the grout to slake—let it sit for approximately 15 minutes to give all the polymers, latex, or other strengthening agents in the mixture sufficient opportunity to blend, ensuring the best

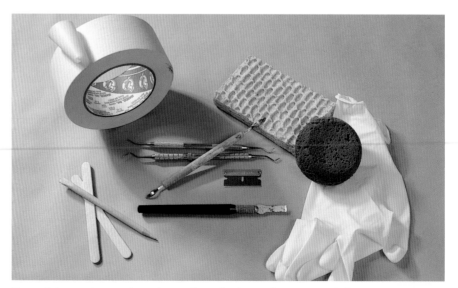

Essential grouting tools and supplies. Clockwise from upper left: Masking tape, sponges, latex gloves, cleaning tools, clay modeling tools, craft stocks.

possible grout finish. Take a portion of mixed grout and spread it around on the surface with your gloved hands, rubbing and smoothing from all directions and pressing the grout firmly into the spaces and crevices. (See Photo 67.)

6. Generously cover the entire piece. Spread the grout as far as it will go and add more if necessary. You must be thorough and work quickly. (See Photo 68.)

7. Keep working quickly until the entire surface is covered and all the gaps are filled. Be careful of sharp edges—they will only be smoothed out once the grout has filled in the joints.

8. If applicable, work grout into any edge tiles. Using your fingers and thumbs, press grout into and along the gap where the surface and edge tiles meet. (See Photo 69.)

9. Always take time to work grout along the edge's underside, between the base and the tile ends. Put the project on a block of wood or old book to raise it just enough to get your fingers underneath to smooth grout along this area, strengthening the tiled edge.

10. Dip a sponge into the container of water, wring out the water as hard as you can, and wipe excess grout off the tiled surface. Be careful not to wipe away too much grout; the material should be level, or nearly so, with the tiles. Rinse and wring out the sponge often as you work; the sponge should be clean and just barely damp. (See Photo 70.)

11. When you have finished the surface, use the sponge to wipe excess grout from the edge tiles. Carefully smooth the grout filling the joint between the surface and edge. If you wipe away too much grout from this gap, add more and smooth it again. (See Photo 71.)

*Note: If you're grouting a large piece you may want to work in sections, applying grout to and wiping and polishing each section before moving on to the next. If you try to grout the entire piece at once the grout you apply at the start may harden before you can wipe off the excess with a damp sponge, making it next to impossible to polish and clean the surface.*

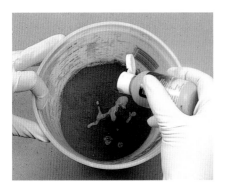
Photo 64

Photo 65

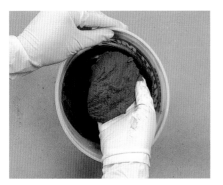
Photo 66

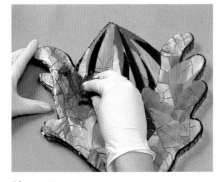
Photo 67

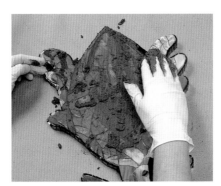
Photo 68

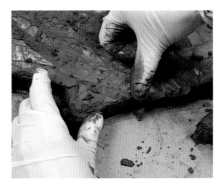
Photo 69

Photo 70

Photo 71

## Polishing and Cleaning

1. Allow the piece to rest for about 15–25 minutes. The surface will haze over as the grout residue dries. The bigger the project and the wetter the grout, the longer this will take. If the excess grout wipes from the tesserae easily, it is dry enough to do a first wipe-down; if it smudges all over, allow it to set for another 15 minutes and try again. Use a soft, lint-free cloth to wipe away and polish off the grout haze. The tiles or glass will return to a beautiful gleam. (See Photo 72.)

2. As a final step, use a hobby knife, dental pick, razor blade, or clay cleanup tool to scrape away any stubborn spots where dried grout residue persists on the face. Be careful not to dig out grout between tiles; you want to merely clean the surface of the tile. On the other hand, be careful not to miss any spots. An otherwise fine piece of mosaic can look shoddy if it's not cleaned thoroughly. (See Photo 73.)

3. Allow the grouted project to set overnight at room temperature. Slow drying will give the piece more strength—do not try to

Photo 72

Photo 73

hurry the process by putting it near heat.

4. The grout can be sealed, if you so choose, which will keep grout from staining. Sealer is only necessary if you expect the mosaic to come in contact with water, food, or drink. Many quality grouts have an additive that seals the grout and eliminates this extra step. Check the manufacturer's instructions before deciding whether or not to use a sealer.

## Two-tone Grouting

For some projects you may want to use a second grout color, such as in an area where a second color would highlight a feature or simply look good.

1. Use regular masking tape to cover up the areas where you don't want the first grout color. Press the tape down firmly to keep grout from creeping beneath. Use regular masking tape.

*Note: The easy-release kind of masking tape sold to painters doesn't have enough adhesive to hold up to the grouting process.*

2. Apply the first grout color; clean and polish the tiles. Wrap the object in plastic and let the grout set overnight. Carefully remove the masking tape.

3. With fresh tape, mask off the already-grouted sections and other areas where you don't want the second grout color. Use plastic sheeting taped in place to cover large areas. Press tape alongside the outside edges of tiles you'll be grouting with the second color.

4. Apply the second grout color; clean and polish the tiles. Remove the masking tape after the grout has set.

## Curing Grout

Once you have finished grouting, cleaning, and polishing the project

it's important to allow the grout to cure properly. Like any cement product, grout must be given time to complete the hydration process, which hardens the material.

Wrap the grouted mosaic in plastic sheeting or kraft paper and let the grout set for at least three days. If the grout dries too quickly it may crack, so keep the object out of direct sunlight. Unwrap and check the project after a day; if the grout seems to be drying too quickly, spray it lightly with water using a plant mister, then rewrap it. Under hot, dry conditions, you may have to mist it more than once a day.

### Grouting an Unframed Edge

When you finish grouting a mosaic with an unframed edge, run a very thin layer of residual grout along the outside edge. Seal the edge with a thin layer of multipurpose paintable adhesive sealant.

### Grouting a Three-dimensional Object

When you are grouting three-dimensional objects such as beads or ceramic flowers, gently use your fingers or a paintbrush to work the grout around the object's edges to avoid damaging or burying them.

### Grouting with Cement-based Non-sanded Grout

The technique for grouting with non-sanded grout is essentially the same as for sanded grout; however, the drying time is faster.

Non-sanded grout tends to develop "pinholes" as it dries, so watch it carefully. If you see these holes developing, apply more grout to the piece to fill them in.

### Grouting with Epoxy-based Grout

If—after you are comfortable with the techniques provided in this book—you would like to use an epoxy-based grout, follow the manufacturer's directions. Remember to try the technique

oout first on a small mosaic piece, as epoxy-based grout is a little more difficult to work with than cement-based grouts.

## Grouting with an Alternative Grout

An alternative grout is anything used to fill the spaces between the tesserae that is not traditional cement-based or epoxy-based grout. You could use this technique, for example, if you would like to use a delicate type of tesserae that will not withstand the traditional grouting process.

Simply apply a thick layer of adhesive over the entire base; quickly place your tesserae, and sprinkle the entire piece with a fine material such as glitter or tiny beads. The fine material will stick to the exposed adhesive and fill in the spaces between the tesserae, giving it a "grouted" appearance.

*Note: When using an alternative grout, the trick is to work quickly, attaching the tesserae before the adhesive dries out.*

## Troubleshooting

There are some mistakes that can be fixed and others that can't. However, there is always something that can be learned from each experience. Here are some tips that may help avoid or fix some of the more common mistakes.

## Mistake #1—Missing Piece

If a piece falls out during the grouting process, clean it off, set it aside, and leave its spot ungrouted. You can reapply the tessera after you have finished grouting. Save some of your grout in a sealed can, jar, or resealable plastic bag so you

can grout the piece in later. Saving the grout instead of remixing a new batch will insure an exact color match. (See Photo 74.)

## Mistake #2—Poor Choice of Grout Color

When in doubt, start light. If you can't decide what color to grout a piece, go for the lightest of your choices; you can always grout over it with a darker color (but usually only once).

You can also try this trick: Get a spray bottle, dilute acrylic paint in your choice of color (one part paint to at least six parts water), and spray it over your piece. Quickly wipe the tesserae clean. Make certain to get all your grout lines, and do not get it too wet.

## Mistake #3—Damaged Found Objects

Grout can ruin a found object that is not sealed properly. Grout can erode the finish and cloud up a piece such as a seashell or button. One way to correct this is with a touch of paint or even a little clear nail polish. Make certain that there is barely any paint/polish on the brush, and apply gently over the object. Repeat, if necessary.

## Mistake #4—Buried Object

When you use a three-dimensional object, it can get lost during grouting. (See Photo 75.) If this happens, let the grout dry, but not cure completely—an hour or so should do it. Then use a dental tool or toothpick to dig the excess grout from around and within the details of the object. Use an old toothbrush to clean it. Touch it up if

necessary. This process is time-consuming, but may save the piece.

*Note: Use a small, stiff paintbrush to spread grout around the object.*

## Mistake #5—Colors are Too Similar

If your mosaic has too many similar colors and no definite look, you may have used too many same-tone tesserae. Your picture can then easily get lost or look muddled. Unfortunately, there is no fix for this one. You will have to scrap the project and try again.

## CARING FOR FINISHED MOSAIC OBJECTS

Handle mosaic objects with care, not only during construction but also afterward. Keep these tips in mind:

- Unless wearing gloves, do not run your hands idly across the surface of a mosaic. One protruding tile edge is enough to cut you.

- Never lean a mosaic on edge. This places the weight of the entire piece on that spot and risks popping off some tiles.

- Lift mosaic objects straight up, and set them down the same way. If you must tilt a piece—for example, to put soil in the cups of the Cascading Planter on page 135—rest the edge on a cushion or folded towel.

- If possible, bring outdoor mosaics indoors when cold weather approaches, and keep them inside until the following spring. Even frostproof mosaics will live longer if you give them shelter in freezing weather.

Photo 74

Photo 75

# SECTION I

# Direct
# Method

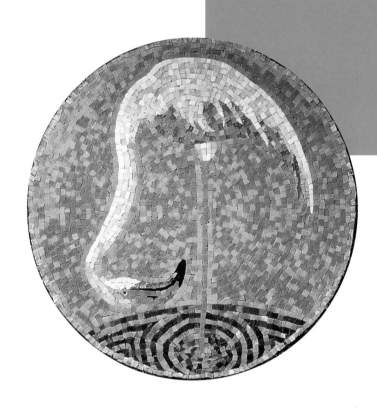

# Geometric Picture Frame

## MATERIALS

Wooden frame, 7" x 9"
Square tiles in 10 colors, ⅜"
  and ⅞"
4 round tiles, assorted colors, 1"
7 round tiles, assorted colors, ½"
3 round tiles, assorted colors, ⅝"

Clear acrylic sealer
Acrylic paint in coordinating
  color
White craft glue
Glue spreader or craft stick
Non-sanded grout, white
Sandpaper, 220 grit

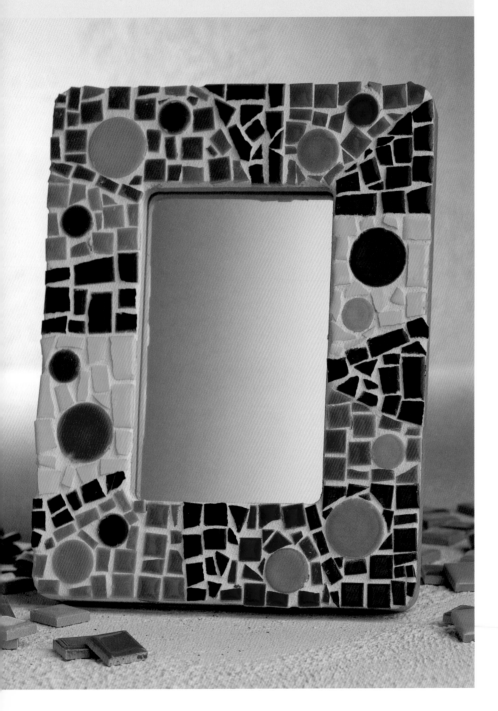

## PREPARATION

1. All surfaces should be oil-free and clean. Lightly sand the wooden frame to even out the area where the tiles will be glued and smooth any part of the surface that will be painted. Wipe or brush away sanding dust.

2. Seal the areas of the wood where you're planning to glue the tile with clear acrylic sealer to protect them from the moisture of the grout. Let dry.

3. Trace the pattern on tracing paper. Using transfer paper and a stylus, transfer the design to the surface.

## ASSEMBLING AND ATTACHING TESSERAE

1. Using tile nippers, nip square tiles into a variety of smaller shapes. They will not always break perfectly—don't be concerned! That's part of the beauty and forgiving nature of mosaics. To break a large number of tiles, place the tiles between terrycloth toweling, amid layers of newspaper, in a brown grocery bag, or inside a thick plastic bag. Use a rubber mallet to strike the tiles and break them into smaller pieces.

2. Working one small section at a time, spread glue on the project surface with a rubber spatula or a craft stick. It is also a good idea to spread glue on the backs of the larger tile pieces for better contact and adhesion.

3. Place the key design pieces (in this case, the circular tiles) first, then position the remaining tiles, one section at a time. (See Photo 1.)

4. As you place the tiles, nip pieces to fit as needed. This is like putting the pieces of a puzzle together. Remember they don't have to fit perfectly—that's what grout is for!

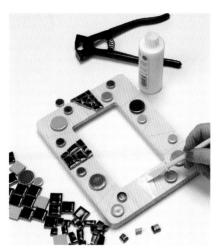

Photo 1

## GROUTING

1. Measure grout and water in a plastic container, following package instructions.
2. Using a rubber spatula, a craft stick, or your gloved fingers, spread the grout over the design and push the grout into all areas between the tiles.
3. Dampen a sponge, squeezing out excess water. Wipe away any excess grout, being sure there is grout between all the tiles. If you notice a hole, fill with grout, then wipe. Rinse the sponge, squeeze out excess water, and wipe again. Do this over and over until all the tile pieces are visible through the grout. Wipe gently but thoroughly. Allow to dry 15 minutes.
4. Before the grout is completely dry, brush away any "crumbs" of grout with a stiff bristle brush. Let dry completely.
5. When the piece is completely dry, polish off the grout haze by rubbing with a soft cloth.

## FINISHING

1. Sand the edges of the frame with sandpaper to smooth the edges of the grout and to remove any stray grout from the sides of the frame. Wipe away dust.
2. With a small foam brush and acrylic craft paint, paint the edges of the frame; both outside edges and the inside edges where the mirror will reflect the wood.

*Note: You can also choose to paint your project surface before beginning to mosaic. If you do this, you may need to touch up the paint after the mosaic has dried.*

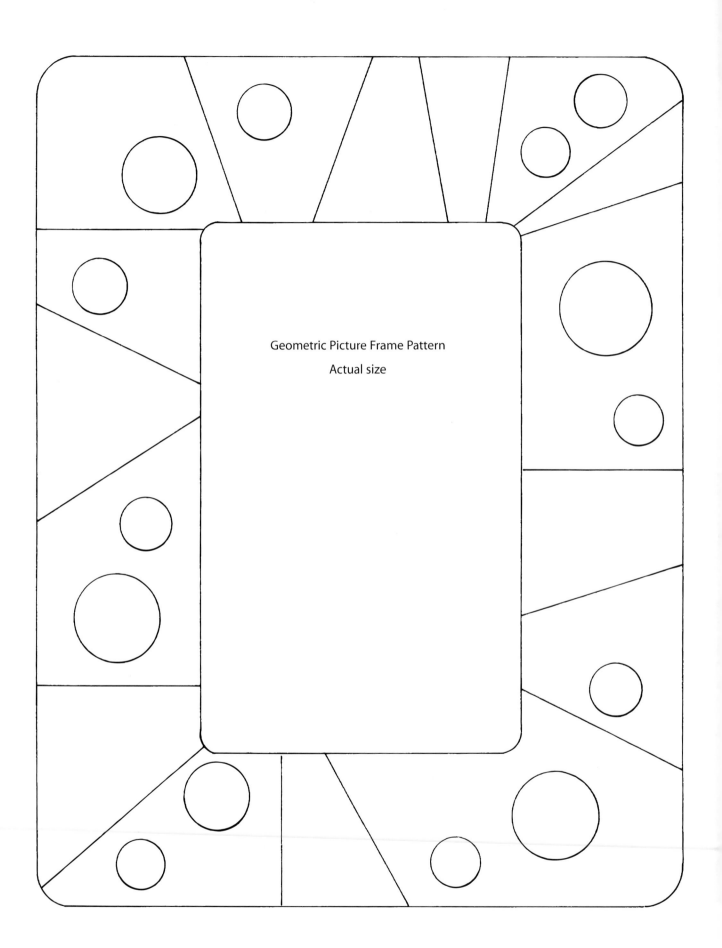

Geometric Picture Frame Pattern

Actual size

# Hearts & Circles Trivets

Mosaic area: 6" x 6"
(36 square inches)

## MATERIALS

### Trivet with Light Background

Black metal trivet frame with
fiberboard insert, 6" x 6"

Tiles, ⅜" square; blues, greens,
white

Leaf tiles with veins; 1 green,
1 white

Assorted shaped tiles; rounds,
ovals, hearts, pebbles
(see Note)

Sanded grout, buttercream

White craft glue

Sandpaper, 220 grit

Tack cloth

Paper & pencil

Transfer paper *(optional)*

### Trivet with Dark Background

Black metal trivet frame with
fiberboard insert, 6" x 6"

Tiles in various shapes/colors:
⅜" squares; hearts, ovals, peb-
bles, rounds

5 flatbacked marbles

Sanded grout, deep blue

White craft glue

Sandpaper, 220 grit

Tack cloth

Transfer paper *(optional)*

*Note: You can use any type of tiles to
make trivets, as long as they are of
the same thickness so the surface will
be fairly even—you want a hot dish
to be able to sit on the trivet securely.*

## Trivet with Light Background

### PREPARATION

1. Remove fiberboard insert from
   frame. Sand smooth. Wipe away
   dust. Trace shape of insert on a
   piece of paper with a pencil.
2. Seal the fiberboard base. Let dry.
3. Arrange the tiles on the paper
   template, making a freeform
   design that pleases you. Use
   photo as a guide. Trace around
   the shapes to make a pattern.
   *Optional:* Transfer to the fiber-
   board base.
4. Glue the fiberboard base into
   the trivet frame. Let dry.

### ATTACHING TESSERAE, GROUTING, AND FINISHING

1. Glue the tiles in place on the
   fiberboard base of the trivet,
   using your template or trans-
   ferred pattern as a guide. Let dry.
2. Mix grout according to package
   instructions. Spread over tiles.
   Wipe away any excess grout,
   being sure to remove all traces
   from trivet frame. Let dry.
3. Wipe away haze and polish with
   a soft cloth.

## Trivet with Dark Background

### PREPARATION

1. Remove fiberboard insert from frame. Sand smooth. Wipe away dust. Trace shape of insert on a piece of paper with a pencil.
2. Seal the fiberboard base. Let dry.
3. Arrange the tiles and flatbacked marbles on paper, using the photo on page 39 as a guide, or placing the marbles to make a design that pleases you. Take care to distribute the marbles evenly so a hot pot or baking dish placed on the trivet will be secure. Trace around the shapes to make a pattern. Transfer your pattern to the fiberboard base *(optional)*.
4. Glue the fiberboard base into the trivet frame. Let dry.

### ATTACHING TESSERAE, GROUTING, AND FINISHING

1. Glue the flatbacked marbles and tiles in place on the fiberboard base of the trivet, using your template or transferred pattern as a guide. Let dry.
2. Mix grout according to package instructions. Spread over tiles and marbles. Wipe away excess, being sure to remove all traces of grout from the trivet frame. Let dry.
3. Wipe away haze and polish with a soft cloth.

Hearts & Circles Trivet Pattern

Enlarge 127%

# Fish Tile

Mosaic area: 8" x 8" (64 square inches)

## MATERIALS

Vitreous glass tiles, ¾"; blue, green, lavender, yellow
Ceramic tiles, 1"; black, white
Stained glass; green, red, white
Lead strip, ½" x 12"
Backerboard, 8" x 8"
White glue (PVA)
Tile adhesive
Dry grout

Tile nippers
Glass cutter *(recommended)*
Safety goggles
Sharp knife
Palette knife or small spatula
Dental probe or tweezers
Transfer paper
Scissors
Needle-nose pliers
Rubber gloves
Grout float
Sponge
Lint-free rags

## PREPARATION

1. Enlarge and copy the pattern on page 000.
2. If your backerboard is plywood, sand any rough edges and seal the entire piece with a mixture of 50% white glue and 50% water. Once the wood is dry, draw or transfer the pattern; then score the surface with a sharp knife. If you are working with a cement backerboard, sketch or transfer the design directly.
3. Using tile nippers and guided by the pattern, cut a quantity of vitreous glass and ceramic tesserae for the fish. You can use tile nippers to cut small pieces of stained glass if you first cut the glass into strips.

*Note: Tile nippers tend to nibble the edges of the glass and make unpredictable cuts, however. For more control, use a glass cutter to shape the pieces for the fins.*

## ATTACHING TESSERAE, GROUTING, AND FINISHING

1. Use a palette knife to apply a thin layer of adhesive to the backerboard and the back of each tessera. Working a small area at a time, build up the fish to Line A. (See pattern, page 42.)

*Note: A pair of tweezers or a dental probe is useful for adjusting the pieces as you work. Be sure to leave grout spaces between the tesserae.*

2. Fold the lead strip in half lengthwise. Squeeze it together with pliers, using care to flatten it uniformly. Position this strip, with the fold uppermost, along Line A, from snout to tail. Remember to leave grout spaces on either side of the lead. Complete the tail and remaining fins.

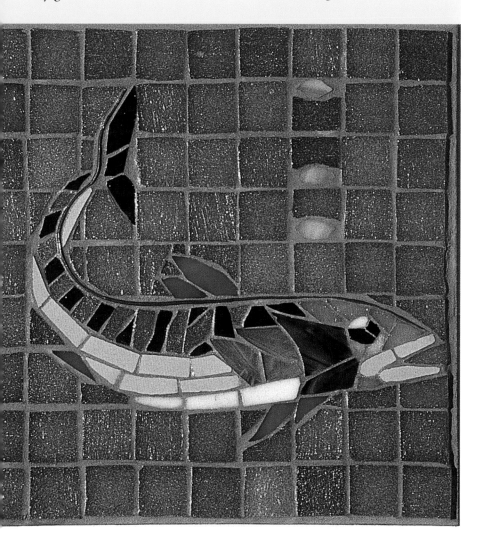

3. The background is done in opus tessellatum (see page 19), using full-size vitreous glass tiles applied in nine rows. For the most effective presentation, make certain that each row is straight and the grout spaces are all fairly uniform. Cut three pieces of stained glass or vitreous glass for the air bubbles and place them as desired. Allow the mosaic to dry for 24 hours.

4. Following the manufacturer's instructions, mix a small amount of grout. Spread the grout over the mosaic, working it into all the crevices with a float or your gloved fingers. Apply an even amount of grout along all four edges of the mosaic to make a beveled edge with the backerboard. Using a slightly damp sponge or lint-free rag, remove the excess grout and any haze on the surface.

Fish Tile Pattern

# Zodiac Bowls

Mosaic area: 8" diameter, each

## MATERIALS

Vitreous glass tiles; beige, black, blue, brown, dark and light green, deep turquoise, yellow

Ceramic tiles; dark blue, red, turquoise

Smalti, a few (for highlights)

Terracotta dishes, 8" diameter

Tile adhesive

Dry grout

Matte or satin polyurethane (optional)

Tile nippers

Safety goggles

Transfer paper

Palette knife or small spatula

Dental probe or tweezers

Rubber gloves

Grout spreader

Sponge

Lint-free rags

Paintbrush (optional)

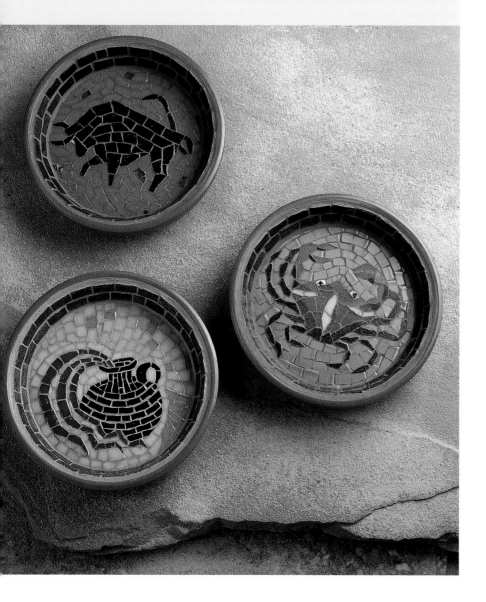

## PREPARATION

1. Cut a circle of carbon paper just large enough to fit the interior base of one of the terracotta dishes. Enlarge one of the figures shown on page 44, or sketch a design and transfer it to the dish.

2. Using tile nippers, cut a quantity of tesserae to fit the desired motif. In the Taurus design, for example, relatively large, chunky pieces give the impression of strength; in the Aquarius dish, the flow of tiles on the pot emphasizes the roundness of the shape; in the Cancer mosaic, the tesserae are deliberately placed randomly to suggest the fragility of the crab.

## ATTACHING TESSERAE AND GROUTING

1. Working in one small area at a time, apply a thin layer of tile adhesive to the dish with a palette knife. Butter the back faces of the tesserae and adjust their positions with a dental probe or similar tool.

2. Once you have completed the central motif, begin filling in the background. In each of these examples, the flow of tesserae in the background complements the shape of the subject and the roundness of the dish.

3. Work the sides of the dish in a contrasting or complementary color, using slightly larger rectangular tesserae. Place the final row of tesserae slightly below the lip of the dish and make sure that the beveled edge of each piece in this row faces upward. Allow to set for at least 24 hours.

4. Mix a small amount of grout as instructed by the manufacturer. Spread the grout over the surface of the mosaic and press it into the crevices. Wipe away any excess grout with a barely damp sponge or clean rag. To ensure that the lip is neat and even, you may need to wait about an hour and apply some additional grout. Remove any remaining haze with a lint-free rag, turning the rag frequently.

## FINISHING

After several days, the entire dish can be brushed with a thin coating of matte or satin polyurethane, if desired. It is a good idea to seal the terracotta, which is quite porous if left untreated.

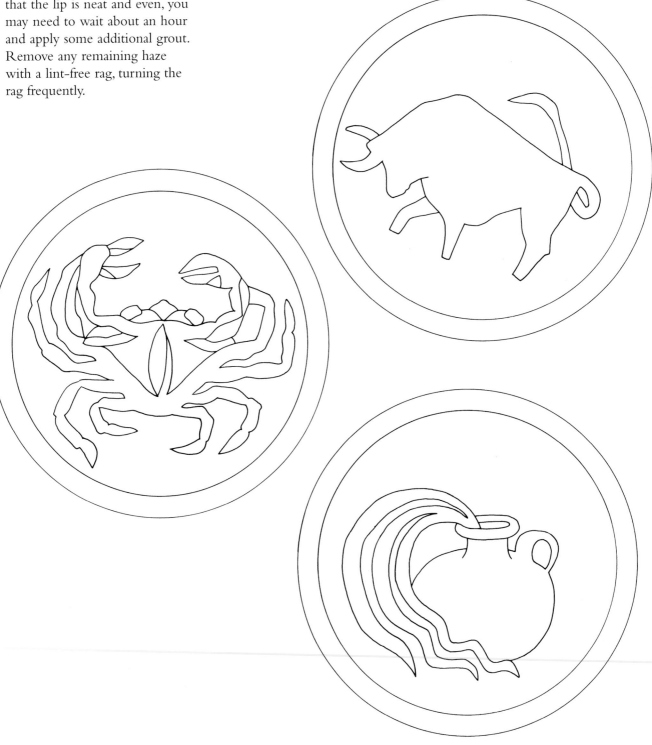

Zodiac Bowl Patterns

# Rooster Art

Mosaic area: 11½" diameter

## MATERIALS

Octagonal wooden plate, 11½"
  diameter
Square tiles, ⅞"; black, green, light
  blue, orange, pink, red, royal
  blue, white, yellow
Flatbacked marbles in
  complementary colors
Mirror, a few broken pieces

Sanded grout, black and white
Acrylic craft paint, red
Acrylic sealer, clear
Transfer paper & stylus
Tracing paper
Pencil
Sandpaper, 220 grit
Permanent marking pen, fine-tip
  black
Cotton swabs
Tile nippers

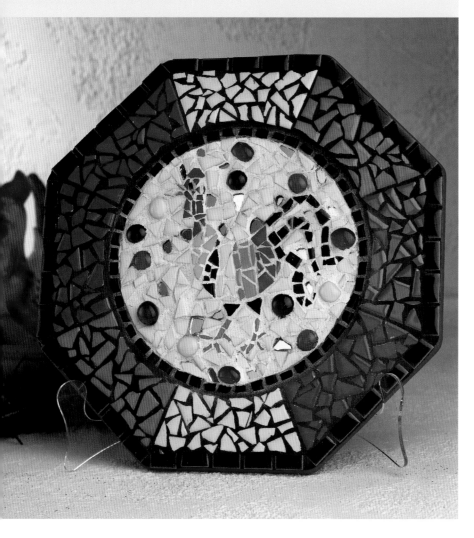

at left as a guide, nip some into
small pieces for the rooster.

## ATTACHING TESSERAE AND GROUTING

1. Glue the tiles for the rooster in
   place first, then glue the smaller
   black tile pieces for the inner
   border.
2. Fill in the area between the
   rooster and the inner border
   with flatbacked marbles, white
   tiles, and mirror pieces. Nip
   pieces to fit as needed.
3. Glue the larger black tile pieces
   around the outer edge to form
   the outer border.
4. Draw guidelines from each cor-
   ner of the octagonal rim to
   divide the rim into eight sec-
   tions. Fill the sections with
   pieces of orange, red, green, and
   yellow tiles, alternating colors as
   shown in photo at left. Let dry.
5. Mix black grout according to
   package instructions (and/or
   refer to pages 30–31). Spread
   black grout over colored tiles
   and black tiles in rim and bor-
   ders, being careful not to get it
   in the center area. Wipe away
   excess. Remove any grout from
   center area with damp cotton
   swabs. Let dry.
6. Mix white grout according to
   package instructions. Spread
   over tiles in round center area.
   Wipe away excess. Thoroughly
   remove any white grout from
   black grout. Let dry.
7. Wipe away haze and polish with
   a soft cloth.

## FINISHING

Paint edges and back of plate with
red paint. Let dry.

## PREPARATION

1. Sand the wooden plate and
   carefully wipe away any dust.
   Seal the surface with clear
   acrylic sealer. Let dry.
2. Copy the pattern on page 46,
   enlarging or reducing it to fit
   the center of your plate.
3. Transfer the rooster design to
   the plate. Go over the pattern
   lines with black permanent

marking pen so you will be able
to see them through the glue
when placing the tiles.
4. Use tile nippers to shape black
   tiles into rectangular pieces in
   two different sizes—smaller ones
   for the inner border and larger
   ones for the outer border. Break
   other colored tiles into irregu-
   larly shaped pieces. Using photo

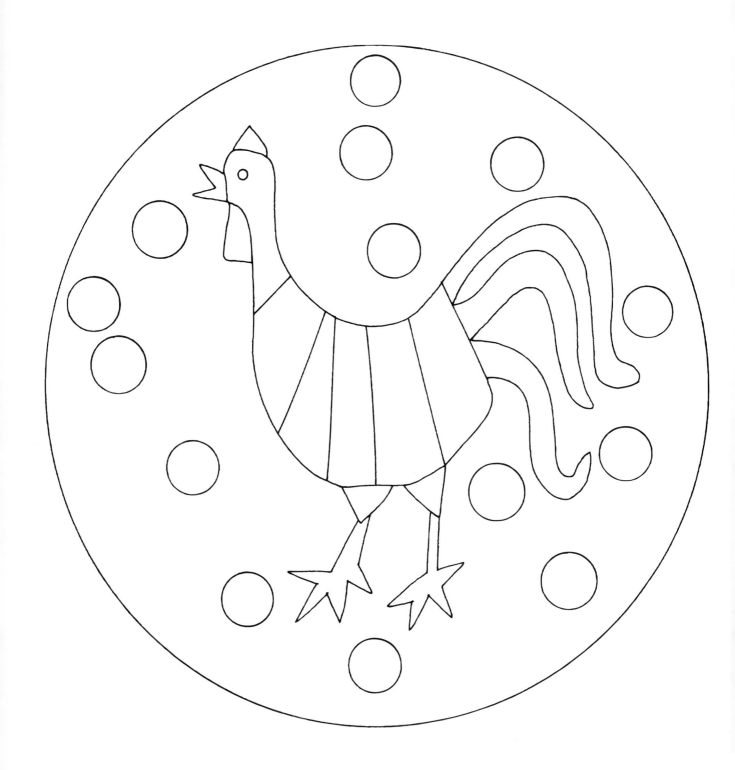

Rooster Art Pattern

# Flamingo

Mosaic area: 26" diameter

## MATERIALS

Vitreous glass tiles; black, blue-greens, blues, bronze, pink, pink vein, various grays, white
Backerboard
White glue (PVA)
Tile adhesive
Dry grout
Tile nippers

Safety goggles
Glue brush
Transfer paper
Sharp knife
Small trowel
Mixing container
Rubber gloves
Grout float
Sponge
Lint-free rags

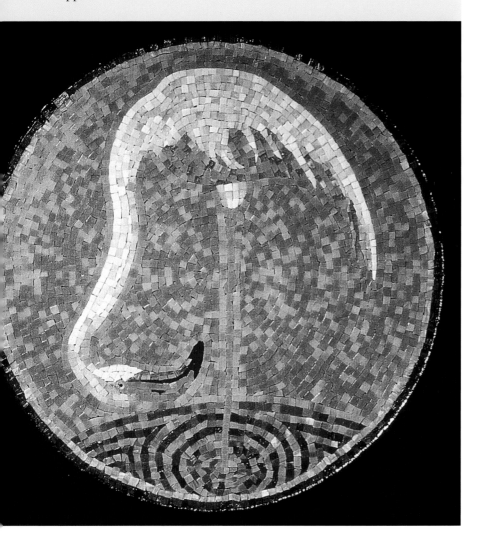

## PREPARATION

1. Cut backerboard into a 26"-diameter circle. If using plywood, carefully sand any rough edges and seal all the surfaces with a mixture of 50% white glue and 50% water. Allow the board to dry completely.
2. Copy and enlarge the pattern on page 48. Transfer the design to the board and score the surface with a sharp knife or hacksaw blade. If using a thin cement backerboard, sketch or trace the design onto it after cutting.
3. Use tile nippers to cut a quantity of ⅜"-square tesserae, sorting the pieces by color.

## ATTACHING TESSERAE, GROUTING, AND FINISHING

1. Create the key line of the flamingo's back and neck in white and gray tones.

*Note: This line will play a major role in the overall design, so it is important to make a clear, strong, flowing line.*

2. Apply a thin layer of adhesive on the backerboard and butter the back of each tessera before placing it. Be sure to leave grout spaces between tesserae.
3. Continue to fill in the flamingo's body, cutting triangular tesserae as needed to emphasize the wing and tail feathers. Use bits of gray as shadowing and include a few pale pink tesserae in the upper body to create greater depth and dimension. When working the facial features, make your cuts as precise as possible and use smaller tesserae for a more realistic effect.

4. Once you've finished the flamingo, place a single line of blue tesserae in a "halo" all around its head, neck, and body, and most of the way down its leg. This is the andamento, opus vermiculatum.(See page 19.)

5. If desired, finish the raw edge of the plaque by placing a line of tesserae around it. Be sure to leave grout spaces between tesserae.

6. To achieve perfect radiating circles for the sky background, begin by placing the outermost border of bronze tesserae.

Position these pieces slightly inward from those just attached to the outer edge so that there's sufficient room for grout in between. Work inward toward the center.

*Note: If you use the more conventional approach of working outward from the subject, you are much more likely to produce noticeably out-of-round circles as you reach the perimeter.*

7. Place the pool of water design at the base of the mosaic, arranging the colors to create the effect of ripples on the surface. When the

mosaic is complete, allow the adhesive to set for at least 24 hours.

8. Mix the powdered grout as directed by the manufacturer, then spread it over the entire surface and edges of the plaque. Using a grout float or your gloved fingers, carefully work the material into all the crevices.

9. Remove any excess grout and haze with a barely damp sponge or lint-free rag.

Flamingo Pattern

# Seaside Treasures

Mosaic area: 26" x 18"

## MATERIALS

Unglazed ceramic tiles, 1"; black,
blue, green, off-white, pale yel-
low, terracotta, white
Backerboard, 26" x 18"
White glue (PVA)
Tile adhesive
Dry grout
Tile nippers

Safety goggles
Glue brush
Transfer paper
Sharp knife
Tweezers
Spatula or small trowel
Mixing container
Rubber gloves
Grout float
Sponge
Lint-free rags

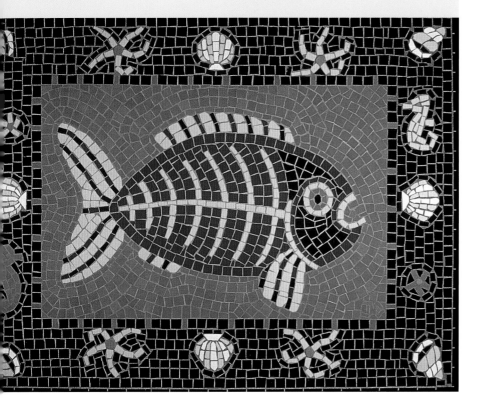

## PREPARATION

1. If using plywood for your
   backerboard, carefully sand any
   rough edges and seal all surfaces
   with a mixture of 50% white
   glue and 50% water. Allow to
   dry completely.
2. Copy and enlarge the pattern on
   page 50, then transfer it onto
   the backerboard.
3. Score the wood surface with a
   sharp knife. If you are using a
   cement backerboard, there is no
   need to score it; simply sketch
   or transfer the design.

4. Precut a number of black tiles
   into ¼" squares for the border.
   Cut batches of several colors
   approximately into eighths for
   the motifs. For the fish, cut a
   quantity of terracotta and yellow
   tiles into quarters, using the
   photo above as a guide.

## ATTACHING TESSERAE, GROUTING, AND FINISHING

1. Apply a thin layer of tile adhe-
   sive to the border area and lay a
   line of black squares around the
   outer edge of the backerboard,
   buttering the back of each
   piece. Allow grout spaces

between tesserae and make sure
to leave a ¹⁄₁₆" to ⅛" gap from
the very edge so that when the
"framing" tesserae are applied to
the edges there will be enough
space for grouting.

2. Using the smaller tesserae, create
   the shells, starfish, and sea horses.
   Surround each motif with a line
   of black pieces.
3. Outline the central fish motif
   with terracotta squares; use pale
   yellow pieces to form the mouth,
   eye, gill, and fish-bone pattern.
   After filling in the main body of
   the fish, begin the background
   sea by placing a "halo" of blue
   around the fish. Complete the
   background in blue with a sprin-
   kling of green for added texture.
4. When the design is complete,
   lay the mosaic face-down on a
   clean surface. This will ensure
   that the top surfaces of the
   framing tesserae will be flush
   with the face of the mosaic.
5. Cut to size a quantity of black
   tesserae and apply the pieces to
   the edges, allowing small gaps
   for the grout. For added
   strength, overlap the corners.
   Allow the mosaic to dry at least
   24 hours.
6. Mix the powdered grout as
   directed by the manufacturer.
   Spread the grout over the entire
   surface of the mosaic, working it
   into the crevices with a float.
   Make sure the edges and corners
   are well grouted before wiping
   off the excess grout.
7. Using a barely damp sponge or
   clean rag, polish the surface to
   remove any haze.

Seaside Treasures Pattern

# Timely Beauty Clock

Mosaic area: 8½" x 8½"

## MATERIALS

Wooden birdhouse clock base,
   6½" x 10¼"
Round clock movement and
   gold-tone bezel, 2¼" diameter
Square tiles, 3/8"; black, green,
   orange, red, royal blue, yellow
2 metallic square tiles, ⅜", gold
Gloss acrylic craft paint, black

Foam brush, 1"
Metallic gold rub-on wax
Non-sanded grout, red
White craft glue
Sandpaper, 220 grit
Tack cloth
Transfer paper
Tracing paper
Pencil
Permanent marking pen, fine-tip
   black

## PREPARATION

1. Set the clock bezel in the clock base and trace around it. (This way, when your mosaic is finished, you'll have left room for it.)
2. Sand the wooden base to prepare for painting. Wipe away dust with a tack cloth.
3. Seal the area where the mosaic will be. Let dry.
4. Trace pattern, enlarging as needed. Transfer to wooden base. Go over the lines with a black marking pen.

## ATTACHING TESSERAE AND GROUTING

1. Spread white glue on design one section at a time and fill in with tiles, nipping and breaking as needed to fit. Use photo at left as a reference for color placement and continue until the design is complete. Don't place tiles inside the line you traced for the bezel. Let dry.
2. Mix grout according to manufacturer's instructions. Spread over mosaic. Wipe away excess, being careful to remove grout from wooden areas to be painted. Let dry.
3. Wipe away haze from tile with a soft cloth.

## FINISHING

1. Paint the wooden roof, sides, base, entrance hole, perch, and around the place where the clock movement will be with black gloss paint. Let dry. Apply a second coat, if needed to achieve complete coverage. Let dry.
2. Rub gold metallic wax along the edges of the roof and base and on the end of the perch.
3. Insert clock bezel and battery.

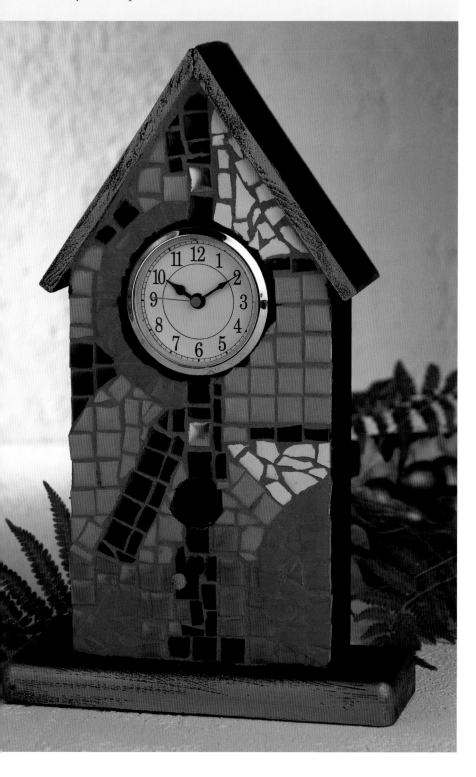

Timely Beauty Clock Pattern

Enlarge 140%

# Jeweled Mirror

Mosaic area: 12" diameter

## MATERIALS

Tesserae
Filigree beads, gold
Filigree buttons, 4 gold
Marbles, white
Stained glass; pink iridescent,
  white iridescent
Acrylic paints: black, white

Clean dry cloth
Cork-backed metal ruler
Glass cutter
Grout, cement-based, sanded,
  black
Mirror, 6" diameter
Picture hanger
Spray sealant, clear gloss
Wheel glass cutter/nipper
Wooden circle, 12" diameter

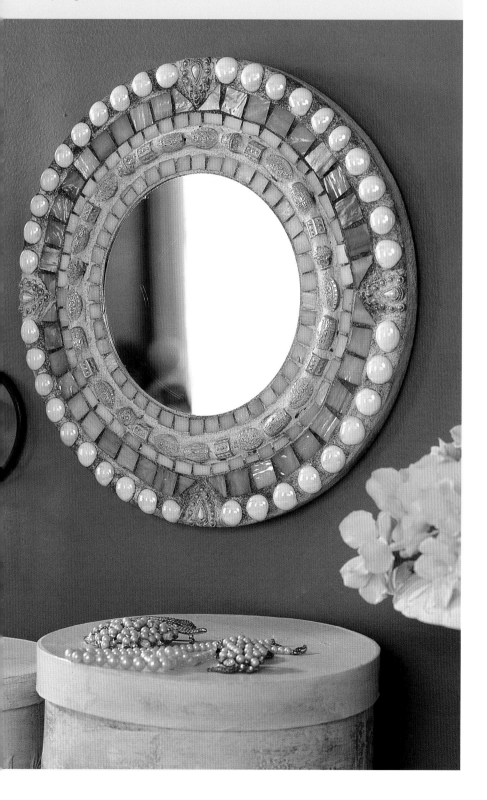

## PREPARATION

1. Establish the center on the
   wood base and mark with an
   "X." Draw a 6" circle in the
   center for mirror placement.
   (See Photo below.)

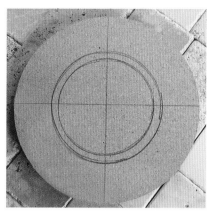

*Note: You can use a slightly larger
mirror to help with the placement of the
first ring of beads.*

2. Key and prep the wood. (See
   page 13.)
3. Attach hanger onto back of
   wooden circle.
4. Cut stained glass. (See pages
   21–24.)
5. Seal filigree beads and buttons
   with spray sealant.

*Note: You can seal the beads and but-
tons before or after you attach them.
Just remember to seal them before you
attach any glass or marbles, as the
sealant will leave a film on the glass
tesserae.*

## ATTACHING TESSERAE AND GROUTING

1. Attach filigree buttons at 3, 6, 9,
   and 12 o'clock points on the
   wooden circle.
2. Working in rings, attach the first
   ring of tesserae around the mirror
   placement, and the second ring
   around the outside edge. Then fill
   in the middle.

*Note: In setting the buttons and beads,
use more adhesive to ensure a strong
attachment and avoid the possibility of
losing any when grouting.*

3. Attach mirror onto center. Allow to set at least 24 hours.

4. Grout; allow to set. (See Grouting with Cement-based Sanded Grout on pages 30–31.)

## FINISHING

1. Mix a 1:1 wash of white paint and water. Brush over entire piece except the mirror. Quickly wipe paint off surface of glass pieces with a clean dry cloth.

2. Paint back of piece black.

*Options:*

- Use a different shape for your mirror such as a square, rectangle, or oval.

- Select tesserae to match the decor of the room in which you will place the mirror.

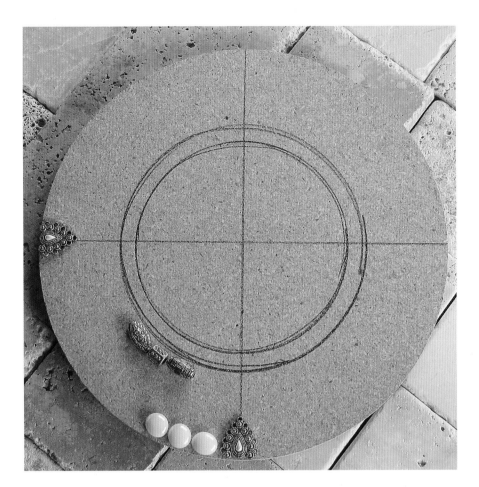

# Sea Treasures Mirror

## MATERIALS

Baltic birch plywood, 16" x 21", ¼" thick

Wooden frame, 11" x 12½", with a 5" x 7" opening

Assorted seashells and beach glass

70 square tiles, ⅞", light blue

30 tiles, various shapes and colors

20 flatbacked marbles, various colors

Broken mirror chips

Silicone adhesive

Wood glue

Sanded grout, tan

Scroll saw with #5 blade

Drill with a drill bit slightly larger than the width of the saw blade

Mirror, 5" x 7"

8 window glazier's points

Picture wire, 24"

2 screw eyes

Tracing paper

Transfer paper & stylus

Sandpaper, 100 and 150 grits

Tack cloth

Gloss acrylic craft paint, deep blue

Flat artist's brush, #12, or ½" foam brush

## PREPARATION

1. Photocopy and enlarge pattern; transfer to plywood.
2. Drill a hole in one corner of the mirror cutout; insert scroll saw blade in the hole and cut out the opening for the mirror.
3. Cut the curved frame edges.
4. Glue the plywood cutout to the front of the wood frame with wood glue. Let dry.
5. Sand the plywood surface with 100, then 150 grit sandpaper. Remove dust with a tack cloth.

## ASSEMBLING AND ATTACHING TESSERAE

1. Nip square tiles in half. Nip some of the halves into quarters.
2. Glue half and quarter tiles around the inside edge of the frame.
3. With photo at left as a guide, glue lines of tiles in place from the center to the outside of the frame and along the outer edges.
4. Glue shells, beach glass, mirror chips, flatbacked marbles, and remaining tile pieces on frame. Use extra glue on larger pieces. Let dry.

## GROUTING

1. Mix grout with water according to manufacturer's instructions. With gloved fingers, spread the grout around the tiles and around and under shells. To get an ocean-washed beach effect, partially bury some shells with grout for a realistic look.
2. Wipe away excess grout with a sponge. Let dry 15 minutes.
3. Brush away excess grout from the nooks and crannies of the shells with a stiff bristle brush or toothbrush. Let grout dry completely.
4. Using a soft cloth, wipe the surface to remove any haze.

## FINISHING

1. Paint all edges of frame with deep blue paint. Let dry.
2. Insert mirror in frame and attach with glazier's points.

Sea Treasures Mirror Pattern

1 square = 1″

# Aquarium Backsplash

Mosaic area: 15½" x 15½"
(240 square inches)

## MATERIALS

Rot-resistant plywood rectangle, ½"-thick (cut to fit the space behind your sink, this one is 20" x 12")

Square tiles, ⅞" and ⅜"; black, blue, green, orange, red, yellow

Square tiles, ⅜", 70 white (for top border, plus additional for the design)

Tiles in assorted colors and shapes; novelty, oval, round, triangular

Transfer paper & stylus

Tracing paper

Brown kraft paper

White craft glue

Non-sanded grout, blue

Permanent ceramic paint; black, white

Acrylic craft paint, blue

Sandpaper, medium grit

Sponge brush, ½"

Round artist's paintbrush

Clear acrylic sealer

## PREPARATION

1. Trace the outline of the plywood rectangle on a piece of brown kraft paper. Sketch the placement of the fish shapes inside the outline, incorporating the fish patterns and tile shapes. Use the photo at left as a guide.

2. With a pencil, draw an irregular shape along the top edge around the shapes of the fish. Cut out the shape with a scroll saw. Sand edges smooth.

3. Seal plywood surface with clear acrylic sealer. Let dry.

4. Transfer your design to the plywood rectangle. Go over the lines with a black marker. Study the photo to note the various shapes—some of them whole tiles—that have been used to create the bodies of the fish.

5. Paint eyes on round tiles that will be the eyes of the larger fish and on some of the elongated oval and odd-shaped tiles that will be the bodies of the smaller fish with permanent ceramic paints. Bake tiles in oven to set paint according to package instructions.

6. Break some of the square tiles into pieces of various shapes.

## ATTACHING TESSERAE AND GROUTING

1. Glue a row of ⅜" white tiles across top edge.

2. Fill in fish shapes with tiles of different colors and shapes, using photo at left as a guide.

3. Fill in areas around fish with blue tiles.

4. Mix grout according to manufacturer's instructions and apply. Wipe away excess. Let dry.

5. Wipe the haze away and polish with a soft cloth.

## FINISHING

Paint edges of backsplash with blue acrylic paint.

# Spirited Tabletop

## MATERIALS

Rot-resistant wood, 1"-thick,
   11" x 20"
Side-table base
Mirrors: 6" x 6", rose; 6" x 8",
   purple; 12" x 12", rust
Stained glass: 2" x 2", rust, yellow;
   4" x 4", bright pink with
   white mix, medium pink with
   white mix, teal blue

6" x 6", blue with white mix,
   light blue, mottled green,
   purple
Silicone glue
Sanded grout, white, 1½ lbs.
Liquid pure pigment, purple,
   1 oz.
Acrylic grout fortifier
Sandpaper, medium grit
Wood sealer
Wheel glass cutters
Lazy Susan (optional)

## PREPARATION

1. Photocopy, enlarge, and transfer
   the pattern on page 62 onto the
   wood. (See page 20–21.) Be sure
   to go over the graphite lines
   with permanent marking pen.

*Note: The design can easily be adapted
to accommodate a small, round, cafe-
style tabletop.*

2. Using a scroll saw, carefully cut
   out the tabletop. Sand any rough
   edges smooth.
3. Apply two coats of outdoor
   wood sealer to the tabletop,
   including the edges, allowing
   drying time between coats. (You
   may have to do just one side
   and the edges first, then the
   other side.) Let the tabletop dry
   completely overnight.

## ASSEMBLING AND ATTACHING TESSERAE

1. Start with the three large spirals.
   Cut several rows of purple mir-
   ror, roughly ⅜"-wide. Use wheel
   glass cutters to snip rows into
   squares as you work, gluing the
   squares in place onto the spirals.
2. Fill in squiggles between the
   spirals. Cut several ¼"-wide rows
   of rose mirror, snip into squares,
   and glue them in position as
   shown in the pattern on page 62.
3. With the design elements com-
   pleted, follow the color chart and
   fill in the circles and spaces by
   nipping and gluing irregular
   shapes of stained glass.
4. Notice that on each of the three
   sides, at least one of the polka-dot
   circles spills over the side onto
   the edge. Fill these edge sections
   as you go, placing the pieces in a
   double row. A lazy Susan can be
   especially helpful now because it
   allows you to turn the object
   without touching (and possibly
   knocking off) freshly glued edge
   pieces.

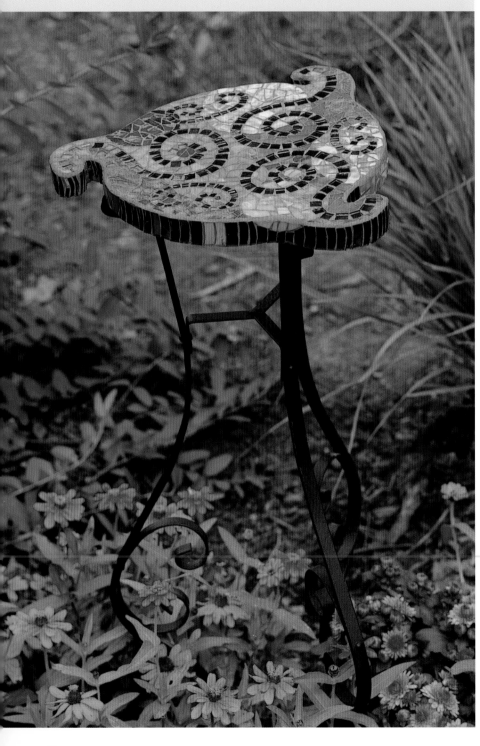

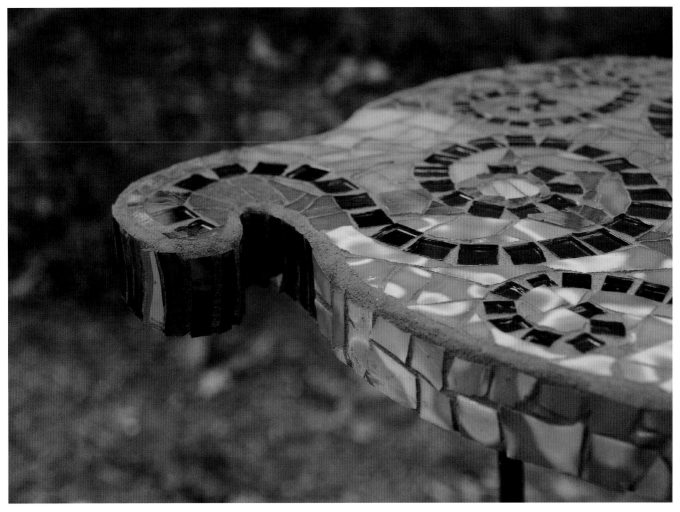

Photo 1

4. Finish the edges with rust mirror. Cut several 1"-wide strips of mirror using a glass cutter and running pliers. Then snip the strips into slender rectangles with wheel glass cutters and glue the pieces in place. Cut the rectangles especially slim at points where the edge curves sharply inward. (See Photo 1.)

5. Let glued tabletop dry overnight.

## GROUTING AND FINISHING

1. Before grouting, put the tabletop on something that raises it slightly off the work surface; an old book, a few bricks, anything that will allow you to get your fingers up under the wood to grout the bottom edge will do.

2. Mix the grout, pigment, and fortifier. Smooth the grout on carefully, filling all the spaces. Take special care not to cut yourself on the glass, and exercise particular caution on this piece when pushing the grout into hard-to-reach areas of the curving edge. Stronger gloves than latex are better at this point.

3. Be sure to press the grout firmly into both the top and bottom edge lines, filling the bottom edge from underneath. Smooth the edge lines with a well-protected finger.

4. Wipe the grouted surface with a damp sponge. Allow the glass to dry a few minutes and haze over; then polish with a soft cloth. Clean away any remaining dried grout residue. Wrap the tabletop in plastic or kraft paper and cure for three days.

# Spirited Tabletop Pattern

## Enlarge 160%

Purple mirror

Rose mirror

Rust mirror

Light blue

Blue with white mix

Teal blue

Mottled green

Rust

Purple

Bright pink with white mix

medium pink with white mix

Yellow

Dotted lines indicate edge; circle shapes and colors extend over side onto adjacent edge.

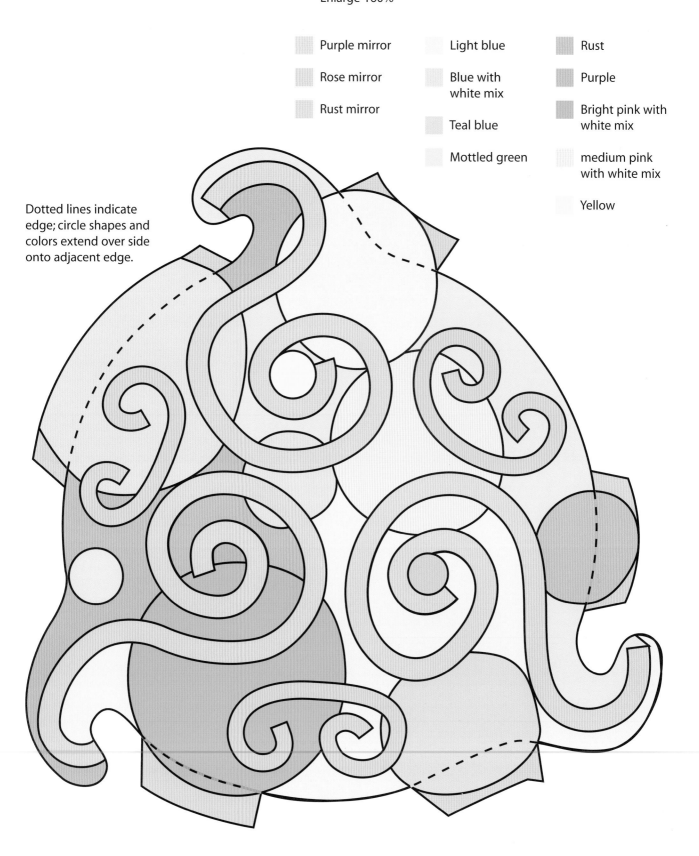

# Deco Dream Table

Mosaic area: 24½" x 13½"
(330 square inches)

## MATERIALS

Wooden rectangular coffee table,
24½"" x 13½"
Square tiles, ¾"; black, blue gray,
purple, white
Square tiles, ⅜", 25 each of blue,
teal

10 round tiles, 1", in coordinating
colors
Non-sanded grout, purple
Gloss acrylic craft paint, black
Mosaic sealer
Sandpaper, 220 grit
Tack cloth
Black permanent marker

## PREPARATION

1. Sand the top of the table and
prepare the rest of the table for
painting. Wipe away dust with a
tack cloth.
2. Trace pattern, adapting design as
needed to fit your table. Transfer
design to table top. Go over
lines with a black marker.

## ATTACHING AND GROUTING TESSERAE

1. Glue black and purple square
tiles along long sides of table to
make a border.
2. Nip black tiles in half to make
rectangles and glue on both
short sides to make a border.
3. Glue tiles to create chevron
designs at centers of four sides
and at corners. Nip tiles to fit as
needed.
4. Glue round tiles in place.
5. Break or nip white, black, teal,
and purple tiles. Glue to create
remaining design motifs.
6. Fill in background with blue
gray tiles, breaking or nipping as
needed to fit. Glue in place.
Let dry.
7. Mix grout with water according
to package instructions. Spread
over tiles. Wipe away excess.
Let dry.
8. Wipe away haze with a soft
cloth.

## FINISHING

1. Clean away grout from wooden
areas to be painted.
2. Paint legs of table and rim of
table top with black paint.
Let dry.
3. Apply sealer to mosaic area.
Let dry.

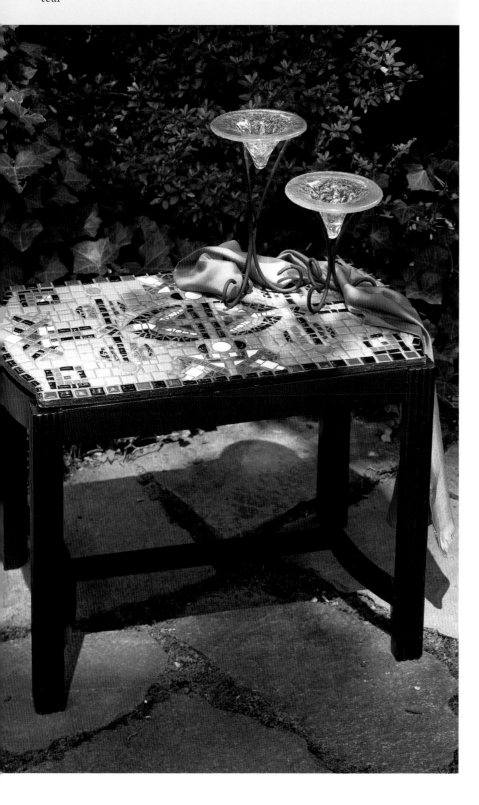

Deco Dream Table Pattern

1 square = 1"

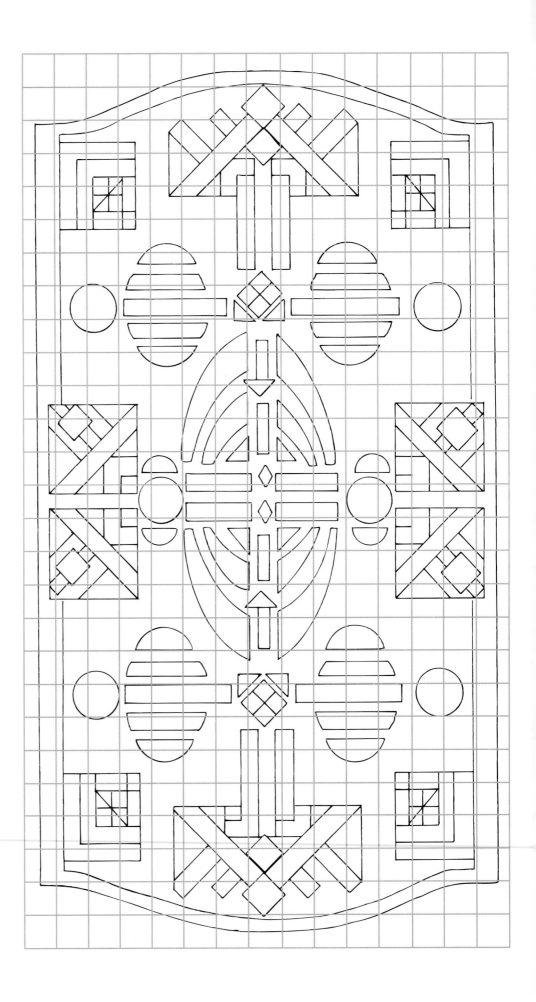

# Daisies Tile Picture

Mosaic area: 18" x 25"

## MATERIALS

Tumbled travertine square tiles,
   3"; forest green, light purple,
   seafoam green, speckled brown
   (2 shades), white, yellow
Cement-based, sanded grout,
   pewter

Permanent marking pen
Mastic, thin-set, exterior grade
Metal frame
Screwdriver
Tile nippers
Wood screws
Wooden panel

## PREPARATION

1. Cut the wood to size and attach
   the panel to the metal frame,
   screwing it onto the frame
   through the back.
2. Key and prep the wood. (See
   page 13.)
3. Photocopy and enlarge to the
   desired size the Daisies Tile
   Picture Pattern on page 66. Use
   photocopy as a pattern to center
   and transfer the design to the
   wood. Go over the marks with a
   permanent marking pen.
4. Cut and shape tiles. (See page
   25.)

## ATTACHING TESSERAE AND GROUTING

1. According to the design, attach
   tiles onto the wooden panel,
   pressing firmly to ensure a good
   grip. Adhere the central motif
   and border first, then fill in the
   background, using random rec-
   tangles and squares.

*Note: Use a graduating color effect from
the bottom right-hand corner to the top
left-hand corner to create a casual look
with a random feel.*

2. Allow to set at least 24 hours.
3. Mix grout according to manu-
   facturer's instructions. Apply
   grout. (See Grouting with
   Cement-based Sanded Grout on
   pages 30-31.) Allow to set.

*Options:*

- Use the design of your choice in
  the same metal frame.

- Change the look of the mosaic by
  choosing a different frame.

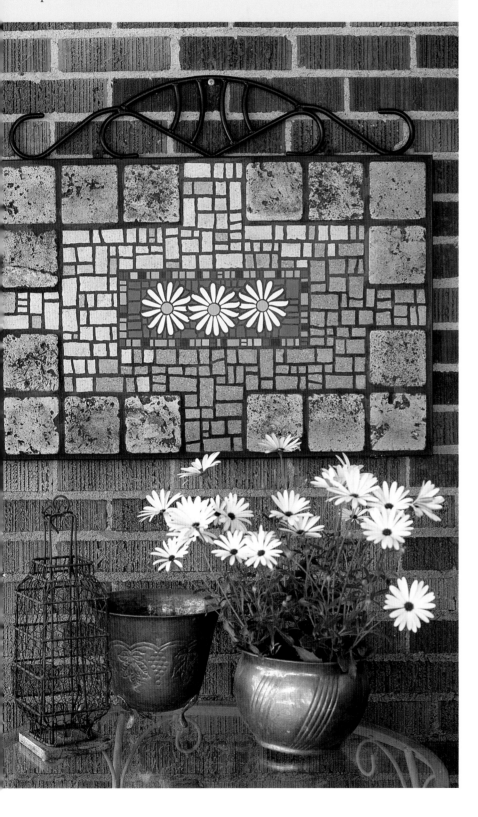

Daisies Tile Picture Pattern

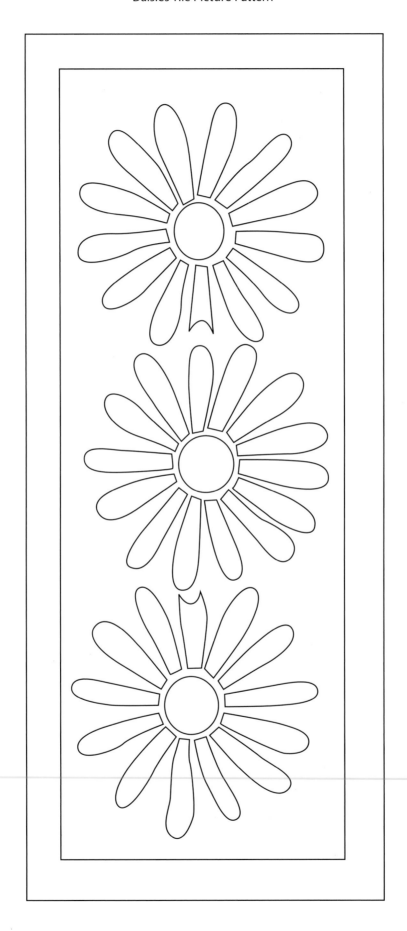

# Pictures-Under-Glass Mosaic

## MATERIALS

Beveled glass, 16" square, clear
Drawing or print, 9" x 13"
¼" plywood, 9½" x 13½"
Trim molding, 4'
Miter saw
Tape measure or ruler
Spray adhesive
Silicone adhesive
Wheel glass cutter
Wood glue

Cement-based, sanded grout, white
Sponge
Soft cloth
Masking tape
Acrylic paints: dark green, light green, off-white
Acrylic crackle texture medium
Spray sealant
Paintbrushes
Picture hanger

1. Spray adhesive on back of print, covering the entire surface. Center and adhere the print on the plywood. (See Photo 1.)

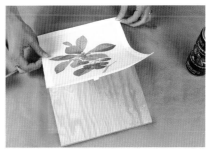

Photo 1

2. Carefully eliminate all lumps or air bubbles. If necessary, use a ruler or the back of a spoon to smooth out the print.
3. Refer to Cutting Glass on pages 21–24. Cut the beveled glass into approximately 1"-square tesserae. (See Photo 2.)

Photo 2

## ATTACHING TESSERAE AND GROUTING

1. Apply a bead of silicone adhesive across the top of the print. Press the glass squares into the adhesive. Working in rows, continue attaching the glass from the top to the bottom. Allow to set at least 24 hours. (See Photo 3.)

*Note: If your picture has features, such as eyes on a face, maneuver the glass tesserae to place each feature in the center of a square. If you do not, you could lose the features in the grout lines.*

**67**

Photo 3

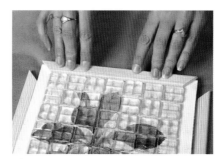

Photo 4

Photo 5

2. Measure trim molding to fit around the mosaic. Cut molding to the measurements with a miter saw.

3. Apply a bead of wood glue along the outside edge of the mosaic. Press frame molding into glue to create a picture frame. Allow to set 24 hours. (See Photo 4.)

4. Prepare grout according to directions or see Cement-based Sanded Grout on pages 30–31. Grout the pictures, sponge off any excess grout and allow to haze. Polish with a soft cloth.

## FINISHING

1. Cover mosaic with masking tape to avoid getting paint on the glass or the grout.

2. Paint wood molding with off-white acrylic paint. Allow to dry.

3. Paint frame with crackle texture medium. Allow to dry until tacky.

4. Mix dark green and light green paint to make an olive green color. Paint trim with olive green. The paint will begin to crackle so the off-white color shows through. Allow to dry.

*Note: Only brush paint over an area once to avoid mixing it with the crackle texture medium.*

5. Spray sealant over molding. Allow to dry and remove masking tape.

6. Attach a picture hanger onto the wood backing.

*Options:*

• Use different prints.

• Use different paint colors or wood finish for trim.

# Stained Glass Lampshade

## MATERIALS

Clear glass lampshade
Transparent millefiori, ⅜" pieces
(enough to encircle lower edge
of shade)
Transparent stained glass; dark
blue, lavender, light blue, light
green, teal

Cork-backed metal ruler
Glass cutter
Denatured alcohol
Cement-based, sanded grout, gray
Grout sealer
Multipurpose adhesive
Wheel glass cutter

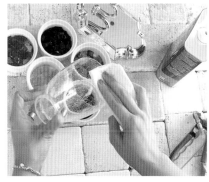

Photo 1

Photo 2

## PREPARATION

1. Refer to Cutting Glass on
   pages 21–24. Cut stained glass
   into approximately ⅝"-square
   tesserae. Keep colors in separate
   small containers for convenience.

2. Prep the glass surface of the
   lampshade by going over it once
   with denatured alcohol. (See
   Photo 1.)

## ATTACHING TESSERAE AND GROUTING

1. Attach the millefiori around the
   bottom edge of the cover with
   the multipurpose adhesive. (See
   Photo 2.)
2. Attach each color, one row at a
   time, using the following pattern
   from the millefiori row up to
   the top of the light cover: one
   row of lavender, one row of

light blue, one row of light
green, one row of all colors
alternating, one row of teal;
again, one row of lavender, one
row of light blue, and one row
of light green, nd so on.

*Note: Remember to leave the top edge
uncovered so it will fit into the light
fixture.*

3. Allow adhesive to set for at least
   24 hours.
4. Refer to Grouting with
   Cement-based Sanded Grout on
   pages 30–31. Grout lamp shade.
   Gently wipe away excess grout
   with a damp sponge. Allow the
   grout to haze over, then polish
   with a soft cloth, being careful
   not to abrade the glass.
5. Seal the grout.

*Option:*

• Use different colors and patterns
  of glass.

# Cake Stand

## MATERIALS

Stained glass, amber transparent,
amethyst transparent, clear
textured iridescent
Acrylic paint, purple
Clear glass cake stand with cover
Denatured alcohol

Cement-based, sanded grout,
white
Grout additive
Non-permanent marking pen
Multipurpose adhesive
Wheel glass cutter

## PREPARATION

1. Refer to Cutting Glass on pages
   21–24. Cut stained glass into
   approximately 1"- and ½"-
   square tesserae. Keep the colors
   separated in small containers for
   ease in working.

2. Prep surfaces of the cake stand
   and cover by going over them
   once with denatured alcohol.

Photo 1

3. If you need the guidance, draw
   the design on the underside of
   the glass, using the marking pen.
   (See Photo 1.)

## ATTACHING TESSERAE

1. Apply a bead of adhesive all
   around, approximately ½" from
   the bottom edge of the cover.
   (See Photo 2.)
2. Rotate large amethyst pieces so
   they look like diamonds and
   press them into the adhesive.
   (See Photo 3.)
3. Cut large amber pieces into tri-
   angles and attach them in the
   upper and lower spaces between
   the amethyst diamonds.
4. Attach approximately four rows
   of large clear pieces, one row at
   a time, from the upper amber
   triangle row to the top of the
   side edge. (See Photo 4.)

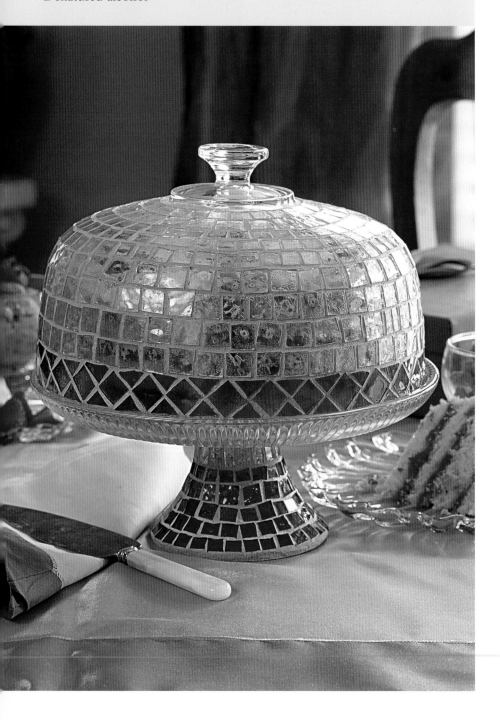

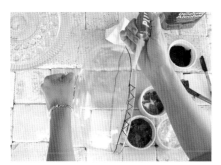

Photo 2

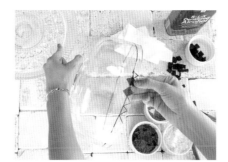

Photo 3

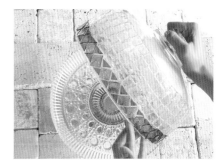

Photo 4

*Note: The process of starting from the bottom and proceeding up helps to keep the design even. Also, it ensures that the higher tesserae do not slide down.*

5. Attach approximately five rows of small clear pieces, one row at a time, from the top of the side edge to the handle on the cake stand cover.

6. Apply a bead of adhesive along the bottom edge of the stand's base. Press one row of small amber pieces into the adhesive.

7. Attach remaining small pieces, one row at a time, from the bottom row to the top of the stand's base. Use the following pattern from the bottom up: three more rows of amber, one row of amethyst, one row of clear, and one row of amethyst.

8. Allow to set at least 24 hours.

## GROUTING

1. Mix a very small amount of paint with white grout to tint the grout a light shade of lavender.

2. Refer to Grouting with Cement-based Sanded Grout on pages 30–31. Grout with additive and allow to set.

*Option:*

• If you want a little more working time, you can use silicone adhesive instead of multipurpose; it is just as good but does not dry as quickly. It will not cause sliding; just make certain to get a strong attachment.

# Clear Delight Bottles & Mirror

## MATERIALS

*For Ungrouted Glass Bottles:*
Glass vase, clear or tinted
Glass bottles, clear or tinted with
    stoppers or corks
Polished glass pieces
Small glass beads or pearls,
    in coordinating colors
Silicone adhesive
Acrylic craft paint, metallic gold
    (for painting corks)
Organza ribbons, , ½ yd. each of
    various colors

*For the Mirror Tray:*
Mirror, 16" x 9"-rectangle
Stained glass fragments; blue,
    gold, green, purple
Textured glass fragments, clear
Flatbacked marbles: clear and
    opalescent, coordinating colors
White craft glue
Acrylic craft paint, gold
Artist's paintbrush, small
Sanded grout, cream
Rubber gloves
Felt
Scissors
Silicone adhesive
Fabric with tiny floral motifs,
    scrap *(optional)*
Fabric stiffener *(optional)*

Buy a mirror tray or have a glass
shop cut a piece of ¼"-thick mirror
glass to size and polish the edges.
Use felt protectors on the bottom.

### BOTTLES

1. Clean and dry the glass bottles.
2. Glue glass fragments on sides
   and around tops of bottles and
   vase with silicone adhesive.
   Let dry.

*Options:*

• Paint corks with gold paint.

• Glue two marbles halves
  together to make a bottle stop-
  per for a
  bottle with a narrow opening.

• Glue marbles to corks and
  stoppers.

• Tie bows with ribbon around
  necks of bottles.

### MIRROR TRAY

1. Clean mirror. Let dry.
2. Glue stained glass fragments at
   the corners of mirror in a design
   of your choice, or use photo at
   left as a guide for placement.
   Intersperse the flatbacked
   marbles with the glass pieces.
   Let dry.
3. Mix grout according to manu-
   facturer's instructions or see
   pages 30–31.
4. With gloved fingers, spread the
   grout over the mosaic areas,
   creating smooth, curved edges
   along the tray side of the mosaics.
   Wipe away any excess grout.
   Let dry.
5. Wipe haze from glass pieces and
   polish with a soft cloth.
6. Paint the curved edges of grout
   gold. Let dry.

*Option:*

• Stiffen fabric scrap with fabric
  stiffener. Let dry. Cut tiny floral
  motifs from the fabric. Attach the
  motifs here and there to the
  mosaic with silicone adhesive.

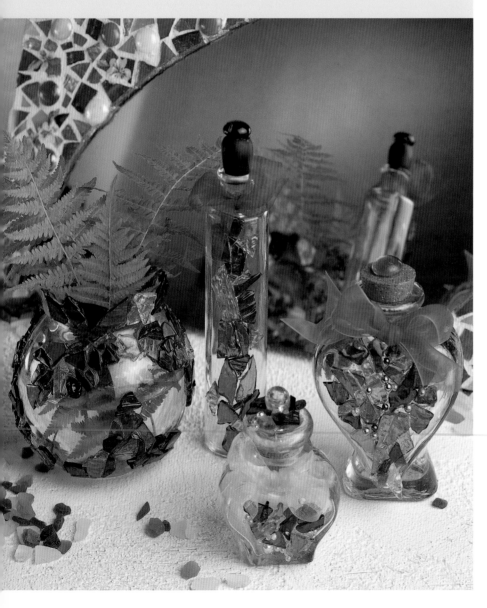

# SECTION II

# Indirect Method

# Wall Clock

Mosaic area: 8" x 8"
   (64 square inches)

## MATERIALS

Vitreous tiles; shades of blue,
   shades of green, white, yellow
Acrylic paints; royal blue, silver
Tracing and transfer papers
Brown kraft paper
Clockwork
Cement-based, sanded grout,
   bone

Mallet
Miniature metal fork and spoon
Notched spreader
Picture hanger
Power drill
PVA adhesive, diluted 1:1 with
   water
Silicone adhesive
Sponge
Wheel glass cutter/nipper
Small wooden board,
Wooden panel, 8"-square

Photo 1

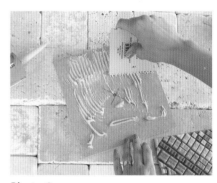

Photo 2

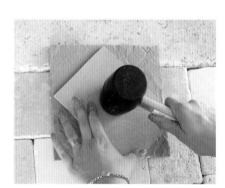

Photo 3

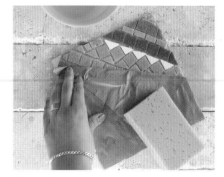

Photo 4

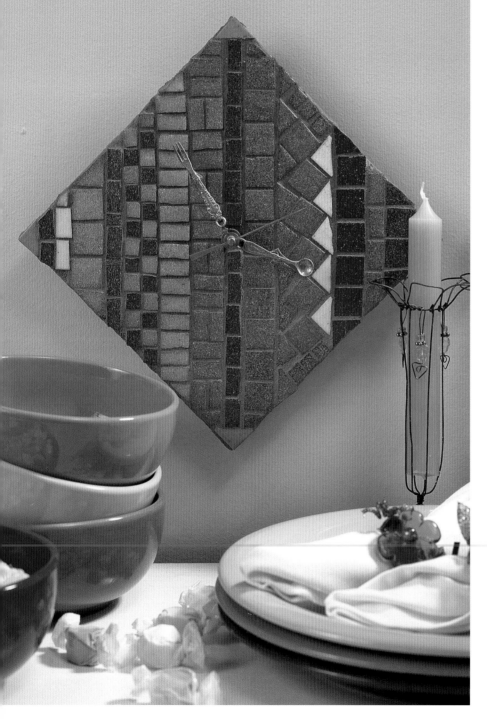

## PREPARATION

1. Center and drill a hole in the wooden panel. Attach a picture hanger onto back of wooden panel. Key and prep the wood. (See page 13.)
2. Photocopy and enlarge the pattern on page 76. Trace the photocopy then reverse and transfer the design onto kraft paper.
3. See Making Tiles from Glass and Mirror on pages 21–22 and cut tesserae from tiles.

## ATTACHING TESSERAE AND GROUTING

1. According to the design, attach tesserae, face-side down, onto brown paper with the diluted PVA. Allow to set 2–3 hours. (See Photo 1.)
2. Using a notched spreader, apply adhesive evenly onto the base. (See Photo 2.)

3. Place the mosaic, with paper-side up, on the base. Place the wooden board over the mosaic and tap it with the mallet to make the piece even. (See Photo 3.)
4. Allow piece to set for at least 24 hours.
5. Wet and wring out a sponge, then dampen the paper. Gently peel the paper off; if it does not come off easily, dampen it a bit more. Carefully wipe the glue residue from the mosaic. (See Photo 4.)

*Note: Do not soak the paper. You are only trying to break down the adhesive's grip.*

6. Mix blue paint with bone grout to desired color. Apply grout. (See Grouting with Cement-based Sanded Grout on pages 30–31.) Allow to set for 24 hours.

## FINISHING

1. Clear any grout out of the central hole. Run a little clear adhesive over the grout around the center hole to keep small particles from getting into the clock's works.
2. Attach the clockwork.
3. Paint the clock hands silver; glue on the miniature fork and spoon.
4. Paint the back of the piece blue.

*Options:*

• Use a multipurpose adhesive.

• Use the Direct method for this project.

# Two Doves

Mosaic area: 22" x 10"

## MATERIALS

Unglazed ceramic tiles, 1"; gray, light and medium blue, terra-cotta, white
Glass tiles, gold-backed
Temporary backing board, slightly larger than mosaic
Brown kraft paper
Gummed paper tape
Transfer paper
Wallpaper paste
White glue (PVA)
Dry cement mortar with polymer additive
Dry grout, gray
Tile nippers
Safety goggles
Tweezers
Glue brush
Rubber gloves
Small trowel
Notched trowel
Small block of wood
Mixing containers
Grout float
Sponge
Lint-free rags

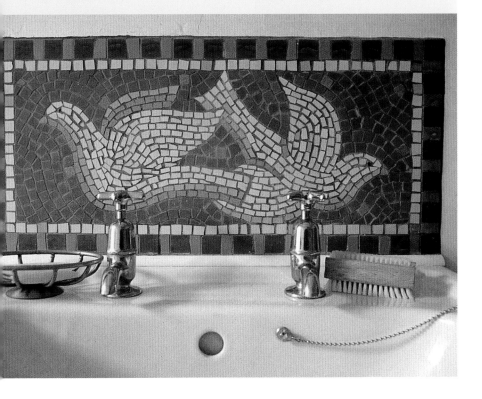

The form of two doves caught in midflight is emphasized by the andamento, or flow of the tesserae, both in the subject and the background of this project. To create a permanent backsplash, assemble the mosaic using the Indirect method, then mount it directly on the wall without a backing board. This approach will minimize the thickness of the piece and make a more elegant installation.

## PREPARATION

1. Cut the kraft paper into a 30" x 16" rectangle and soak it in water. Stretch the wet paper onto the backing board, securing it with gummed paper tape. When the paper is dry, transfer the design using carbon paper and a dull pencil.

*Note: Since the finished mosaic will be a mirror image of the working drawing on the kraft paper, you may want to reverse the design before transferring it.*

2. Use nippers to cut some of the white and gray tiles into eighths, making some pieces rectangular, some square, and some triangular for the doves' feathers. Use the photo at left as a guide.
3. Cut some white and gray tiles into ¼" squares for the inner border and cut a good amount of medium and light blue tiles into quarters for the background. The outer border will consist of full-size terracotta tiles alternating with light blue tiles cut in half.

## ASSEMBLING TESSERAE

1. Mix a small amount of wallpaper paste and begin the mosaic with the outer border, making certain the tesserae are square and evenly spaced. Follow with the inner border, placing a gold square (gold-side down) in each corner.
2. Complete the doves, using white tesserae for the main portions and gray for shadows. The flow of tesserae should reflect the natural pattern of feathers on a live bird. Use tiny fragments of gold for the eyes, placing them with tweezers.
3. Work the background, starting with a row of blue in opus vermiculatum (see page 19) around the doves. Continue the undulating flow outward to meet the border, carefully completing one row before starting another.
4. After the paste has dried, cut the mosaic off the board. On the back of the paper, draw a swirl of random lines. Cut the mosaic in half using a crooked cutting line; the random linear pattern on the paper will help you match the two halves when mounting your mosaic on the wall.

## ATTACHING TESSERAE AND GROUTING

1. Prepare your site and materials for installation by scoring the wall to create a rough surface; mix a batch of polymer-

enhanced cement mortar as instructed by the manufacturer; and preparing a watery solution of white glue.

2. Size the wall with the watery glue. Spread the mortar onto the wall, making even passes with a notched trowel to ensure a consistent depth.

3. Using a small trowel, butter the back of one half of the mosaic with mortar and position it on the wall. Repeat with the second section, making sure the two halves are well matched and have a thin grouting space between. Tamp the sections in place with a wooden block and wipe any excess cement from the edges.

4. Allow the cement to set for several hours until it becomes firm, then soak the kraft paper with hot water until it peels off easily. For best results, remove the paper from the top down.

5. Mix the grout with water as recommended by the manufacturer. (See also pages 30–31.) Apply mixed, slaked grout to the mosaic, using a float to press the grout into all the joints.

6. Remove the excess grout and any remaining haze with a barely damp sponge or lint-free rags.

*Option:*

• For a less permanent treatment, mount the tesserae on backerboard using the Direct method.

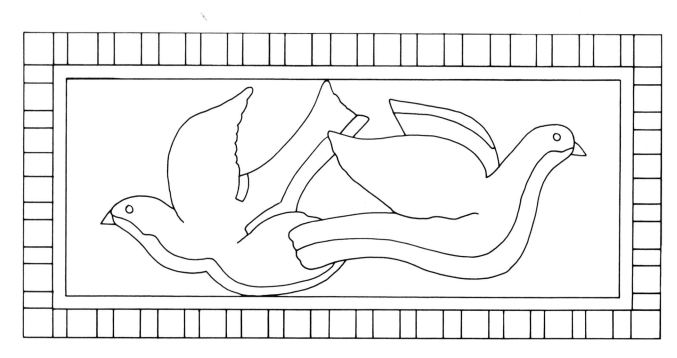

Two Doves Pattern

# Fire Salamander

Mosaic area: 18" x 18"
(324 square inches)

## MATERIALS

Marble tiles; white, yellow
Granite tiles, black
Temporary backing board, slightly
   larger than mosaic
Brown kraft paper
Gummed paper tape
Transfer paper
Wallpaper paste
Wood framing to fit mosaic,
   ¾" x 1½"
Petroleum jelly
Mineral spirits
White glue (PVA)

Sand
Cement
Galvanized wire mesh cut
   to fit mosaic
Dry grout, dark gray
Tile nippers
Safety goggles
Glue brush
Tweezers
Screwdriver and wood screws
Rubber gloves
Trowel
Mixing containers
Toothbrush
Grout float
Sponge
Lint-free rags

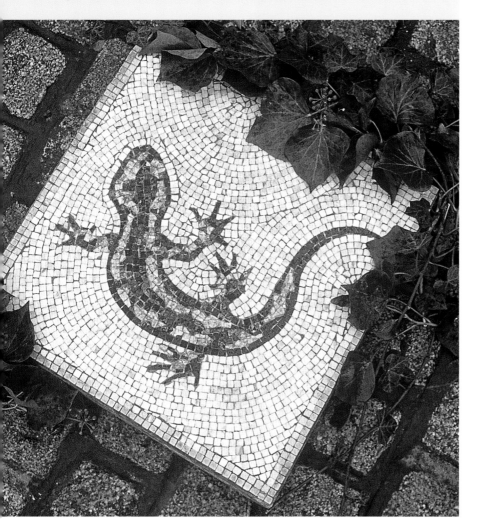

## PREPARATION

1. Cut a piece of kraft paper slightly larger than the mosaic, moisten it, and stretch it onto the backing board, holding the paper in place with strips of gummed paper tape.
2. Enlarge the salamander design to the desired size and transfer it onto the kraft paper using transfer paper and a dull pencil.

*Note: Since the finished mosaic will be a mirror image of the working drawing, you may wish to reverse the design before transferring it.*

3. Using tile nippers, cut a quantity of granite and marble tesserae into cubes about ⁵⁄₁₆" on each side. When you have enough material accumulated, mix a small batch of wallpaper paste.

## ASSEMBLING TESSERAE

1. Begin the mosaic by forming the outline of the salamander's back. Remember that the finished surface of the mosaic is the one that touches the paper, so examine each cube carefully, apply the paste to the desired surface, and place it facing down on the paper. Adjust the placement of tesserae with tweezers, and allow small gaps between pieces for the grout.
2. Continue to mosaic the salamander's body, nibbling the yellow marble tesserae into appropriate shapes to create the mottled skin pattern. Shape the tesserae into more angular pieces to form the feet and tail.
3. When the salamander is complete, outline the figure in a single line of white marble tesserae. Form the border of the stepping stone in two rows of straight lines. Fill in the background area by following the flow of the key line of the salamander's back.

## ATTACHING TESSERAE, GROUTING, AND FINISHING

1. Construct a mold for the stepping stone by attaching four wooden boards to the paper with white glue. Set the boards on edge about ¼" from the border of the mosaic and screw them together at the corners so that the weight of the concrete doesn't collapse the mold. Paint a mixture of 50% petroleum jelly and 50% mineral spirits on the inside surface of the wooden frame—this acts as a release agent when you unmold the paver.

2. Sprinkle a small amount of sharp sand into the crevices of the mosaic to prevent the concrete from flowing underneath the tesserae and onto the surface of the mosaic.

3. Combine equal amounts of sand and cement in a large bowl. When they're thoroughly mixed, make a well in the center and gradually add water until the concrete has the consistency of thick mud. Pour the mixture into the mold, filling it halfway.

4. Tap the sides of the frame with the handle of the trowel to settle the concrete. Add the wire mesh and complete the pour to fill the mold. After tapping the sides once more, smooth the surface of the concrete with the trowel.

5. Allow the concrete to harden for at least a week; then unscrew and remove the wooden frame. Turn the slab over and remove the backing board.

6. Soak and remove the paper. Use an old toothbrush to remove any loose sand from the crevices.

7. Following the manufacturer's instructions, mix a small batch of powdered grout and apply it to the mosaic using a float. Remove any grout haze and polish the surface of the mosaic with lint-free rags.

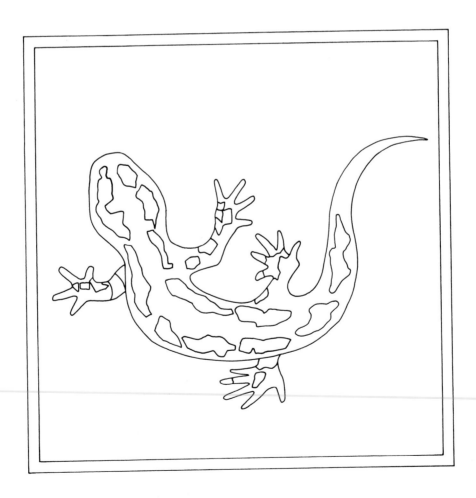

Fire Salamander Pattern

# Tree & Maze

Mosaic area: 23" x 14½"

## MATERIALS

Marble tiles; in beige, brown, and
   green tones
Unglazed ceramic tiles, dark
   brown shades
Brown kraft paper
Two temporary backing boards,
   slightly larger than mosaic
Gummed paper tape
Transfer paper
Wallpaper paste or flour
Wood framing to fit mosaic,
   ¾" x ¾"
Petroleum jelly
Galvanized wire mesh

Fine sharp sand
Cement
Tile nippers
Safety goggles
Pointed tweezers
Glue brush
Corner clamps, or screwdriver
   and wood screws
Rubber gloves
Mixing containers
Sieve
Wire cutters
Large and small trowels
Grout float
Sponge
Lint-free rags

## PREPARATION

1. Cut a piece of kraft paper
   slightly larger than the mosaic
   and wet it thoroughly in water.
   Stretch the moist paper on a
   backing board, securing the
   edges with gummed paper tape.
   Allow it to dry in place.
2. Enlarge the pattern to the size
   desired. Transfer the design onto
   the kraft paper using transfer
   paper and a dull pencil.

*Note: Since the finished mosaic will be
a mirror image of your working draw-
ing, you may wish to reverse the design
before transferring it.*

3. Using tile nippers, precut a good
   amount of tesserae into ¼"
   squares for the maze and trunk
   of the tree. Cut small triangles of
   green marble for the leaves.

## ASSEMBLING TESSERAE

1. Mix a small amount of wallpaper
   paste or make a flour paste by
   adding some water to two
   spoonfuls of flour. The flour
   paste should have the consis-
   tency of milk and must be
   stirred over heat until it thick-
   ens. Use either the wallpaper
   paste or flour adhesive to apply
   the tesserae, keeping in mind
   that the face applied to the
   paper will be the surface visible
   in the finished mosaic.
2. Begin in one area and work
   outward, leaving small gaps
   between tesserae for the grout.
   In this mosaic, the application of
   the background pieces in uni-
   form rows complements the
   geometry of the maze and adds
   to the serenity of the design.

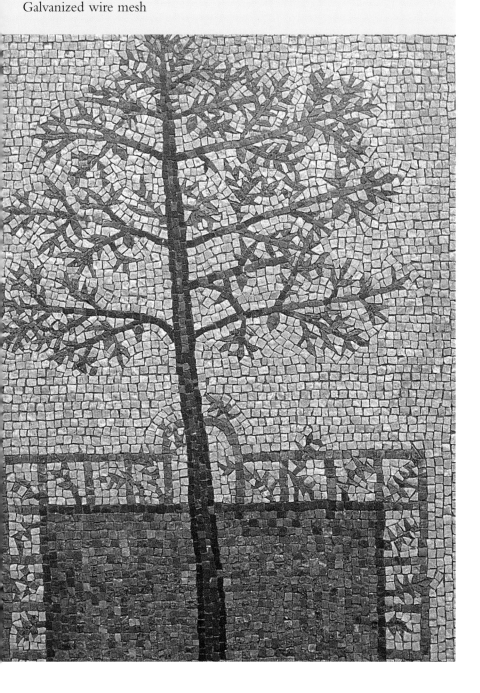

3. When the design is completed, make a mold by placing the wooden boards around the mosaic, leaving a gap of ¹⁄₁₆" all around. Use corner clamps or wood screws to fasten the corners. After rubbing a small amount of petroleum jelly on the inner surface of the mold, place it in position around the mosaic on the backing board.

*Note: The lubricant will make it easier to remove the mold later.*

## ATTACHING TESSERAE AND GROUTING

1. Cut the wire mesh to fit inside the mold, cutting it ⅜" smaller all around.
2. In a bowl, mix five parts of sifted sand with two parts of cement for the grout. Add water until the mixture has the consistency of thick syrup. Sprinkle some dry sifted sand over the mosaic, slightly filling the spaces between tesserae. Place some grout onto the mosaic and press it into the crevices with a small trowel. Remove any excess grout.

3. In another container, mix five parts of unsifted sand with two parts of cement and add just enough water to make a stiff, mud-like consistency. Bear in mind that adding too much water weakens the setting.
4. Trowel the mortar onto the grouted tesserae, filling the mold halfway. Add the wire mesh. Fill the mold with mortar, paying special attention to the corners and edges.
5. After leveling the surface of the mortar with a large trowel, sprinkle a little dry cement onto the wet surface. Clean the mold with a damp sponge, place a sheet of newspaper over the mortar, and add the other backing board on top.
6. Holding both backing boards tightly together, turn over the mosaic and lay it flat on your work surface. Remove the top backing board and dampen the kraft paper. Then beat the surface firmly with the grout float. This encourages the grout to come up to the surface. Wet the

paper thoroughly and leave it for about 10 minutes.
7. Gently peel off the paper. Check that no tesserae have become dislodged. If a piece did get disturbed, add a bit of mortar to the hole, replace the tessera, and tap it gently with the underside of the trowel until it is level with the surrounding pieces. Grout any gaps with mortar.

## FINISHING

1. Carefully clean the mosaic with an almost dry sponge, rinsing the sponge frequently in clean water and wringing it well. Burnish the surface with clean, dry rags.
2. Leave the mosaic to dry for a week, placing a wet cloth and a few weights on the surface. When it has dried thoroughly, remove the wooden mold.

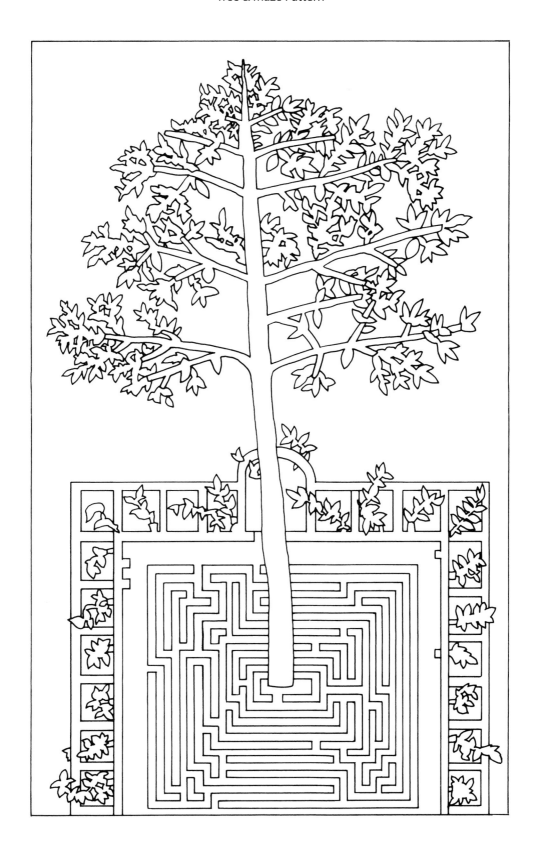

# Starburst Appliqué

## MATERIALS

Vitreous glass tiles; bright
   turquoise, cobalt blue, light
   grass green, medium teal,
   metallic grass green, orange
Flatbacked glass jewels; multicolor
   tulip, opal rectangular, opal
   teardrop, oval jewel
Mirror, royal blue
Sanded grout
Pigment, blue
Plain white paper slightly larger
   than the pattern

Masking tape
Ruler
Cling wrap
Fine-weave cotton latch-hook
   mesh★
Silicone glue
Wide, flat board
Rubber hammer
Plastic sheeting or cut-open
   garbage bags
Small metal spatula

★Available in fabric stores

## PREPARATION

1. Tape the white paper to your
   work surface. With a ruler, draw
   two perpendicular lines (one
   from top to bottom and the
   other from side to side) intersect-
   ing in the paper's center, creating
   crosshairs. Then add two lines on
   the diagonals, creating a grid
   divided into pie-piece shapes.

2. Transfer the pattern to the paper
   (see pages 20–21), aligning it
   with the crosshairs. Tape plastic
   sheeting or cling wrap over the
   paper. (See Photo 1.)

3. Cut the mesh to the same size as
   or slightly larger than the pat-
   tern. Center the mesh over the
   plastic-topped design and tape it
   in place, with the mesh's grid
   aligned to the vertical and hori-
   zontal crosshairs. You should be
   able to see the design and
   crosshairs clearly through the
   mesh. Make sure the mesh's grid
   is aligned with the vertical and
   horizontal crosshairs.

4. Using wheel glass cutters, cut
   four triangles ⅜" long and ¼"
   wide at the base from medium
   teal tile. The triangle tips must be
   narrow enough to fit between
   the paired tulip-shaped jewels.

## ASSEMBLING TESSERAE

1. Glue triangular tesserae in place,
   aligning them with the vertical
   and horizontal crosshairs. Glue
   the rectangular opal jewel in the
   middle first.

2. Glue two tulip-shaped jewels ⅛"
   apart on each of the middle
   opal's four main sides, leaving ⅛"
   space all around that center
   jewel. (See Photo 2.)

3. Cut four rectangles, ⅛" x ⁵⁄₁₆",
   from cobalt blue tile and glue
   the tiny rectangles at the corners
   of the central jewel, as indicated
   on the color-keyed pattern on
   page 86.

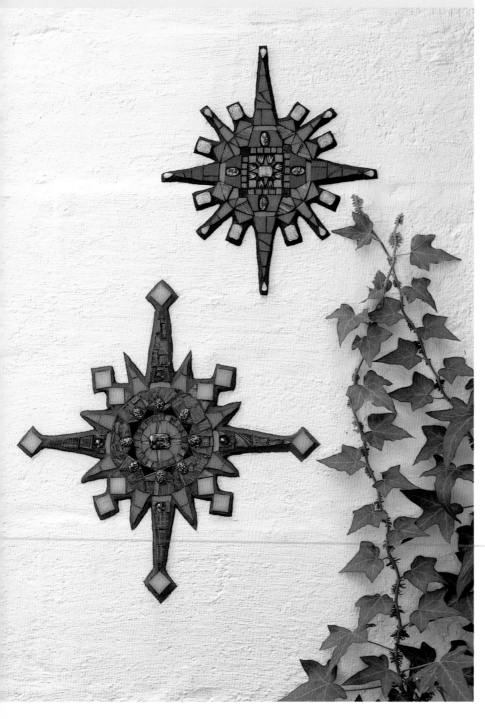

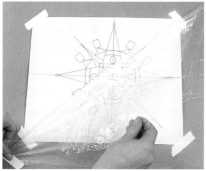

Photo 1

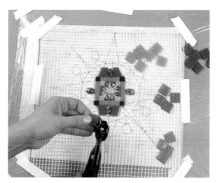

Photo 2

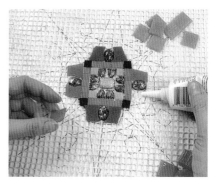

Photo 3

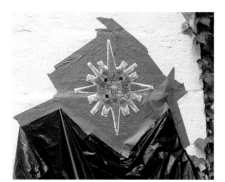

Photo 4

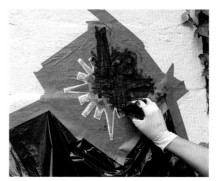

Photo 5

4. Cut four ⅜" squares from light grass green tile; glue these squares in the corner spaces flanking the four sets of tulip-shaped jewels, enclosing the center square.

5. Cut 20 squares approximately ¼" x ¼" from orange glass tile; glue them in place on all four sides of the center square, leaving the corners empty.

6. Cut four ⅜" squares from royal blue mirror; glue them in the empty corner spaces flanking the orange squares.

7. Glue in the blue oval jewels, aligned with the vertical and horizontal crosshairs. (See Photo 3.)

8. With the central square completed and the inside jewels in place, continue cutting, nipping, and gluing tile pieces for the remaining spaces, using the pattern on page 86 as your guide. When cutting pieces that form or abut the circle's outline, move the mosaic cutter slightly inward or outward, as necessary, to create the curve. Cut square tiles diagonally to form triangles. Cut and nip random shapes to fill in the large and small rays until you've filled in the pattern.

9. Glue the rectagular opal jewels at the tips of the small outer triangles, and the teardrop opals at the ends of the rays. Let the glue on the completed mosaic dry overnight.

## ATTACHING TESSERAE AND GROUTING

1. Carefully lift the tiled mesh off the cling wrap and trim away the extra mesh around the edges, as close to the tiles as possible.

2. With a helper if necessary, hold the mesh-backed mosaic in place against the surface where you will be installing it and trace around the mesh with a pencil. If the surface is painted or especially smooth, rough it up with sandpaper first; then spread an even layer of adhesive within the tracing.

3. Press the mesh-backed mosaic into position in the glue. You must get it properly aligned right away, before the adhesive dries too much.

*Note: It is helpful to have someone standing behind you to tell you when the mosaic is positioned correctly.*

4. Place a flat board over the mosaic and tap lightly with a hammer all over the surface to ensure that the entire piece is securely embedded and level.

5. Using dental picks or a razor blade, clean away any adhesive that has come up through the mesh onto the tiles. Let the glue dry for 24 hours. If the installation is outdoors and rain is threatening, cover the mosaic with plastic.

6. Using masking tape, mark off the edges around the mosaic, leaving an even ¼" between the mosaic and the tape, for grout. Use the tape's edge to create straight lines; use scissors to snip the tape to fit angles. Press the tape down firmly, especially if you're taping on a rough or uneven surface. Cover the area below the mosaic with plastic so that excess falling grout won't stain the surface. (See Photo 4.)

7. When grouting the mosaic, see Grouting with Cement-based Sanded Grout on pages 30–31. (See also Photo 5.)

## FINISHING

1. When the grout is semi-set, use the small spatula to carve a beveled edge along the outside grout lines, slanting the grout from the level of the top of the glass down to the inside edge of tape. Don't wait too long. If the grout has dried too much it will be difficult to carve. By the time you finish grouting the piece, the first section you grouted should be ready to bevel.

2. Carefully remove the tape and plastic. Clean and polish the mosaic. If any grout crept under the masking tape, clean away as much as possible. Touch up messy edges with a fine paintbrush and paint that matches the surface.

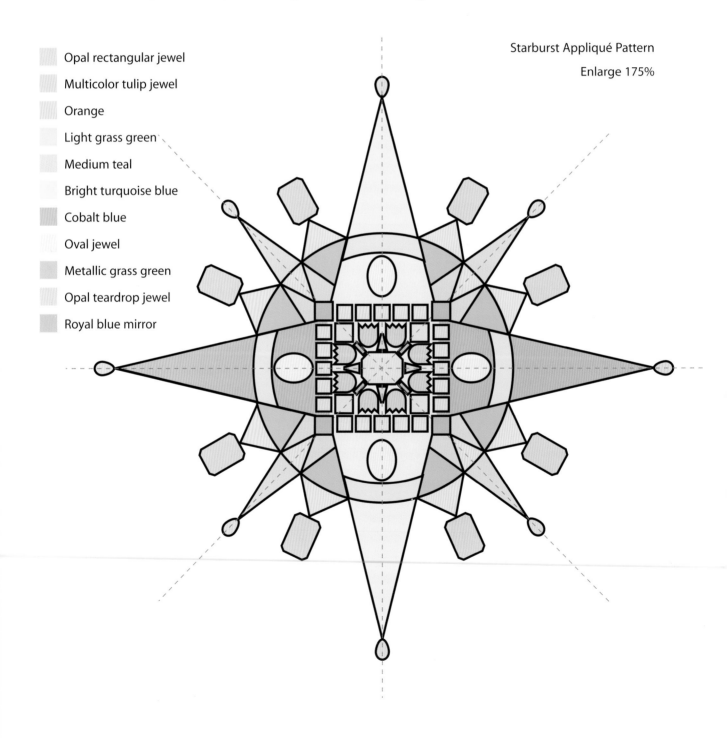

Opal rectangular jewel

Multicolor tulip jewel

Orange

Light grass green

Medium teal

Bright turquoise blue

Cobalt blue

Oval jewel

Metallic grass green

Opal teardrop jewel

Royal blue mirror

Starburst Appliqué Pattern

Enlarge 175%

# Sun/Moon Appliqué

## MATERIALS

Mirror tesserae; bronze, dark blue, light blue, light bronze, light gold, medium blue, orange, red, yellow
Cork-backed metal ruler
Glass cutter
Sanded, cement-based grout, color to match wall
Grout additive

Grout sealer
Masking tape
Permanent marking pen
Mesh
Pencil
Drawing or backing board
Plastic wrap (or other plastic sheeting)
Silicone adhesive
Wheel glass cutter/nipper

## ASSEMBLING TESSERAE

1. Refer to Andamento/Opus Musivum on page 19. Using silicone, attach the tesserae onto mesh. Alternate shades of blue for crescent; red and orange for sun; and shades of bronze, gold, and yellow for rays.
2. Allow to set for 2–3 hours. Carefully flip mosaic over onto a protected work surface. Remove the board, pattern, and clear plastic so they do not stick permanently to the piece. Allow to set for at least 24 more hours.
3. Trim mesh to ¼" around the mosaic. (See Photo 2.)

## ATTACHING TESSERAE, GROUTING, AND FINISHING

1. Prep the surface that is to receive the mosaic. (See Bases on pages 12–13.)

*Note: If this surface is flat, you may want to pre-grout your piece before attaching it.*

2. Hold the mosaic up to the surface and draw a light outline on the final location.
3. Mix epoxy resin, following the manufacturer's directions. Spread a thin layer of epoxy inside the outline.

*Note: Be aware that the epoxy will run a little if the area is not horizontal. Use a quick-set (5-minute) epoxy for vertical applications.*

4. Quickly attach the mosaic piece onto the resin, holding in place as necessary. Allow resin to set completely (usually a couple of hours).
5. Refer to Grouting with Cement-based Sanded Grout on pages 30–31. Grout with additive and allow to set and cure. Seal the grout.

*Option:*

• Mosaic this pattern using the Direct method if you have access to a surface for the entire process.

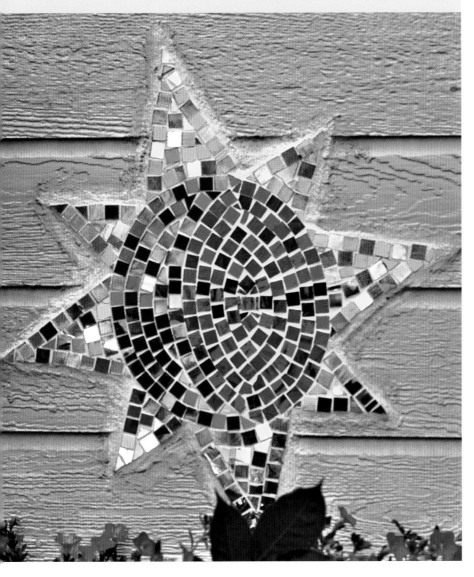

## PREPARATION

1. Photocopy and enlarge the pattern on page 88. Colorize pattern to serve as guide if desired, and attach to a drawing board or other flat, rigid backing. Tape a piece of clear plastic over pattern to protect it from the adhesive.

2. Lay the mesh over the plastic and tape in place. Draw the design onto the mesh, using the marking pen. (See Photo 1.)
3. Cut mirror pieces into approximately 1"-square tesserae.

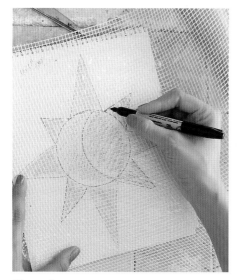

Photo 1

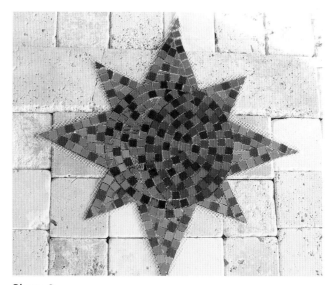

Photo 2

Sun/Moon Appliqué Pattern

# Greenhouse Side Table

## MATERIALS

Square china plate
Acrylic paints: off-white, orange
Contact paper
Sanded, cement-based grout,
    white
Grout additive
Grout sealer

Mallet
Small square metal plant stand
Multipurpose adhesive
Notched spreader
Small wooden board
Wooden piece to fit into plant
    stand frame

This project uses the Double-reverse method. It is useful if you are working with tesserae that are plain on the back so that you cannot see the pattern you are creating.

### PREPARATION

1. Remove the existing top from the plant stand. Place wooden piece into frame; attach with multipurpose adhesive for the mosaic base.
2. With multipurpose adhesive, seal around the edges to keep the grout from seeping.
3. Cut two pieces from contact paper slightly larger than the mosaic base.
4. Refer to Cutting China/Crockery on pages 25–27. Break plate into pieces as desired.

### ASSEMBLING TESSERAE

1. Reassemble the plate, picture-side up, on one piece of contact paper. (See Photo 1.)
2. Lay remaining piece of contact paper over the assembled pieces; make certain they are attached well. (See Photo 2.)
3. Flip over and carefully remove the contact paper from the back side. (See Photo 3.)

### ATTACHING TESSERAE AND GROUTING

1. Apply adhesive very thickly onto the base in the frame, using a notched spreader to even it out. Make certain to apply it thickly enough to be able to set all the china pieces into it and maintain a flat surface. Flip mosaic over and place pieces into adhesive, picture-side up. (See Photo 4.)
2. Place the wooden board over the mosaic and tap it with the mallet to make the piece even. Allow to set at least 24 hours. (See Photo 5.)

*Note: The piece may need at least two days to set because of the thickness of the adhesive.*

3. Gently and carefully remove the contact paper. (See Photo 6.)

4. Referring to Grouting with Cement-based Sanded Grout on pages 30–31, mix orange paint with bone grout to desired color. Grout and allow to set and cure.

## FINISHING

1. Seal the grout, following manufacturer's instructions.
2. Paint the plant stand as desired.

*Options:*

• Keep an eye out at bed-and-bath stores and garden stores for metal plant stands, which frequently sell for under $20.

• If you want to use a round metal table that does not have a frame, you can purchase a round metal hoop from a craft store in the correct diameter to "frame" the table. (See Photo 7.) Attach the hoop to the table with heavy-duty adhesive.

Photo 1

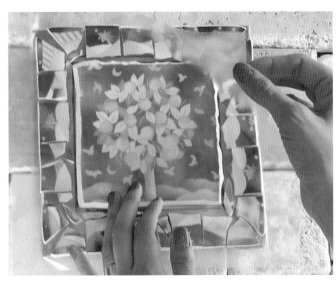

Photo 2

Photo 3

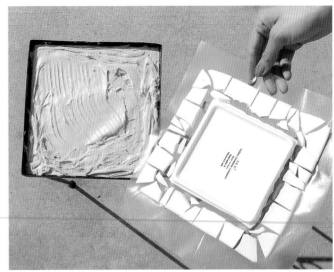

Photo 4

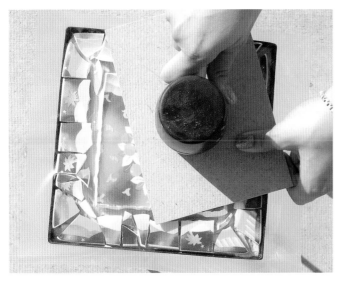

Photo 5

Photo 6

Photo 7

# Mister Mooch

Mosaic area: 17½" x 22"

**MATERIALS**

Unglazed porcelain tiles, 1"; beige
  black, blues, browns, grays,
  greens
Paper-backed clear adhesive film
High-tack clear adhesive film
Thin cement backerboard
Heavy braided mirror-hanging
  wire
Polymer-enhanced dry cement
  mortar
Polymer-enhanced dry grout
Tile nippers
Safety goggles
Tweezers
Jigsaw with carbide blade
Electric drill with ¼" masonry bit
Rubber gloves
Grout float
Notched trowel
Sponge
Stiff toothbrush
Nylon scouring pad
Lint-free rags

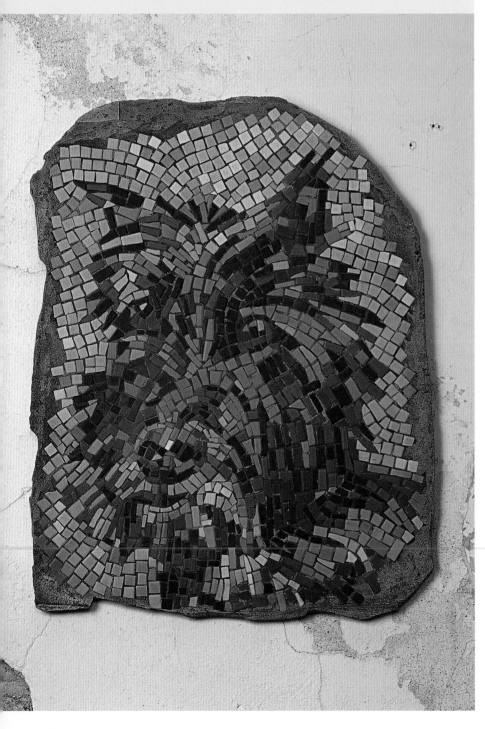

Mister Mooch is rendered in a
loose, impressionistic style. The
method used to create the mosaic
is largely self-grouting (i.e., the
mortar fills many of the grout
joints), so choose a mortar and
grout that match.

**PREPARATION**

1. Photocopy and enlarge the pat-
   tern or sketch to the size desired
   and tape it face-up on your
   work surface. Then cut enough
   paper-backed clear film to cover
   the entire drawing and secure it,
   sticky-side up and minus the
   paper backing, over the image.
2. Using the photo at left as a
   guide for size and quantity, cut
   tesserae and group by color.

**ASSEMBLING TESSERAE**

1. Begin assembling the mosaic on
   the adhesive film. Define the
   outer edges of the dog and its
   key features—eyes, nose, and
   mouth. To obtain the loose and
   open style shown here, mix in
   some other colors with the black
   and brown tesserae used to out-
   line the features. Fill in the dog's
   face and shoulders, cutting many
   of the tesserae into long, narrow
   shapes and placing them in lines
   to suggest the flow of hair.
2. Place the background tesserae to
   echo the flow of hair. Continue
   the lines outward, leaving ragged
   edges all around.
3. When the design is complete,
   apply the high-tack film adhe-
   sive side down onto the mosaic.
   If necessary, use two pieces of
   film to cover the entire mosaic.
   Using a dry rag, rub the surface
   of the film to adhere all the
   tesserae. Trim the film to match
   the mosaic.
4. Turn over the mosaic, holding it
   firmly between two boards to
   steady it, so that the bottom sur-
   face now faces up. Fold the low-
   tack film back on itself and gen-
   tly peel it off the mosaic.

5. Use a jigsaw with a carbide blade to cut the cement backerboard into an irregular shape a little larger than the mosaic. Save a scrap to use later as a test sample. Using a masonry bit about ¼" in diameter, drill two holes through the backerboard at the appropriate locations for a wire hanger.

## ATTACHING TESSERAE AND GROUTING

1. Mix a batch of cement mortar following the manufacturer's instructions. Use a brand that is already polymer-enhanced or add the polymer as a separate ingredient for extra strength. While the mortar briefly cures, assemble a test sample of tesserae on a scrap piece of high-tack film. Moisten the backerboard with a damp sponge.

2. Using a rubber grout float, apply a thin coating of mortar to the mosaic. If a few tesserae become dislodged in the process, just pick them out with tweezers. They can be replaced later using the Direct method.

3. Stuff the holes in the backerboard with paper. Apply an even coating of mortar to the entire surface with the smooth edge of a notched trowel. Use the notched edge to go over the mortar and set the depth.

4. Lift the film-mounted mosaic and set it carefully onto the backerboard. Try to place it accurately, but don't lift it to try again if you're a little off-center. The alignment is less critical when you have an irregularly shaped plaque with "blank" space around the mosaic. Adjust the placement if necessary by tamping the mosaic with glancing blows of the rubber float.

5. Starting in the center and working outward in a spiral, beat the surface evenly with a clean rubber float to create a good bond. When you're done, remove any excess mortar that may have squeezed out along the edges. Repeat the process with your test sample, then allow both to dry for several hours.

6. Test the sample by carefully peeling off the film. When the test shows a good bond, check the mortar with a fingernail or pencil; it should be firm but capable of being dented. Gently remove the film from the face of the mosaic.

7. Brush the surface of the mosaic with a stiff toothbrush or bristle brush to accentuate the grout joints. Scrubbing in a circular motion, cover the entire surface evenly. Remove excess mortar with a damp sponge.

8. Mix a batch of polymer-enhanced grout that matches the color of your mortar. Apply the grout to the mosaic, pressing it into the surface with the float. After waiting about 10 or 15 minutes, wipe off the excess grout and haze with a damp nylon scrubbing pad. Continue to polish the surface with dry rags until it's clear of grout film. Then allow the mosaic to cure for at least 24 hours.

## FINISHING

1. To stucco the blank area around the mosaic, first cover the mosaic with clear adhesive film to keep it clean. Then mix some matching grout and apply it to the blank area and the edges of the plaque. Trowel on sufficient material to cover the backerboard and match the thickness of the mosaic. Allow the grout to set for 24 hours.

2. Remove the paper stuffing from the holes in the backerboard. To attach a hanger, make a knot at each end of a length of heavy braided wire. Apply a liberal amount of epoxy to the knots and insert them into the holes in the backerboard.

# SECTION III

# Picasiette

# Picture Frame

## MATERIALS

China with white and floral areas
China edge pieces for border
MDF, ¾"-thick (for base)
Safety goggles
Towel
Hammer or mallet
Jigsaw or scroll saw
Tile nippers
Rubber gloves

Tile mastic
Blue paper shop towels
Chip paintbrush
Disposable container
Sanded grout
Stir stick
Eye screws
Strong picture wire
Chain of antique crystals
*(optional)*

The frame shown is 9½" x 13½". The frame is displayed on a large antique mirror—embellished with a chain of crystals—framing an antique broach.

### PREPARATION

1. Determine the size of your frame by measuring the art you wish to frame. Enlarge the pattern on page 97 so the inner opening fits this measurement.
2. Transfer the design onto ¾"-thick MDF and cut it out with a scroll saw or jigsaw.
3. Prepare the wood of the frame. (See Wood Bases on pages 12–13.) Attach eye screws and picture wire to the back.
4. Referring to Cutting China on pages 25–27, prepare the tesserae from your china.
5. Lay out the china pieces on the pattern paper in a "dry run." Place your desired arrangement near your work area.

*Note: It can be frustrating to have half of something glued down and realize that you've misplaced a piece or have messed up the pattern. Planning the layout in advance is a way to ensure you have what you need right to hand.*

### ATTACHING TESSERAE AND GROUTING

1. Place major design features first, such as the central floral motif or gilded pieces, in select areas. Apply mastic to the frame in small 3" sections, or butter directly onto each tessera and stick them to the frame base. Give each piece a little twist to ensure that full contact has been made between adhesive and china. Leave a minimum of ⅛" space between each piece to allow room for grout.

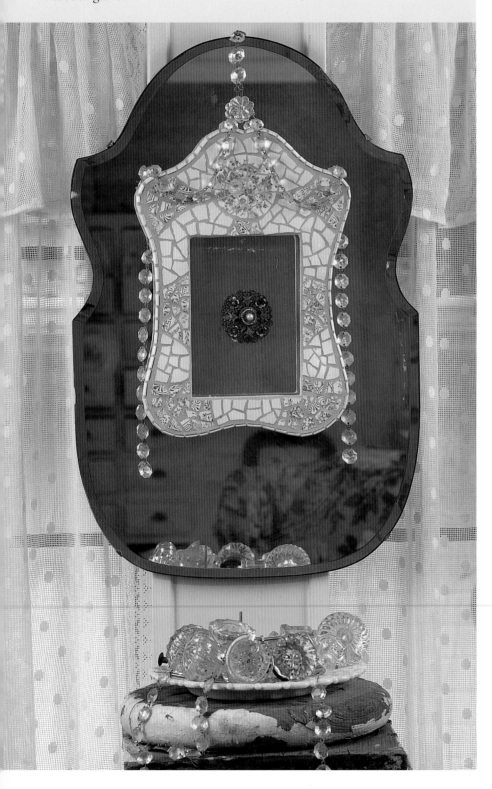

2. Refer to Tiling Edges on pages 28–29. Apply small pieces from a plate edge vertically along the side of the frame. Make sure that the smooth edge is flush with the front of the mosaic to create a smooth outside edge. (See Photo 1.)

Photo 1. Special care is taken to select, cut, and place pieces from the edge of a plate along the side edge of the frame.

3. Fill in the field with plain, off-white china, working one small section at a time to keep the adhesive from drying out. You will likely need to cut pieces as you fill in the field. Therefore, restrict adhesive application to create stopping points, in case you want to cut more pieces or take a break.

4. Place a small amount of dry grout into a container and add some water. Do not follow the manufacturer's instructions—they work well on traditional tile projects, but not so well for picasiette. Stir until grout is the consistency of peanut butter; the mixture should not drip off of the stir stick when held over the container.

5. Apply a portion of mixed grout on the surface and spread it around with your gloved fingers, making certain to force the grout into all the joints. Sculpt the grout onto the edges to make them beveled and smooth. You must be thorough and work quickly, as the cut surfaces of the shards are very absorbent and rapidly draw the moisture out of the grout.

6. Wipe off as much excess grout as possible—cleaning off grout at this stage will save a lot of work later. Rapidly rub the entire surface with your gloved hand. Be careful to avoid sharp edges, which will only be smoothed out once the grout has filled in the joints.

7. Use blue shop towels to rub away any excess grout. Continue rubbing until the grout is as smooth as possible and the tesserae are as clean as they can be. Allow the piece to set for 10–15 minutes.

*Note: Blue shop towels are recommended for grout removal because they are the only type of paper toweling that will not flake off and stick in the grout.*

8. With a soft, lint-free cloth, buff away any remaining haze and dust.

### FINISHING

Allow the project to set overnight at room temperature. Do not put it in a warmer place—slow drying will give the piece more strength. Seal grout, if desired.

Picture Frame Pattern

Enlarge 225%

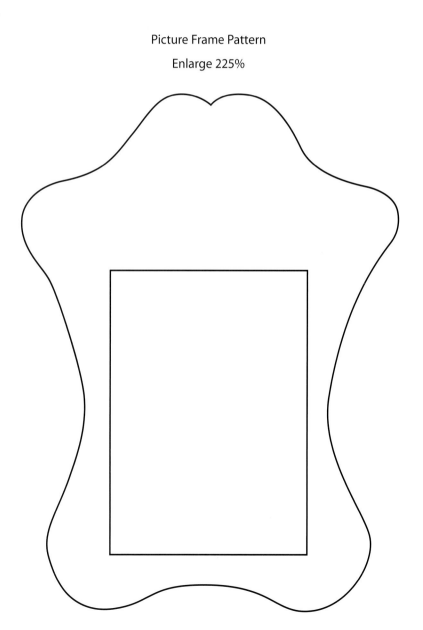

# Cross

## MATERIALS

Teacup with floral motif
Dessert plate border pieces
China fragments, off-white
MDF, ¾"-thick
Safety goggles
Towel
Hammer or mallet
Jigsaw or scroll saw

Tile nippers
Rubber gloves
Tile mastic
Blue paper shop towels
Chip paintbrush
Disposable container
Sanded grout
Stir stick
Hardware for hanger (optional)

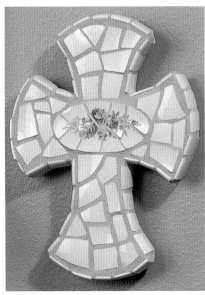

Photo 1. A finished edge was incorporated into this design. Precut and save edge pieces of the same pattern in dedicated containers so they are readily available when you need to work a piece that requires a finished edge.

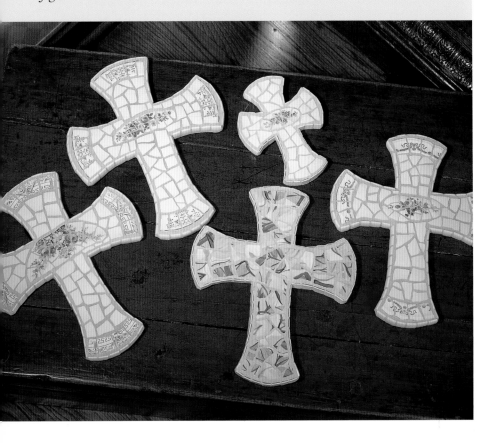

## PREPARATION

1. Transfer the pattern on page 99 to ¾"-thick MDF. Cut out with scroll saw or jigsaw. Drill a hole as a hanger, or attach hardware to hang cross on wall.
2. Prepare the wood of the frame. (See Wood Bases on pages 12–13.)
3. Break or shape tesserae with tile nippers. Use random pieces in a scattered informal pattern or follow the photos above to create a more structured look. The shape and size of the cross will accommodate two easily attainable china elements—the floral motif that is often found either on the inside or outside of a

teacup for the center of the cross, and the border from a dessert plate to cover the curve of the outside edge with smooth pieces.
4. Lay out the china pieces on the pattern paper in a "dry run." Place your desired layout near your work area.

## ATTACHING TESSERAE AND GROUTING

1. Place design features first. Butter adhesive of choice directly onto each piece and stick to base. Give each piece a little twist to ensure that full contact has been made between adhesive and china. Leave a minimum of ⅛"

space between each piece to allow room for grout.
2. Refer to Tiling Edges on pages 28–29. Apply small pieces from china edging along the side of the frame. Make sure that the smooth edge is flush with the front of the mosaic to create a smooth outside edge. (See Photo 1.)
3. Fill in the legs of the cross with plain, off-white china.
4. Place a small amount of dry grout into a container and add some water. Stir until the consistency of peanut butter.
5. Apply mixed grout to the surface of the cross and spread it around with your gloved fingers, making certain to force the grout into all the joints. Sculpt the grout onto the edges to make them smooth.
6. Wipe off any excess grout. Rapidly rub the entire surface with your gloved hand.

7. Use blue paper shop towels to rub away any excess grout. Continue rubbing until the grout is as smooth as possible and the tesserae are as clean as they can be. Allow the piece to set for 10–15 minutes.

8. With a soft, lint-free cloth, buff away remaining haze and dust.

**FINISHING**

Allow the project to set overnight at room temperature. Do not put it in a warmer place—slow drying will give the piece more strength. Seal grout, if desired.

Cross Pattern

Actual size for small cross

Enlarge 175% for large cross

# Boudoir Mirror

Mosaic area: 11" x 17½"

## MATERIALS

3 pieces of china with floral
   motifs (1 dessert plate,
   2 teacups)
Border pieces from 2 patterns
   of china (equivalent to
   3–6 bowls each)
China fragments, off-white
MDF, ¾"-thick
Safety goggles
Towel
Hammer or mallet

Jigsaw or scroll saw
Tile nippers
Rubber gloves
Tile mastic
Blue paper shop towels
Chip paintbrush
Disposable container
Sanded grout
Stir stick
Paint in coordinating color
   (for mirror back)
Plate stand; or hardware
   (for hanger)

## PREPARATION

1. Enlarge the pattern on page 101
   to desired size.
2. Transfer the design onto ¾"-
   thick MDF and cut it out with
   a scroll saw or jigsaw.
3. Prepare the wood of the frame.
   (See Wood Bases on pages
   12–13.) If desired, attach hard-
   ware to back for hanger.
4. Have a mirror cut to fit. Attach it
   to the prepared wooden frame.
5. Referring to Cutting China on
   pages 25–27, prepare the tesserae
   from your china. Cut edge
   pieces from bowl borders to take
   advantage of their vertical,
   curved shape.
6. Lay china pieces on the pattern
   paper in a "dry run." Place your
   desired arrangement near your
   work area.

## ATTACHING TESSERAE AND GROUTING

1. Attach the inside border with
   mastic first. Remember to give
   special attention to the curves of
   the border so they not only
   frame the viewer's face, but also
   allow the borders to maintain
   their natural curve. This will
   determine where you place the
   bottom edge of the central cir-
   cular design. (See Photo 1.)
2. Apply the central circular
   design, then attach the two cup
   motifs on either side. Butter
   each with tile mastic and give
   each piece a little twist to ensure
   that full contact has been made
   between adhesive and china.
3. Place the outside border, letting
   the outside finished edge of the
   china hang over about ⅛" beyond
   the frame edge.
4. Fill in the field with plain, off-
   white china. Leave a minimum
   of ⅛" space between each piece
   to allow room for grout. Allow
   mastic to dry.

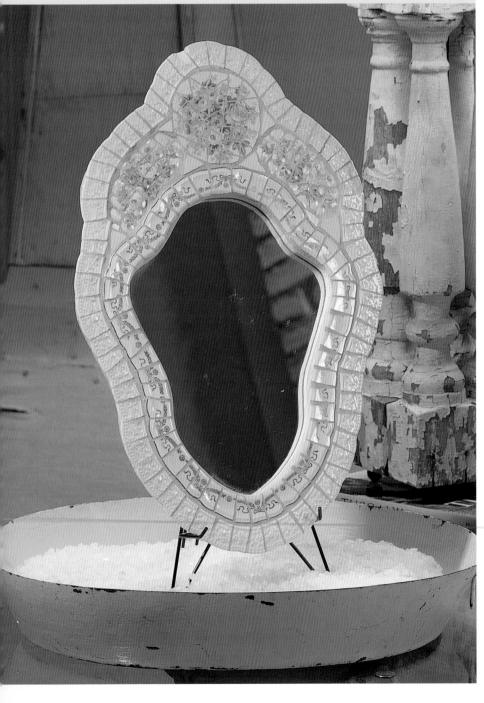

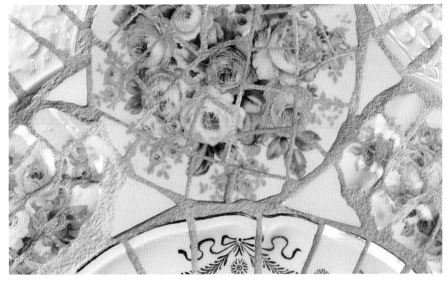

Photo 1

7. Wipe off any excess grout. Use blue paper shop towels, a barely damp sponge, or lint-free rags to rub away excess grout. Continue until the grout is as smooth as it can be and the tesserae are as clean as possible. Allow the piece to set for 10–15 minutes.

8. Buff any remaining haze away with a soft, lint-free cloth.

## FINISHING

1. Allow the grouted project to set overnight at room temperature. Do not put it in a warmer place—slow drying will give the piece more strength. Seal grout, if desired.

2. Paint the mirror back with a coordinating color.

*Option:*

- Enlarge the pattern even more for a wall mirror to go above a dresser or in a powder room.

5. Place a small amount of dry grout in a container and add some water. Stir until the consistency of peanut butter.

6. Apply a portion of mixed grout to the surface and spread it around with your gloved fingers. Make certain to force the grout into all the joints. Sculpt the grout around the edges to make them beveled and smooth. Be thorough and work quickly, as the cut surfaces of the shards are very absorbent and rapidly draw the moisture out of the grout.

Boudoir Mirror Pattern

Enlarge 250%

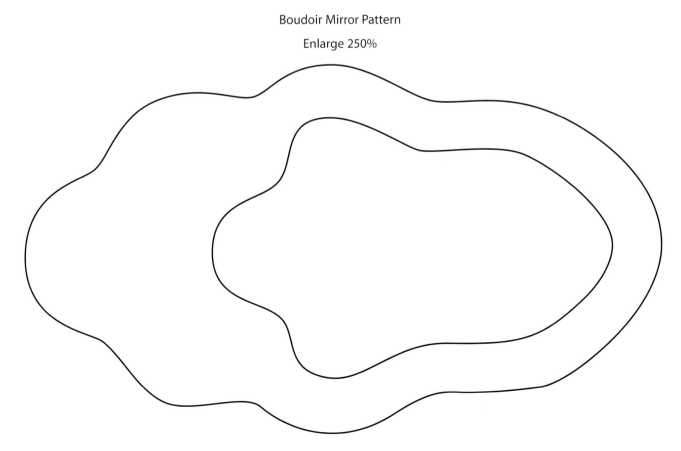

# Nightstand

## MATERIALS

Large square floral plate
Floral dessert plate
2 large transferware plates
Brown kraft or butcher paper
Ruler
Permanent marking pens
Ceramic tile adhesive
Spreader for adhesive
Safety goggles

Tile nippers
Disposable container
Grout
Rubber gloves
Stir stick
Water
Chip paintbrush
Blue paper shop towels or
    lint-free cloths

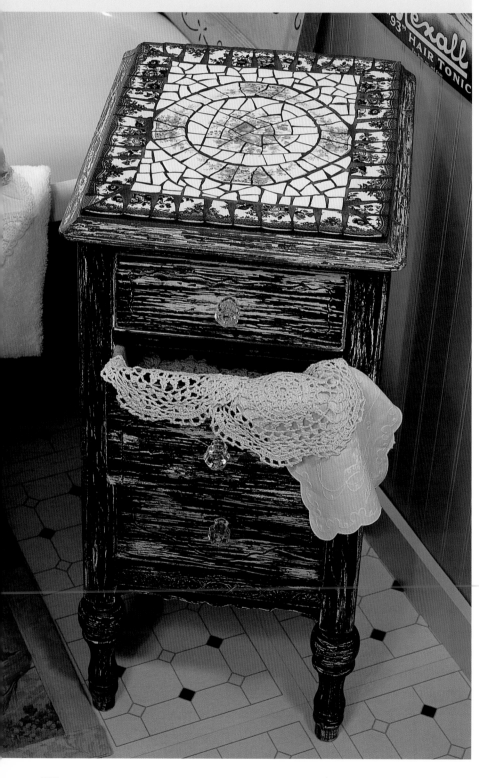

To create this nightstand, the border of a square plate has been set as a diamond shape around the center of a circular plate. Border pieces from two large black transferware plates make up the outside edge, complementing the crackle finish on the chest. The piece is grouted in black because a light-colored grout would not have been bold enough for the dark nightstand. The continuity of the piece as a whole is maintained by the selection of a floral china pattern with strong color and black accents.

### TIPS FOR WORKING ON A SQUARE OR RECTANGULAR GRID

1. Choose a plate you would like to use as a focal point. Center the plate on a large piece of paper and draw around it. Sketch a design for your mosaic around this space.
2. Mark a grid over the design, figuring the scale that it will be once transferred to your surface.
3. Draw the scaled grid on the surface. Work square by square, recreating the design on the surface with tesserae. Use the grid as a guideline to determine where you will place pieces within the design.
4. Use the Dry-setting technique: Before adhering any design with mastic, assemble the pieces in the location they will be on the finished project. Be sure the spacing is accurate and nothing is out of order. It is far better to work out these details before you involve adhesive.
5. Set the outside border, then work from the center of the design out toward the edges.

## PREPARATION

1. Find and mark the center of your table surface. Mark a cross in black ink through the center and, in another color, measure a grid pattern outward to the edges. You can use the small plate to draw a circular perimeter for the central plate design. (See Photos 1, 2, and 3.)
2. Referring to Cutting China on pages 25–27, use tile nippers to break plates into tesserae.
3. Organize the tesserae into color categories for convenient access when assembling the design.

4. Dry-set the central design. Assemble the pieces of a pattern or border edge in the location that it will be on the finished project before adhering anything with mastic. In this way you can be sure the spacing is accurate and nothing is out of order. It is better to work out these details before you involve adhesive.

## ATTACHING TESSERAE AND GROUTING

1. Apply mastic in small 3"–4" sections, approximately ⅛" thick. Avoid making the band of adhesive wider than the width of the border pieces. If you lay down too much mastic, it will squish up between the applied pieces and fill in the space where the grout must go. (See Photo 4.)

*Note: Restricting the adhesive coverage while you work not only avoids having the adhesive dry up if you don't work fast, but it will also create a stopping point if you want to take a break.*

2. Place the outer border pieces on top of the mastic and give each piece a little twist to ensure that full contact has been made between adhesive and china. Leave a minimum of ⅛" space between the pieces to allow room for grout. (See Photo 5.)
3. Adhere the inner border around the central design. (See Photo 6.)
4. Fill in the field with plain, off-white china, working one small section at a time to keep the adhesive from drying out. You will likely need to cut the pieces as you fill in the field to be able to fit them into the space between the outer border and the central design. (See Photo 7.)

*Note: Use the grid as a guide when cutting china pieces. The squares can help you to determine whether to cut one or more pieces to fill each grid square. By using the grid in this manner, you will be able to create a uniform design.*

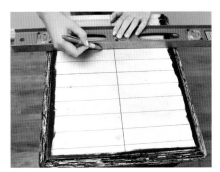

Photo 1

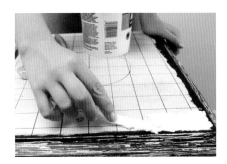

Photo 2

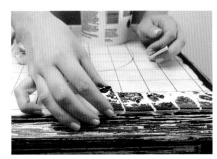

Photo 3

Photo 4

Photo 5

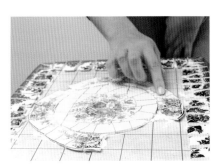

Photo 6

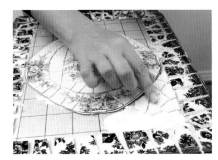

Photo 7

5. Place some dry, sanded grout in a container and add some water. Stir until the consistency of peanut butter. Pour out a portion of mixed grout onto the surface. (See Photo 8.)

6. Spread the grout around with your gloved fingers, making certain to force the grout into all the joints. Be thorough and work quickly, as the cut surfaces of the shards are very absorbent and rapidly draw the moisture out of the grout. Sculpt the grout onto the edges to make a nice, smooth edge. Generously cover the entire piece. (See Photo 9.)

7. Wipe off as much excess grout as possible. Rub the surface with lint-free cloths until the grout is as smooth as possible and the tesserae are as clean as they can be. You can use a large chip paintbrush or small hand-broom to whisk away powder throughout this process. (See Photo 10.)

8. Allow the piece to set for 10–15 minutes. Using a soft, lint-free cloth, buff away any remaining haze and dust.

9. Let project set overnight at room temperature. Do not put it in a warmer place—slow drying will give the piece more strength.

**FINISHING**

Because a nightstand can be expected to come in contact with water or drink, it is recommended that you apply grout sealer to keep the grout from staining. Many quality grouts have an additive that seals the grout and eliminates this extra step, so check the manufacturer's instructions before deciding whether or not to use a sealer.

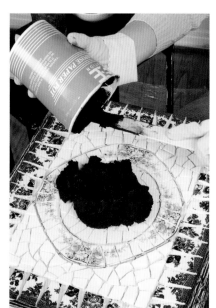

Photo 8

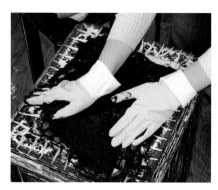

Photo 9

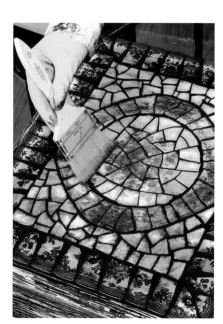

Photo 10

# Blue Transferware Backsplash

## MATERIALS

1 transferware platter, blue
2 additional patterns of blue
   transferware
Ceramic tile border pieces, white
Safety goggles
Towel
Hammer or mallet
Jigsaw or scroll saw

Tile nippers
Rubber gloves
Tile mastic
Blue paper shop towels
Lint-free cloths
Chip paintbrush
Disposable container
Sanded grout
Stir stick

Because it need not be smooth, a vertical surface is well-suited for the application of a broken serving platter. This mosaic incorporates picasiette and traditional tile: edge pieces of two different china patterns provide inside and outside borders; figured pieces from those same patterns—shading light to dark from the center outward—fill in the field; and the whole piece is framed with commercial tile molding.

### PREPARATION

1. Find and mark the center on the surface you are covering. (See page 103.) Measure and draw a grid outward from this point.
2. Break or use tile nippers to create tesserae from your selection of china. Take care in creating the edge pieces. (See pages 25–27.)
3. Draw a duplicate grid on a large piece of paper and lay out your design in a "dry run." Place the desired arrangement near your work area.

### ATTACHING TESSERAE AND GROUTING

1. Adhere the platter to the center of your surface with mastic, using the grid as your guide.
2. Place garland border pieces around the platter.
3. Apply deep blue transferware pieces along the outer edge of the design for an outside border.

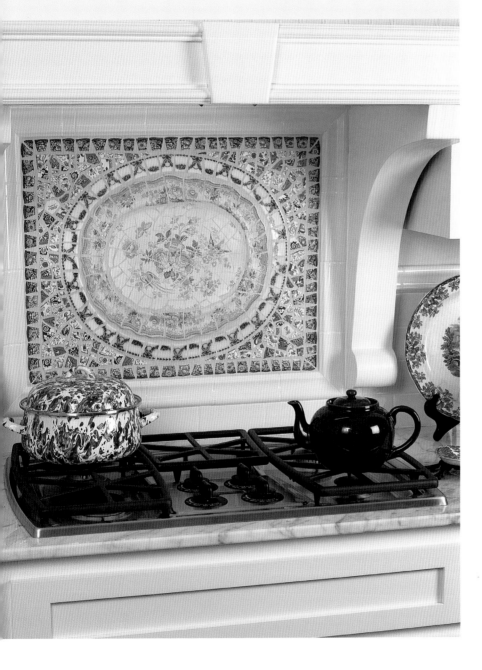

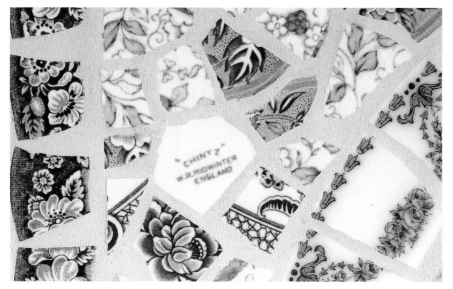

Photo 1. Notice the inclusion of the maker's mark.

4. Break up two more pieces of transferware or your other choice of pattern into small pieces and use them to fill in all of the empty spaces. Make sure that the pieces are spread randomly throughout. You may also choose to incorporate one or two maker's marks in the field for a special touch. (See Photo 1.)

5. Place dry, sanded grout into a container and add water. Stir until the consistency of peanut butter. Apply portions of mixed grout onto the surface.

6. Spread the grout with your gloved fingers, making certain to force the grout into all the joints. Be thorough but work quickly, as the cut surfaces of the shards are very absorbent and rapidly draw the moisture out of the grout. Generously cover the entire piece.

7. Wipe off any excess grout. Rub the surface with lint-free toweling and/or a large chip paintbrush or small hand broom.

8. Let the piece set for 10–15 minutes. Using a soft, lint-free cloth, buff away any remaining haze and dust. Allow the project set and cure for at least 24 hours.

**FINISHING**

A tabletop or backsplash is especially vulnerable to stains. Be sure to apply a sealer to the surface of the mosaic.

*Option:*

• If you do not have continual access to the final surface, use one of the Indirect methods (see Section II, page 67) and build the mosaic in your studio or work area. Draw a grid (see page 103) on a piece of mesh, or on a piece of paper over which you can place the mesh (scrim, gauze, fiber netting, wire mesh, etc.). Carefully transport the mosaic (or its parts) to the final site. Using epoxy or cement mortar, permanently attach the mosaic to the intended surface. Grout in place when adhesive is fully dry.

# Blue Willow Coffee Table

## MATERIALS

Several pieces of Blue Willow
   transferware
China or ceramic pieces, white
Recycled coffee table (for base)
Safety goggles
Towel
Hammer or mallet
Tile nippers

Rubber gloves
Tile mastic
Blue paper shop towels
Lint-free cloths
Chip paintbrush
Disposable container
Sanded grout
Stir stick

Blue Willow is readily available, relatively affordable, and surprisingly compatible with a variety of traditional decors. It has become so popular that there are actually Blue Willow conventions held annually throughout the United States. Although its primary color complements almost any floral pattern, Blue Willow provides a bold color that is fresh and inviting when paired with simple off-white china.

### PREPARATION

1. Draw a grid on the table surface you are covering. Find and mark the center. (See page 103.)
2. Referring to Cutting China on pages 25–27, prepare the tesserae from your china, taking care to preserve as much surface as possible when creating the edge pieces.
3. Sort like-patterned pieces in containers for convenient access.
4. Draw a duplicate grid on a large piece of paper and lay out your design in a "dry run." Place the desired arrangement near your work area.

### ATTACHING TESSERAE AND GROUTING

1. Using the grid as your guide, align and place pieces cut from the centers and edges of three plates in organized, intertwining rings. Adhere them to your surface with mastic.
2. Attach the deep blue outside edge pieces to frame the tabletop.

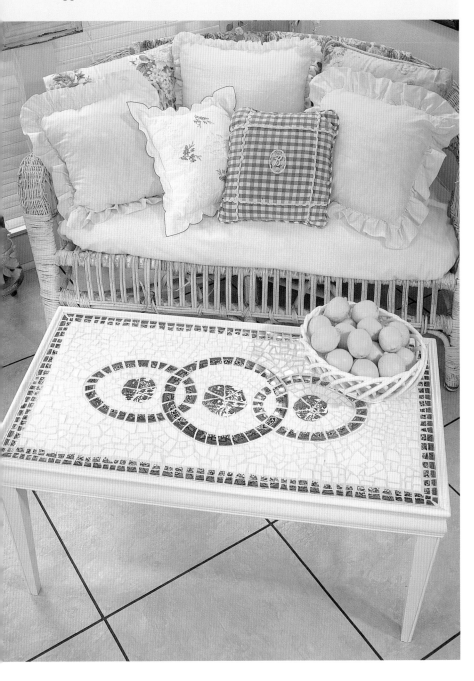

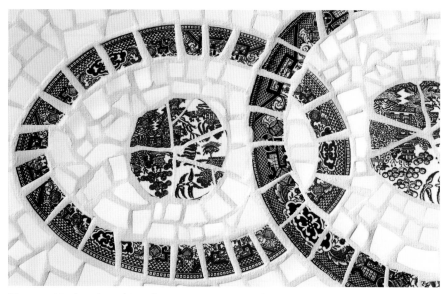

Photo 1. Notice the white china tesserae cut to fit, and the amount of space allowed between them for the grout.

3. Fill in all of the empty spaces with white pieces, making certain that they are spread randomly throughout. Nip and tailor to the spaces, as needed. (See Photo 1.)

4. Place dry, sanded grout into a container and add water. Stir until the consistency of peanut butter. Apply portions of mixed grout onto the surface.

5. Spread the grout with your gloved fingers, making certain to force the grout into all the joints. Be thorough but work quickly, as the cut surfaces of the shards are very absorbent and rapidly draw the moisture out of the grout. Generously cover the entire piece.

6. Wipe off any excess grout. Rub the surface with lint-free toweling and/or a large chip paintbrush or small hand-broom.

7. Let the piece set for 10–15 minutes. Use a soft, lint-free cloth, to buff away any remaining haze and dust.

8. Allow the project to set and cure for at least 24 hours.

### FINISHING

A tabletop is especially vulnerable to stains. Therefore, be sure to apply a sealer to the surface of the mosaic.

# Patio Table

## MATERIALS

1 large dinner plate
3 luncheon plates
3 dessert plates or soup bowls
China or tiling (enough to
    provide border pieces and
    fill-in tesserae)
Circular base surface
Permanent marking pens
Right-angle ruler
Metal tape measure
Safety goggles

Towel
Hammer or mallet
Tile nippers
Rubber gloves
Tile mastic
Blue paper shop towels
Lint-free cloths
Chip paintbrush
Disposable container
Sanded grout
Stir stick

This project combines vibrant yellow and cobalt blue pieces with a floral pattern that contains these two colors plus a few accent colors. The grouping creates an island of explosive color surrounded by a field of off-white, enclosed with another colorful plate border. Do not be afraid to push the envelope where color is concerned—especially when working on outdoor pieces. A color wheel can be useful to help you visualize and choose color combinations.

### PREPARATION

1. Find and mark the center on the surface you are covering. Measure and draw a grid from this point outward .
2. Break pieces or use tile nippers to create tesserae from your selection of china, using care to preserve as much border area as possible when creating the edge pieces. If you are using soup bowls, carefully nip away curved surfaces so the tabletop will be as level as possible.
3. Draw a duplicate grid on a large piece of paper and lay out your design in a "dry run." Place the desired arrangement near your work area.

### ATTACHING TESSERAE AND GROUTING

1. Adhere the plates (or your choice of focal design) to the center of your surface with mastic, using the grid as your guide. To even up a surface that needs to be flat, use a flat wood block to press the tesserae into the adhesive once you have completed a section of the design. Apply the pieces for the next section and repeat with the wood block.

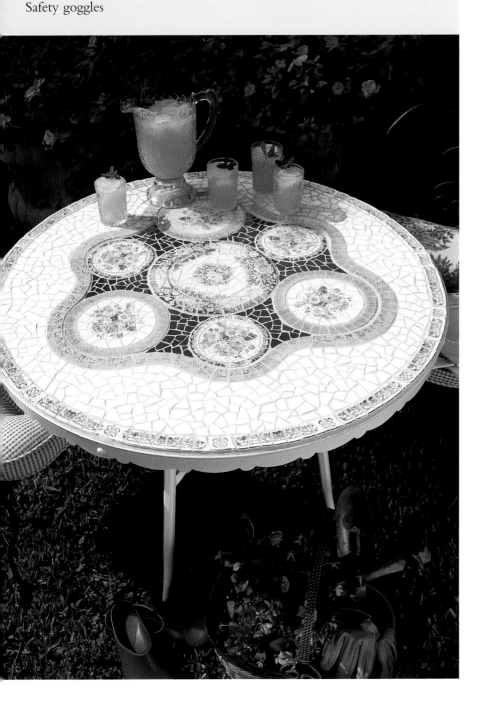

**109**

## GRID LAYOUT ON A CIRCULAR SURFACE

Laying out a grid on a circular area is perhaps even more essential than laying one out on a rectangular or square base. It is extremely difficult to maintain a symmetrical pattern if you do not first take the time to create a radial grid. Otherwise, you could run the risk of ending up with a lopsided result.

1. Draw an axis in the center of the circle. An axis is two lines that are perpendicular to each other and intersect in the center of the circle. This will divide the circle into four sections. (See Photo 1.)

2. Mark 4" out from the center point on each line. (See Photo 2.)

3. Connect each point with a straight line to form a square at the center of the circle. (See Photo 3.)

4. Find the center point of each side of the square and place a mark there. (See Photo 4.)

5. Connect the two center points on the opposite sides of the square. This will divide the circle into eight sections. (See Photo 5.)

6. Measure and mark every inch from the center of the circle along each radial line. (See Photo 6.)

7. Draw a connecting line between each radial line at each corresponding set of marks. (See Photo 7.) You now have a radial grid on the circular surface that will guide you in laying out the pattern in a symmetrical fashion. (See Photo 8.) The lines should not necessarily be followed exactly, but they will assist you in keeping the design on track.

Photo 1

Photo 4

Photo 7

Photo 2

Photo 5

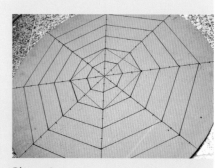
Photo 8

Photo 3

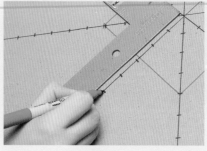
Photo 6

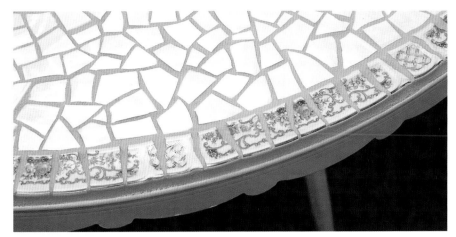

Photo 9

2. Place the pieces for the curved border around the plates.
3. Apply deep blue (or color of your choice) filler pieces inside this curved border. Press with the wood block to even out surface.
4. Arrange and adhere the outside edge border pieces. (See Photo 9.)

5. Apply white pieces to fill in the field between the curved inner border and the outside edge border, flattening with the wood block as you work. Allow mastic to dry.
6. Place dry, sanded grout in a container and add water. Stir until the consistency of peanut butter. Apply portions of mixed grout onto the surface.

7. Spread the grout with gloved fingers, making certain to force the grout into all the joints. Be thorough and work quickly, as the cut surfaces of the shards are very absorbent and rapidly draw the moisture out of the grout. Generously cover the entire piece.
8. Wipe off any excess grout. Rub the surface with lint-free cloths and/or a large chip paintbrush or small hand-broom.
9. Let the piece set for 10–15 minutes. Use a soft, lint-free cloth to buff away the remaining haze and dust.

**FINISHING**

1. Allow the project to set and cure completely for a few days.
2. Apply a sealer to the surface of the mosaic.

# Many-Handled Lamp

## MATERIALS

Assorted teacups with handles
Ceramic tesserae (enough to
    cover base)
Porcelain lamp base
Safety goggles
Tile nippers
Rubber gloves
Towel
Hammer or mallet

Latex-based tile adhesive
Low-tack masking tape
Disposable container
Sanded grout
Stir stick
Palette knife
Lint-free cloths
Polyethylene foam sheeting
    (a packing material)

Working three-dimensional mosaic offers unique challenges. Sculptural mosaics may be viewed from many angles, so you must give equal attention to every surface. Your style of working may be impacted as well—due to the contours of your base, you may need to cut smaller tesserae than you ordinarily would. The example shown here provides an ideal opportunity to incorporate some unconventional elements into the mosaic, but you must keep your design from succumbing to the forces of gravity as you assemble it.

Because you will need to turn the piece upside down and set it on its side to examine it from several angles, you should assume at least three or four working sessions with 24-hour drying periods in between.

## PREPARATION

1. Sketch your design or pattern lines directly onto the object, or plan to let the materials take you where they may.
2. Select an assortment of materials and cut a quantity of tesserae.
3. Cut cup handle pieces from teacups. The object is to remove most of the cup and leave a small base for the handle to be attached to the mosaic. Make the first cut by placing your thumb next to the handle to brace it; place the tile nippers next to your thumb. (See Photo 1.)
4. Make small additional cuts away from the handle. If you place the nippers too close to the handle, the resulting cut will almost certainly cause it to break. Nibble away the unwanted portions of the cup with very small cuts; however, bear in mind that but if you get too ambitious in your cutting, you may lose the handle. Be patient, as this operation isn't always predictable.

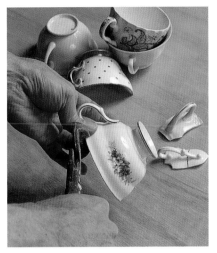

Photo 1

5. Hold the cup handles against the lamp base to determine their best placement. On this project, the natural shape of a cup works well against the broad curve of the upper part of the lamp. You can attach objects that bend against the curve of your base, but they require more adhesive and more grout to meld them into the overall form.

## ATTACHING TESSERAE AND GROUTING

1. Using a palette knife or small metal spatula, apply a liberal amount of tile adhesive to the back of each cup handle. Fill the entire curve with adhesive to make sure there are no air pockets, which might cause the handle to loosen. A latex-based tile adhesive is used here because it adheres well to the glazed surface of the lamp base. (See Photo 2.)

2. Press each handle onto the surface of the base until some of the adhesive oozes out around the edges. Use a palette knife to scrape away any excess adhesive.

3. When the cup handles are fixed in place, you may find that their weight causes them to slip out of position. Secure them in place with low-tack masking tape. (See Photo 3.)

4. Set mosaic aside to dry for 24 hours.

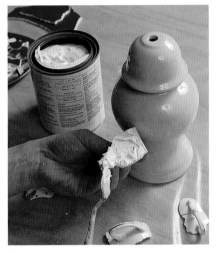

Photo 2

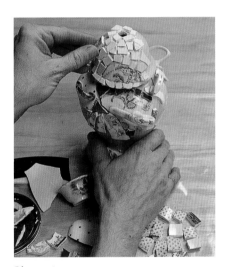

Photo 4

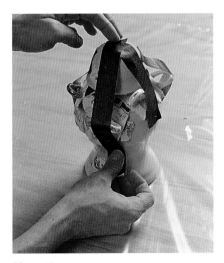

Photo 3

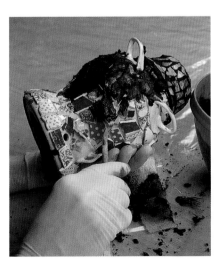

Photo 5

Photo 6

5. Carefully remove the tape. Fill in your design with tesserae, liberally buttering the back of each piece with adhesive before placing it, and leaving spaces for grout. When working on the top of the lamp where the hardware will be attached, try to maintain a uniform thickness in the tesserae. The lamp hardware includes a decorative washer that covers a portion of the mosaic around the top hole. If the surface is uneven, the pressure on the washer may cause the mosaic to break. (See Photo 4.)

6. Use small or curved pieces from bowls, cups, or the rims of plates on a rounded surface. In general, sharper curves require smaller pieces. Experiment with placement; you may need to set some tesserae where they fit best, rather than exactly where you originally envisioned them.

7. After completing the major elements of your design, take the time to go over the entire project and fill in any gaps. Make sure you haven't inadvertently covered the hole near the bottom, which must remain open for the electric cord.

8. Allow mosaic to dry for at least 24 hours before grouting.

9. Mix a small batch of grout. Start with about a cupful of water and add sufficient dry powder to obtain a thick but smooth consistency. After the grout has cured for about 10 minutes, use your gloved fingers or a palette knife to apply it to one section of the lamp at a time. (See Photo 5.)

10. Press the grout into the crevices and wipe away any excess with small pieces of polyethylene foam sheeting or barely damp lint-free cloths. Continue in sections, applying grout and wiping off the excess, until the entire mosaic is complete.

11. Use a large nail to shape the grout around the holes at the top and bottom. In small, concave areas, clean the surface of the mosaic with a stiff toothbrush, a nail wrapped in a dry rag, or a piece of polyethylene foam sheeting. (See Photo 6.)

12. Remove any remaining grout haze; then allow the lamp to dry thoroughly for at least 24 hours.

**FINISHING**

1. Install the hardware and wiring.
2. Attach a lampshade.

# Sparkle & Shimmer Candle Holders

## MATERIALS

Wooden candlesticks, 11½"-tall
Pieces of broken ceramic of
   choice
Metallic paint, gold
Metallic powder, gold
Non-sanded grout, buttercream
   (or with added colorant)

Silicone adhesive
Sandpaper, 220 grit
Clear acrylic sealer
Tack cloth
Foam brush, ½"
Lint-free cloths
Gold leaf and gold leaf adhesive
*(optional, rather than gold paint)*

A pair of candlesticks from a yard sale is transformed with picasiette. Tall, thin, rounded surfaces like these look best when you use very small pieces, so this project is a great way to use up those tiny tesserae left over from other projects.

### PREPARATION

1. Sand candlesticks lightly. Wipe away dust.
2. With clear sealer, seal areas where the mosaic will be located. Let dry.
3. Using tile nippers, create tiny tesserae from your choice of ceramic.

### ATTACHING TESSERAE AND GROUTING

1. Glue tesserae on candlesticks with silicone adhesive. Use adhesive sparingly. Let dry.
2. Mix some gold metallic powder with a small amount of grout to give the grout a slight glow. Mix grout with water according to manufacturer's instructions.
3. With gloved fingers, spread grout over china pieces. Wipe away excess. Let dry.
4. Polish haze from china with a soft, lint-free cloth.

### FINISHING

1. Clean off any excess grout on the areas to be painted, sanding as needed. Wipe away dust.
2. Paint top and bottom areas with gold paint. Let dry.
3. Seal grout to protect from wax spills.

*Option:*

- Apply gold leaf adhesive and gold leaf instead of painting the top and bottom areas.

# Tiled Gem
# Mosaic Egg

## MATERIALS

Snippets of tile and broken china
Papier-maché or wooden egg
Sanded or non-sanded grout,
    buttercream

Lint-free cloths
Silicone adhesive
Clear acrylic sealer
Toothpicks

## PREPARATION

1. Sand egg if using wooden base.
2. Seal egg surface. Let dry.
3. Cut tiny tesserae.

## ATTACHING TESSERAE
## AND GROUTING

1. Glue snippets of china and tile
   on egg with silicone adhesive,
   nipping pieces as needed to fit.
   Use enough glue to hold the
   pieces in place, but not so much
   that the glue squishes up
   between the pieces. (If it does,
   you won't be able to cover it
   with the grout.)
2. Use a toothpick to remove any
   excess glue immediately. Let
   adhesive dry thoroughly.
3. Mix grout according to package
   instructions. With gloved fingers,
   spread grout over egg, pushing it
   into all the crevices and forming
   a smooth, curved shape.
4. Wipe away any excess grout.
   Let dry.

## FINISHING

1. Polish with a soft, lint-free cloth
   to remove any haze.
1. Seal grout to protect, if desired.

# Picasiette Stepping Stone

## MATERIALS

Precast cement stepping stone
Porcelain plates, coordinating
　　solids and patterns
Safety goggles
Latex or rubber gloves
Terrycloth towel
Tile nippers

Dry cement mortar
Mixing container
Spatulas, large and small
Plastic sheeting
Polyethylene foam sheeting
　　*(a packing material, optional)*
Lint-free rags

## PREPARATION

1. Wearing safety goggles, break plates with a hammer (see Breaking China/Crockery on pages 25–27), or use tile nippers. With your first cut, try to remove a small piece of the outer rim; this tends to be unpredictable and may bisect the pattern you want to use in the center of your mosaic. Don't let this deter you; the crack may actually enhance your design.

2. Turn the plate over and begin removing its outer rim in segments. While cutting, remember to place nippers with the blades extending only about ⅛" onto the plate.

3. Cut small working tesserae by nipping off the fine outer edges of the plates wherever they occur to give an even thickness to all your pieces. A central motif can be left in a single large piece or trimmed smaller as desired.

*Note: Save rounded, ridged, and edge pieces for another project. On a mosaic that will be underfoot, it is best to use flat tesserae throughout.*

4. Repeat the process with several more plates to obtain patterned and solid color pieces. For later convenience, sort pieces according to color.

5. Place stepping stone base on another paver, brick, or similar object to elevate it from your work surface and make it easier to reach all sides.

## ASSEMBLING AND ATTACHING TESSERAE

1. Assemble your design. If working with a single large motif, start in the center and work outward. Continue cutting and placing tesserae until you have the main aspects of your design assembled in a satisfactory "dry run."

2. Mix cement mortar as instructed by the manufacturer, starting with a cupful of cool water and adding sufficient dry mortar to produce the consistency of thick mud.

3. While the mortar cures briefly, remove the tesserae from the paver and set them aside.

4. Spread ⅛" coating of mortar on the center area of the stepping stone base and place the central pieces of the design. Lightly butter the backs of the tesserae with mortar to ensure proper adhesion. (See Photo 1.)

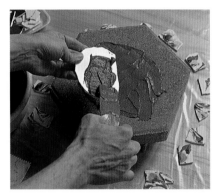

Photo 1

*Note: Width and regularity of grout joints strongly influence the overall feeling of a design. Some artists prefer to minimize grout, others use it boldly as an important design element. With picasiette, uneven spaces complement the irregular shapes of the tesserae.*

6. Use the small spatula to remove any excess mortar that squeezes up to fill the grout joints.

7. Continue spreading mortar and placing tesserae in one small area at a time. When all larger pieces have been set, fill in with smaller bits nipped to fit.

8. Neatly accent the beveled edge on the paver with a single line of small pieces. (See Photo 2.)

*Note: When tesserae are applied to the vertical edges of the paver, they have a tendency to slip. It is especially important at this stage that your mortar not be too runny. If mortar is not thick enough to hold the tesserae in place, do not add dry mortar to the existing mix; make a new batch, instead.*

9. Allow finished project to dry for 24 hours.

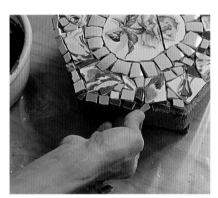

Photo 2

## GROUTING

1. Clean any excess mortar from the surface of the mosaic with a small spatula.

2. Wearing gloves, mix a small batch of grout. Place a cupful of cool water in a bowl and gradually add dry grout, mixing until you have a thick but smooth consistency.

3. Apply grout to the surface and press it into the crevices with a hard rubber float, grout spreader, or your gloved fingers. A small piece of polyethylene foam sheeting is a handy tool for grouting edges, as it is more pliable than a grout spreader or float.

4. When all crevices are filled with grout, remove the excess by vigorously wiping in a circular motion with pieces of foam sheeting or slightly damp, lint-free rags.

5. Allow mosaic to haze over, then wipe, frequently turning the foam sheeting or rag to a clean area.

## FINISHING

1. Allow the grout to set for about 30 to 60 minutes.

2. Polish off any remaining haze with a damp sponge or clean rag.

3. Set the mosaic to cure for at least 24 hours.

4. If desired, apply a penetrating sealer to protect the grout from the weather.

# SECTION IV

# Garden Projects

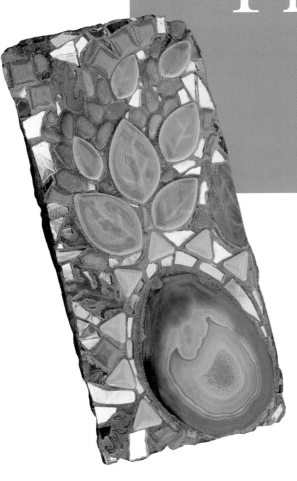

# No Ordinary House Number

## MATERIALS

¾" rot-resistant wood, 12" x 36"
Sandpaper, medium grit
Wood glue
4 finish nails, 1"
Outdoor wood sealer
Ceramic tiles, 4" x 4": 2 each
 slate blue, orange; 3 each red,
 kelly green; 4 royal blue; 6
 each black, mustard yellow
Mirrors: 6" x 6", yellow; 12" x
 12", silver
Silicone glue
1½ lbs. blue sanded grout

¾ oz. phthalo blue liquid pure
 pigment
1½ lbs. white sanded grout
1½ oz. yellow liquid pure pigment
Acrylic grout fortifier
Jigsaw or scroll saw
Hammer
Paintbrush
Leather gloves
Ceramic tile nippers
Glass mosaic cutters
Permanent marking pen
Plastic sheeting
Masking tape

*Note: If your house number comprises more than three digits either reduce the size of the numbers to fit within the space or make the entire project proportionately larger. If your house number has only one or two digits, consider filling the extra space on either side with a decorative tile or design.*

## PREPARATION

1. Transfer the designs for the starburst (back board) and the arched number area (front board) separately onto the wood. Trace around the pattern's entire outer perimeter, transferring the starburst shape for the back board. On a separate section of the wood, transfer the outline and design for the arched number area. This area will be the front board, delineated by dotted lines on the pattern.

2. Cut out both pieces using a jigsaw or scroll saw; if you don't have either, take the job to a woodworking shop. Smooth any rough edges with sandpaper.

3. Glue and nail the front board in place on top of the back board. Let the glue dry thoroughly before proceeding to the next step.

4. Enlarge your house numbers on a photocopier. Cut out the sized numbers from the paper, position the numbers on the board, and trace around each one with a permanent marking pen.

5. Apply two coats of outdoor wood sealer to both the front and back of the wood, allowing drying time between coats. You may have to do just one side and the edges first, then the other side. Let the sealer dry completely overnight.

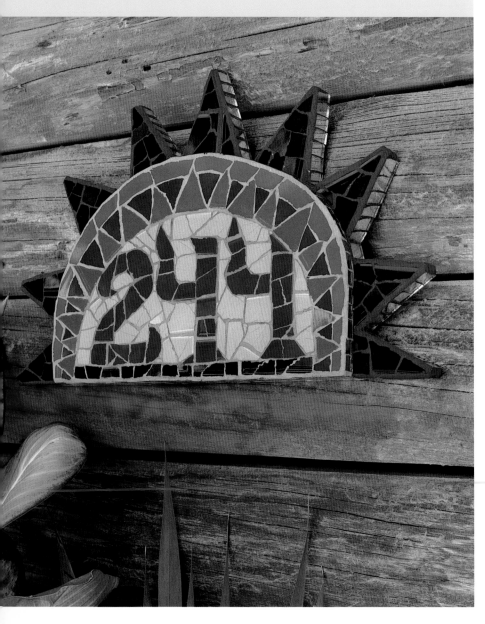

## ATTACHING TESSERAE

1. Wearing leather gloves and using a hammer, break up three to four black tiles. (See pages 25–27.) Use tile nippers to cut and shape the pieces into smaller shards, then glue them to fill the back board's rays.
2. Break up the red and orange ceramic tiles. Use tile nippers to shape and size triangles. Bear in mind that the triangles don't have to be perfectly shaped, or exactly the same shape and size as those in the pattern; use the pattern just as a guide. However, in order to leave room for the blue border, make sure that none of the triangles is tall enough to touch the front board's top edge.
3. Break up green tiles and—using tile nippers and gluing pieces in place as you work—fit green triangles between the red and orange ones. Again, leave plenty of room for the blue border; the green triangle bases can be below the tips of the red and orange triangles.
4. Break two blue tiles into large pieces, then use tile nippers to fashion strips, each cut to fit between a given pair of red and orange triangles. The distance between the tips of the red and orange triangles will determine the length of the pieces you need to cut. The width of the border should range from ½" to ⅝". Make the lengthwise cut first, using the nippers to produce a slight curve. Then cut the strip widthwise, angling each end to match the angles of the red and orange triangle tips the strip will fit between. Glue each strip in place as you cut it.

5. Set tile cutter at ½" and cut one black tile into strips. Use tile nippers to cut each strip at angles into smaller pieces. Glue the pieces across the bottom edge, creating a black border under the numbers.
6. Break, nip, and glue shards of royal blue tiles to fill in the numbers. Shape and place each piece carefully to keep the edges of the numbers crisp and even.
7. Fill in the background with broken yellow tiles nipped to fit. Keep the spaces between pieces consistent.
8. Using a ruler and a glass cutter, cut the yellow mirror into ¾" strips (or a width to match the edge of the front board). Snap off the strips with running pliers, then use glass mosaic cutters to snip each strip into rectangles roughly ¼" wide. Make these cuts straight, not at an angle. Attach around the edge of the front board.
9. Using the same technique as in step 8, cut and snip ¾" strips of silver mirror into ½" pieces, and glue them around the edges of the starburst back board. Where the two sides of a ray meet at the tip, leave approximately ¼" of space. Allow the glue to dry overnight.

## GROUTING

1. Using cleaning tools, carefully remove any excess glue from the surface of the tile and mirror.
2. Cut and tape a piece of plastic sheeting over the face of the front board, and mask off the board's yellow-mirror edge. Smooth all the tape down securely, so no grout will be able to creep underneath.

3. Mix the blue grout with the phthalo blue pigment and fortifier, and grout the back board, starting with the mirrored edge. Be careful to fill all the angled joints in the rays, and remember to lift the piece and grout the edge from behind. Wipe off any excess grout with a damp sponge and let the surface haze over. Polish with a soft cloth.
4. Wrap the entire project in plastic and let the blue grout set overnight before grouting the front board.
5. Carefully remove the tape and plastic covering the front board. Mask off the black tile along the curve where the rays meet the front board's yellow mirror. Make sure the tape is smoothed down securely. Cover the rest of the back board with plastic sheeting, wrapping the plastic around and under the edges.
6. Mix the white grout with yellow pigment and grout fortifier. Grout the front board, starting with the mirrored edge and finishing with the flat surface. Wipe away excess grout with a damp sponge and let the surface haze over. Polish with a soft cloth.

## FINISHING

1. Use cleaning tools to remove any remaining excess grout.
2. Wrap the whole project in plastic or kraft paper and let cure for three days.
3. Attach metal hanger to the back.

No Ordinary House Number Pattern

Enlarge 200% and again 126%

Black

Mustard yellow

Royal blue

Red

Orange

Slate blue

Kelly green

Back board

Dotted line indicates front board outline.

Styled Number Patterns

Enlarge as needed

1 2 3 4

5 6 7

8 9 0

# Mosaic Accent Brick

## MATERIALS

1 brick paver

1 polished agate slice, about ¼" x 2" x 3"

7 ceramic tile triangles, ½"-wide, slate blue

7 leaf-shaped ceramic tiles; 2 large, 2 medium, and 3 small; blue

6 ceramic tiles, ⅜"-square; dark teal

Pebbles, ¼"–½"; 1 handful each; teal, turquoise

Mirror, 1" x 1½", light blue

Ring-mottled stained glass, 3" x 3"; blue/white

Stained glass, 3" x 3"; blue/white mix

Glass mosaic cutters

Waterproof glue

Sanded grout, ¼ lb. blue

Acrylic grout fortifier

Plastic sheeting

*Note: One brick pattern has been provided, but have fun creating several of these miniature mosaics in varying designs. If you plan to make enough bricks to add to a patio or pathway, keep in mind that although each brick is its own composition, all of the bricks must somehow work together. Plan a unifying factor—similar materials, repeating design elements, or a particular color family—that will provide a theme for your group of bricks.*

## ATTACHING TESSERAE AND GROUTING

1. With the brick paver positioned vertically in front of you, use the pattern on page 125 as a guide and place the agate on the brick. Angle the agate slightly inward from the lower right corner to establish movement. When you're happy with its position, lift the agate slightly, brush glue onto that area of the paver, and push the agate onto the glue, applying gentle, firm pressure.

2. Paint glue around the agate's outside edge. Place the ceramic tile triangles next, positioning them so they radiate outward, as if the agate were a sun.

3. Using glass mosaic cutters, nip small, mostly rectangular shapes of blue and white ring-mottled glass. Glue these rectangles between the agate and the ceramic triangles.

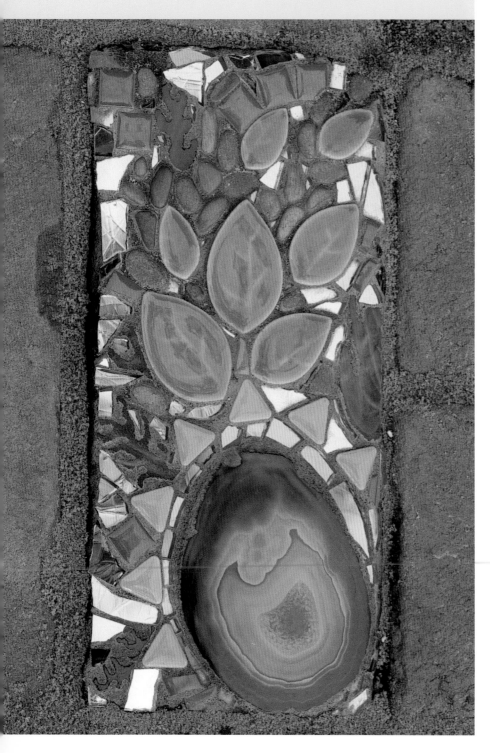

4. Glue the leaf-shaped ceramic tiles in place, with the smallest gently curving off to the right at the top. Then position and glue the six dark teal tiles.

5. Use the small teal and turquoise pebbles to fill this space in between the leaves. Put a few outside of the leaves, too. Take advantage of the pebbles' shapes by placing them so they flow in the same direction as the leaves.

6. Fill in the rest of the space on the brick with small shards of blue/white mix stained glass, adding bits of blue mirror here and there as accents. Let the glue dry overnight.

7. Remove any excess dried glue from the surface of the glass, agate, and mirror.

8. Mix the grout and additive, then grout the brick's surface and outside edge. Wipe with a damp sponge and let the surface haze over. Polish with a soft cloth.

## FINISHING

1. Use cleaning tools to remove any excess dried grout.

2. Wrap the brick in plastic sheeting or kraft paper and let grout cure for three days.

3. Place the accent brick, and others if you've made them, among ordinary bricks in a loose-laid patio or walkway (one in sand or earth). Set these pavers deeply enough to bring their surfaces level with the regular bricks. This will minimize impact and wear.

Mosaic Accent Brick Pattern

Actual size

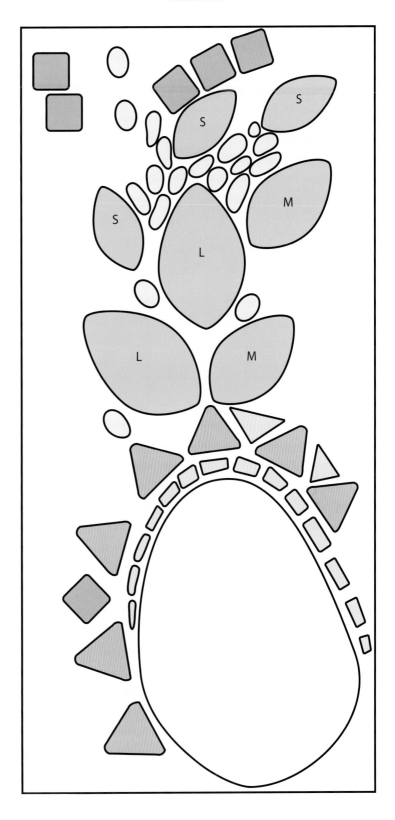

☐ Polished agate slice

▨ Slate blue ceramic triangle

▨ Blue ceramic leaf
  S = small
  M = medium
  L = large

Turquoise/teal pebble

Dark teal ceramic

Combination of blue/white mix stained glass and light blue mirror

Blue/white ring-mottled stained glass

# Looking Glass Garden Stake

## MATERIALS

¾" rot-resistant wood, 12" x 24"
Stained glass: 6" x 8", red-orange mix, rose; 12" x 12", blue-green-yellow mix, 2 sheets
Mirrors: 12" x 12", blue, green, silver
Outdoor wood sealer
Permanent marking pen
Tracing paper
Silicone glue
Jigsaw or scroll saw

Sandpaper
Paintbrush
Ring saw
Glass mosaic cutters
Towel
Rubber gloves
3 lbs. sanded grout, blue
1½ oz. liquid pure pigment, yellow
Acrylic grout fortifier
Plastic sheeting

## PREPARATION

1. Photocopy and enlarge pattern on page 128.
2. Transfer the stake outline and mirror side pattern to the wooden board. Be sure to go over the graphite lines with a permanent marking pen.
3. Using a jigsaw or scroll saw, carefully cut out the stake. Sand smooth any rough edges.
4. Transfer the blossom design to the other side of the stake. Again, go over the graphite lines with a permanent marking pen.
5. Apply two coats of outdoor wood sealer to the entire stake, including the edges, allowing drying time between coats. (You may have to do just one side and the edges first, then the other side.) Let the stake dry completely overnight.

## BLOSSOM SIDE
## ATTACHING TESSERAE

1. Lay the stake on your work surface with the blossom design facing up. Following the pattern, use the glass cutter to score pieces, then use running pliers to snap them free. You can sketch the sliver shapes onto the mirror with a marker and then cut them, but it is easier to eyeball the pattern and score the pieces freehand. Bear in mind that the pieces don't have to exactly match the spaces in the pattern. Cut and glue long slivers of green mirror for the flower bud.
2. With the pattern as a guide, use the same technique to cut slivers of rose and red-orange glass for flower petals. Glue the petals in place.

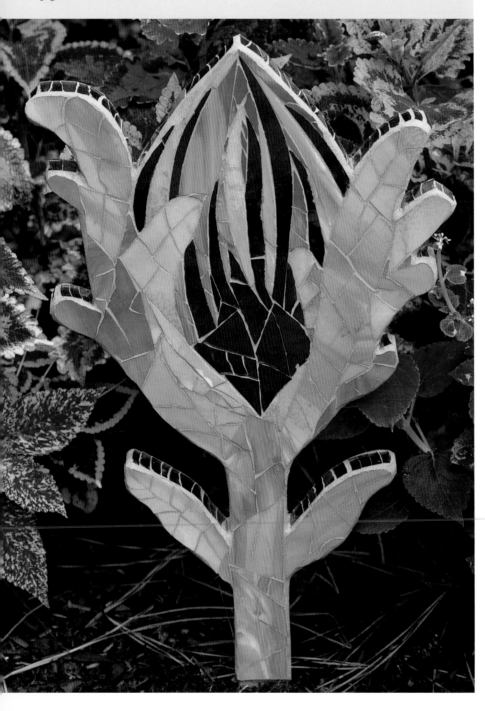

3. Using glass mosaic cutters, nip and shape irregular shards of green mirror. Fill in the bottom of the flower bud.

4. With glass mosaic cutters, create randomly shaped, small to medium pieces of blue-green-yellow mix stained glass. Fill in the remaining space around the blossom and down the front of the stake. Leave the bottom 6" of the stake—the part that will go into the ground—bare. Let the glue on the blossom side dry.

5. Meanwhile, with a glass cutter and running pliers, cut the blue mirror into several straight strips exactly as wide as the stake is thick (¾"). Snip two of the strips into irregular rectangles, roughly ½" wide, using the glass mosaic cutters. Lay the pieces out on your work surface in the order that they are cut.

6. Glue the pieces of blue mirror one after the other onto the edge of the stake. Cut one or two more strips into pieces, glue them in place, and so on until the entire edge is finished in blue mirror. At the most severe curves, snip narrower pieces in order to keep the surface smooth. Make sure no glass sticks out over the sides. Let the glue dry completely.

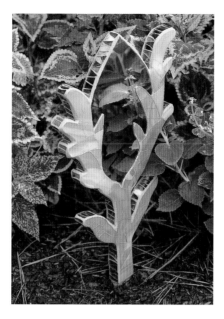

### MIRROR SIDE

1. Place the stake blossom-side down on a towel or cushion to protect it.

2. On a piece of tracing paper, trace around the mirror shape on the pattern. Cut out this shape and trace around it with permanent marking pen on the sheet of silver mirror. Cut the shape out with a ring saw and glue it in place on the garden stake. If you don't have access to a ring saw, you may be able to find a commercial glass dealer or stained-glass shop that can do the job for you. If not, you'll have to cut and glue the mirror in large sections. Use a glass cutter and running pliers to cut

several large pieces, shape them with glass mosaic cutters, then glue the pieces in place.

3. With the mirror section in place, fill in the rest of this side with blue-green-yellow mix stained glass. Leave the bottom 6" uncovered, just as on other side. Make sure no pieces extend over an edge. Let the adhesive dry overnight.

### GROUTING

1. Use cleaning tools to carefully remove any excess dried adhesive from the surface of the glass and mirror on both sides and the edges. (See Grouting on pages 31–32.)

2. Mix the grout, colorant, and fortifier in one container and fill another with water for cleaning.

3. Grout the blossom side and edges, pressing the material into all the spaces and using your gloved fingers to create smooth grout lines along the edges.

4. Wipe away any excess grout with a damp sponge and let the glass and mirror haze over. Polish the surface with a soft cloth.

5. Cover the grout container tightly with plastic and keep it in a cool place while you let the grouted side dry for 45 minutes to an hour—enough to allow turning the stake to work on the other side.

6. Carefully turn the stake over and grout, clean, and polish the mirror side.

### FINISHING

Wrap the stake in plastic or kraft paper and let the grout cure for three days.

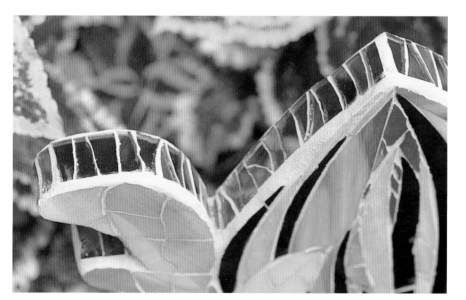

Looking Glass Garden Stake Patterns

Enlarge 200% and again 144%

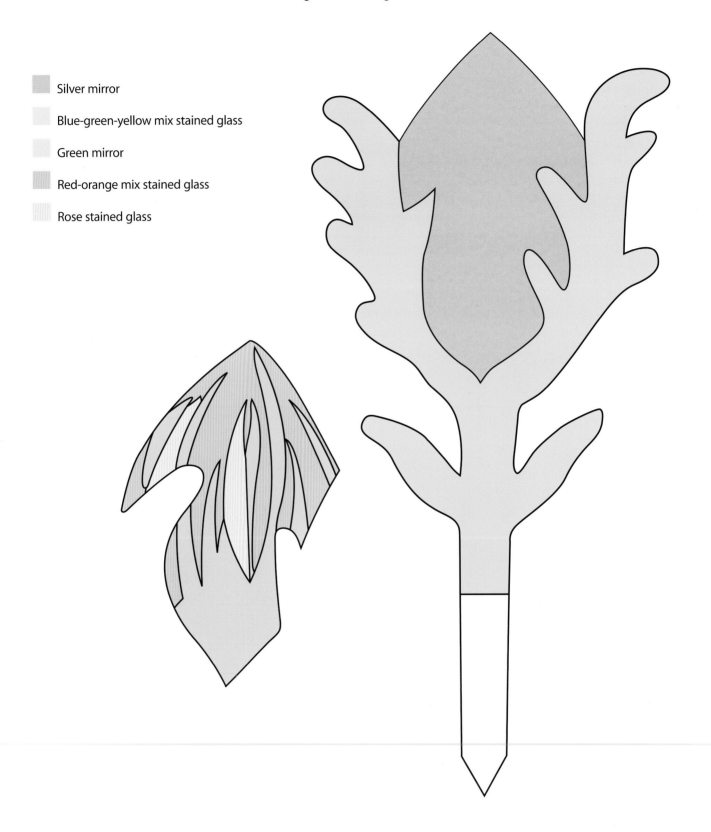

Silver mirror

Blue-green-yellow mix stained glass

Green mirror

Red-orange mix stained glass

Rose stained glass

# Pebble Mosaic Flowerpot

*Note: This Flowerpot coordinates with the Plant Surround described on pages 148-149.*

## MATERIALS

Ceramic flowerpot, approximately 8"-tall

3 lbs. mixed dark pebbles (black–brown–gray)

2 lbs. light turquoise pebbles

Silicone glue

Polyurethane spray

2 lbs. sanded grout, gray

Acrylic grout fortifier

Rubber gloves

Scissors

Masking tape

Ruler

Pencil

Permanent marking pen

Old towel or cushion

Plastic sheeting or kraft paper

## PREPARATION

1. Make two photocopies of the pattern on page 131, enlarging it as indicated. Cut out the spiral shape following the outlines.

2. Hold one of the cutout spirals up to the flowerpot and align the bottom of the pattern with the bottom of the flowerpot. Flatten the paper as much as possible and tape the pattern in place.

3. Measure exactly 2½" to the right of the point indicated by an X on the taped pattern and make a mark on the flowerpot. Position the left-hand edge of the second spiral on this mark, again aligning the bottom of the pattern with the flowerpot's bottom, and tape the pattern down. There should be an even distance between the two patterns on each side.

4. Trace around both patterns as best you can with a permanent marking pen. Remove the tape and paper and fill in any blank areas in the traced outlines where tape or uneven paper made tracing difficult.

## ATTACHING TESSERAE

1. Spread out all the dark pebbles and sort them by size and appearance, putting the nicest, flattest, and most uniform large, medium, and small pebbles on separate plates. Do the same with the turquoise pebbles.

2. Put the flowerpot on its side on top of a towel or cushion, to hold the flowerpot steady, with one of the spiral patterns facing up. Spread glue with a craft stick on about a third of the spiral, starting at its inner, or closed, end. Make sure you're working on the spiral pattern and not the background.

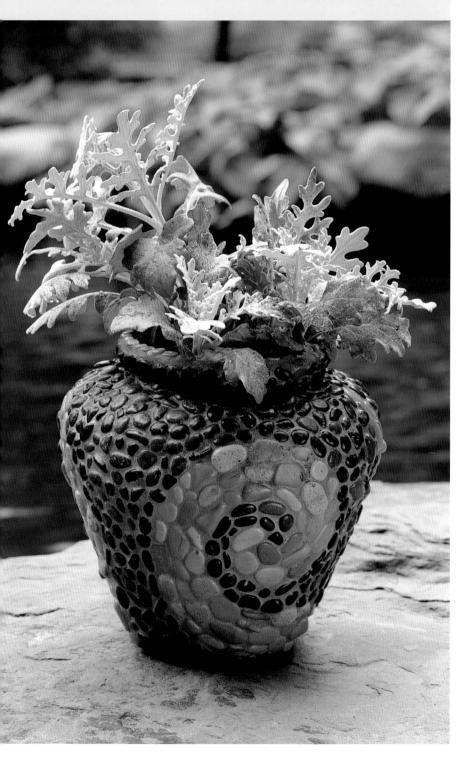

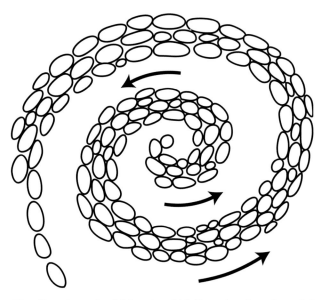

Figure 1 The direction of pebbles should follow the direction of the spiral.

3. Fill in the glued area using the nicest large and medium turquoise pebbles, positioning the pebbles in the direction of the spiral's flow. In other words, orient the pebbles with their longest sides running in the direction of the spiral, rather than across it. (See Figure 1.)

4. Finish tiling the spiral pattern, spreading glue, and positioning pebbles one section at a time.

5. Fill in the background behind the spiral with dark pebbles. Place the dark pebbles enclosed within the turquoise spiral in the direction of the spiral. The remaining dark pebbles can be placed in any direction; just be sure to fit them together nicely, leaving as little gap between the pebbles as possible. When you have filled in as much area as you can without turning the flowerpot, let the glue dry completely.

6. Turn the pot so the second spiral pattern is facing you. Fill in this spiral and its background just as you did the first. Let the glue dry completely.

7. Fill in any remaining portions of the flowerpot's sides. Let the glue dry.

8. Set the pot upright and glue dark pebbles around the flowerpot's upper body, up to the neck. You will work on the neck itself later.

9. Sort the small turquoise pebbles and choose the tiniest, most perfectly oval—about ⅔"-long—specimens. You'll need enough of these pebbles to place around the top of the lip. Spread glue on the lip, then carefully position the little pebbles end to end, keeping them in perfect alignment in a centered row all around the lip's surface. Let the glue dry.

10. For the inside of the lip, again sort through the small turquoise pebbles and pick out the tiniest. These do not have to be perfectly shaped. Spread the glue carefully around the inside lip and fill in the area with three or four rows of little pebbles. Let the glue dry.

11. Turn the flowerpot back on its side on a towel or cushion so you can work on the neck. Fill the band around the neck with small dark pebbles, taking care as you work not to slop glue on the pebbles already in place on either side. Make sure none of the pebbles extends up over the edge of the lip. Let the flowerpot dry overnight.

## GROUTING

1. Use cleaning tools to remove any excess adhesive from the surface of the pebbles—take care not to scratch the pebbles. Either outdoors or in a well-ventilated area, lightly spray the pebbles with polyurethane. Use just enough to coat them so the grout won't permanently adhere to the pebbles, but not enough to make them look too glossy. Let polyurethane dry completely.

2. Mix the grout and fortifier to the desired consistency. Grout the flowerpot in sections, starting with the lip and neck. With your gloved fingers, make sure to push the grout firmly into all the spaces around the pebbles. Take care to grout the inside of the lip as well as the top, and work to create smooth edges around the lip.

3. While you let the grout on the lip and neck partially set, start grouting the main body. Grout about a third of the body, again carefully filling all the spaces around all the pebbles. Then go back to the lip and neck and, with a damp sponge, wipe away any excess grout from that area.

4. Grout another third of the flowerpot's body; then, while that section partially sets, wipe away any excess grout from the preceding section with a damp sponge, and so on, until you've grouted and sponged the entire flowerpot. If at some point in the process a pebble falls off, dry that area thoroughly, add new adhesive, and replace the pebble. Let the glue dry while you work on the rest of the pot, then re-grout that pebble and sponge it clean.

**FINISHING**

1. When the grouted pebbles have hazed over, polish briskly with a soft cloth until clean.
2. Wrap the flowerpot in plastic or kraft paper and let the grout cure for three days.

Pebble Mosaic Flowerpot Pattern

Enlarge 200%

Turquoise pebbles

Dark pebbles (background)

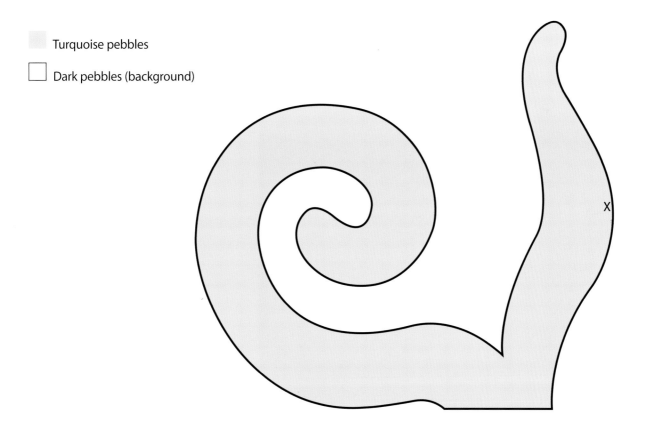

# Night and Day Flowerpot

## MATERIALS

Ceramic flowerpot, approximately
    10"-tall; top diameter 30",
    bottom diameter 16"
Vitreous glass tiles, ¾"-square:
    2 to 4 white; 4 to 6 deep red,
    sky blue; 6 to 8 light olive; 8
    to 10 black, light grass green;
    10 to 12 bright turquoise,
    metallic deep pink; 20 to 24
    medium yellow, metallic deep
    brown, metallic grass green;

½ lb. brick red, light baby blue,
    light blue-green, metallic cop-
    per; 1 lb. metallic baby blue,
    metallic turquoise
Transfer paper
Permanent marking pen
Silicone glue
4 lbs. sanded grout, blue
2 oz. liquid pure pigment, yellow
Acrylic grout fortifier
Wheel glass cutters
Plastic sheeting or kraft paper

## PREPARATION

1. Photocopy and enlarge the pat-
   tern on page 134. Transfer the
   pattern to the surface of the
   flowerpot. Go over the graphite
   lines with permanent marking
   pen.
2. Following the color key on page
   134, and referring to the photo-
   graph at left, use wheel glass
   cutters to nip the tiny circles,
   triangles, and rectangles that will
   make up the eyes, eyelids, and
   eyelashes.

## ATTACHING TESSERAE

1. Start with the center of the eyes
   and work outward. As you cut
   the tesserae, glue them in place.
2. Cut and tile the nose, then the
   mouth, and finally the chin. This
   completes the difficult detail.
3. Cut irregular shapes of medium
   yellow tiles to fill in the crescent
   moon. Then fill the star on the
   cheek with metallic baby blue,
   and the rest of that side of the
   face with brick red.
4. Metallic copper rays will flare
   out from the face's "day side."
   Each ray requires only a few
   tiles cut to fit—a triangle at the
   tip, then a series of increasingly
   wider straight-sided trapezoids.
   If you are having difficulty see-
   ing the shape that needs to be
   cut, simply hold the tile up to
   the spot you're working on and
   mark the tile where the cuts
   need to be made. This step may
   be a little time-consuming, but
   it will make getting accurate
   cuts much easier.
5. Fill in the areas between and
   behind the copper rays with
   metallic grass green. Then cut
   and fill the outer row of wide,
   triangular rays with metallic deep
   brown to complete the face.
6. Determine the center line of the
   face on the front of the pot;
   bring an imaginary line up from
   between the eyes, over the top
   of the flowerpot, to the back

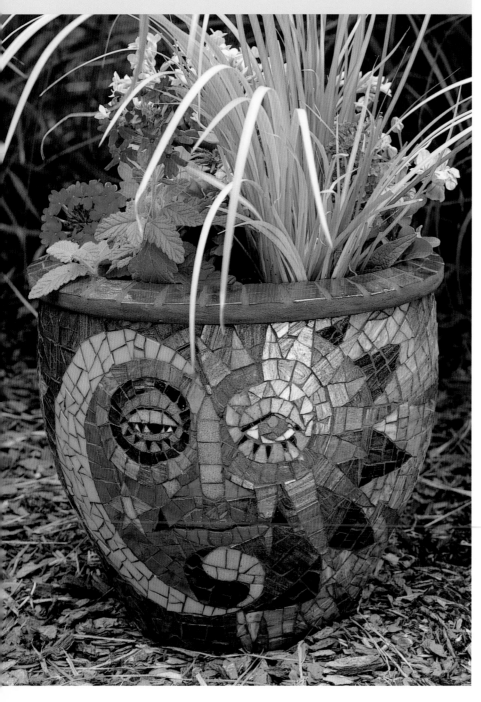

side. Draw a pencil line extending from that point—from top to bottom on the back side, marking the center.

7. Measure and draw a top-to-bottom vertical line 3½" away on each side of this center line. Within this 7"-wide section, you will blend night (metallic turquoise) and day (metallic baby blue). First, though, follow the color chart and pattern, and place all the clouds and stars that wrap around the pot.

8. Tile the backgrounds. Work first with metallic turquoise from the center of the chin on the night sky side to the line that marks the blending section. Return to the front of the flowerpot. Again starting at the chin, tile the day sky with metallic baby blue. Stop when you reach the line that starts the blending section.

*Note: Mosaic color blending is the juxtaposition of tesserae in two colors to simulate a third combined color. The gradual blending allows the two colors to move into each other without butting up against each other and creating contrast. The eye is tricked into seeing the third or blended color rather than either of the two.*

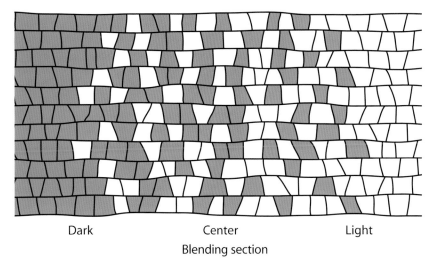

Dark　　　　　　Center　　　　　Light

Blending section

Figure 1  Color Blending: Gradually intersperse the two tile colors, spacing them evenly so they blend subtly.

9. Cut the tiles less irregularly and more rectangular to make the blending easier; you want to mix the two colors evenly to achieve a subtle blend. As you fill in from the sides of the blending section and work toward the center, intersperse the two colors evenly, using the schematic shown here as a guide. (See Figure 1.)

10. For this next step, you'll need enough brick red tiles to circle the flowerpot's top lip. Using glass mosaic cutters, cut all the tiles in half, but keep the two halves of each tile together on your work surface. Now glue each halved tile in place along the lip, with the center cut running parallel to the edge. Keep the spacing between the halves and between the separate tiles uniform to give the rim a professional look.

11. Allow the flowerpot to dry overnight. Clean any excess dried glue off the surface of the tiles.

## GROUTING

1. Mix the grout, pigment, and fortifier.

2. Grout the flowerpot's lip first, making sure to create smooth grout lines along the outside and inside edges.

3. Grout the rest of the flowerpot. Remember to lift the pot and grout the bottom edge at the base. Smooth this edge so that your flowerpot will sit correctly. If you leave any grout chunks under there, the flowerpot will wobble.

4. Wipe grout with a damp sponge. Allow the surface to haze over. Polish with a soft cloth.

## FINISHING

1. Clean any stubborn spots with a razor blade or dental tools.

2. Wrap the pot in plastic or kraft paper and allow to cure for three days.

# Night and Day Flowerpot Pattern

## Enlarge 200% and again 107%

Tape the two pieces together at the arrows.

# Cascading Planter

## MATERIALS

Cement backerboard, ½"-thick

6 tall coffee mugs; 2 periwinkle blue, 4 yellow (see *Note*)

25–30 decorative tiles in assorted sizes and shapes;
1" squares, 1" x 1½" rectangles, 1"- and 2"-diameter circles

28 glazed ceramic floor tiles, 4" x 4"; 7 each of: maroon, medium pink, medium yellow, salmon

Safety goggles

Protective gloves

Spiral saw or utility knife

Silicone glue

Polymer-fortified thin-set tile adhesive

3 lbs. sanded grout, white

1 oz. liquid pure pigment, yellow

Acrylic grout fortifier

Lint-free cloths

*Note: Only three mugs are used in this project, but it is suggested you have at least six on hand, because not all the mugs will break where you want them to when you cut them to fit against the planter board.*

## PREPARATION

1. Cut a 10" x 23" piece of the cement backerboard, using either a spiral saw with ceramic tile bit or a utility knife.

2. Photocopy and enlarge the pattern on page 137. Transfer the background squares and rectangles indicated on the pattern layout to the backerboard.

3. If you want a mug to house a plant, you need to leave enough of the bowl to hold sufficient soil. If you want the mugs to serve as small vases for cut flowers, you can leave less.

4. Consider whether you want a handle showing on any of the mugs for visual interest. Much of this will be determined by the cutting process itself. You may decide where you want to make the cut—and then there's how the break actually occurs.

5. Use permanent marker to draw a line on one mug marking the place for the cut. Wearing leather or strong rubber gloves and safety goggles, align the jaws of the tile nippers on the mark at the mug's mouth, with the jaws facing in the direction of the proposed cut. Squeeze the nippers.

*Note: The mug will break, but almost certainly not exactly along the mark or exactly in half. If you're lucky, you may get something close to what you hoped for, or at least a useable portion of mug will be left intact. If not, try again with another mug.*

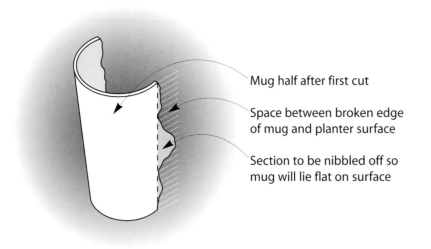

Mug half after first cut

Space between broken edge of mug and planter surface

Section to be nibbled off so mug will lie flat on surface

Figure 1

6. Once you've successfully made the first cut on a mug, hold the mug broken-side down against the cement board's flat surface. Some space here and there between the mug and board is acceptable—but no more than the thickness of the ceramic tile you'll be placing around the mug. Use tile nippers to nibble off small pieces of the mug until you get a reasonably close fit. (See Figure 1.)

7. Repeat steps 3 through 5 until you have three mugs (one blue, two yellow) cut and nibbled to an acceptable fit against the board.

8. Make a mark that's 2½" down from the board's top edge and 2" in from the left side. You'll be placing the upper left corner of one yellow mug here.

9. Squeeze out a bead of silicone glue along the cut edge of the mug. Align its upper left corner with the mark, and the mug's top parallel to the cement board's top edge. Run a craft stick along the outside joint (where the mug meets the board) to remove any glue globs that could keep the ceramic tile you'll be placing later from fitting close to the mug. If you see a gap in the joint, apply more glue.

10. Make a mark 10½" down from the top edge of the cement board and 1½" in from the right-hand side. Glue the blue mug there, with its upper right corner on the mark.

11. Glue the second yellow mug in place, with its upper left corner on a mark measured 16½" down from the top edge and 3½" from the left side.

12. Determine where among the various background colors on the cement board you want to put the decorative tiles. Play with their placement, moving the different shapes and sizes around until you feel they're evenly and pleasingly arranged.

## ATTACHING TESSERAE

1. When you're happy with the design, mix the thin-set mortar according to the manufacturer's instructions and mortar the pieces in position.

2. Use a craft stick to butter each tile, then press the tile firmly into place. Scrape off any globs of adhesive that squish out from under the tiles. You don't want dried mortar interfering with the placement of background-color pieces around the decorative tiles.

3. With gloved hands and using a hammer, break up a couple of the yellow tiles. Use tile nippers to cut these broken pieces into smaller shards and shape them to fit around the specialty tile shapes and mugs already in place.

4. Tile in the two yellow areas, buttering each tessera and pressing it to the surface. Use a craft stick to clean away any excess adhesive that comes up into the spaces between the tile shards or onto the surface of the tiles. Use a slightly damp cloth to wipe off the tiles as you work.

*Note: When tiling around a mug, make sure to place the pieces as close to the mug as possible. Also, tile the board's surface inside the mug as far as you can easily reach.*

5. Following the pattern and color key, repeat this process with the remaining three tile colors; breaking, nipping, and gluing down the tiles in their respective places. Remember to clean off any excess adhesive.

6. Place something beneath the board to elevate it and give you access to the edge's underside— perhaps a few bricks or spare tiles. Use the tile cutter to cut tiles into strips as close as possible to ½"-wide, to match the cement board's thickness.

7. As you cut each strip, nip it into short sections, butter and glue the pieces in place. Work your way around the board, changing tile colors as needed to match adjoining sections, until you've finished the entire edge. Make sure the tile pieces don't extend beyond the board's ½"-width. Let the adhesive dry overnight.

## GROUTING AND FINISHING

1. Use cleaning tools to scrape away any adhesive from the surface.
2. Mix the grout, pigment, and acrylic fortifier. Carefully grout the planter. Be sure to fill all the joints around and down inside the mugs, as well as the joints along the edges. Also grout from the backside on the edge tiles, leaving no chunks of grout to dry on the back.
3. Smooth all the grout lines using your gloved fingers. Wipe away all excess grout with a damp sponge. Let the tiles haze over, then polish with a soft cloth. Remove any stubborn dried grout with a razor blade or dental tools. Wrap the planter in plastic or kraft paper and let it cure for three days.

Cascading Planter Pattern

Background Tile Pattern

Enlarge 200% and again 143%

Mark indicates location of mug corner

Mark indicates location of mug corner

Mark indicates location of mug corner

Salmon

Pink

Yellow

Maroon

# Sugar-and-Cream Strawberry Planter

## MATERIALS

Ceramic planter, 11"-tall,
  12"-diameter top opening
10 cups, creamers, sugar bowls
  (any combination), green and
  yellow pattern (see *Note*)
Ceramic tiles, 4" x 4"; 9 green,
  9 yellow, 18 white
Silicone glue
Polymer-fortified thin-set tile
  adhesive
4 lbs. sanded grout, white
Acrylic grout fortifier
Permanent marking pen

Wheel glass cutters
Ceramic tile nippers
Old cushion or towel
Masking tape
Pencil
Hammer
Leather work gloves
Latex gloves
Ceramic tile cutter
Clay modeling tool
Clay cleanup tool
Plastic sheeting or kraft paper
Lazy Susan *(optional)*

*Note: A total of six cups, sugar bowls, and creamers are actually used on the planter in this project. However, you should probably have at least ten on hand—when you cut them not all will break as desired; some may split and break in ways that make them unusable. Throughout these instructions, cups, creamers, and sugar bowls are all referred to as cups for simplicity's sake.*

This strawberry planter with decorative sugar bowls, creamers, and cups amid mosaic flowers uses dishes from an old set. You could also work out a color scheme with non-matching but compatible pieces rescued from flea markets or thrift stores. If you can't find a planter exactly the same size and shape as this, just adapt the instructions to fit your project.

## PREPARATION

1. Think about where you want to place the cups on the planter. Visualize a design with some cups near the top, some near the bottom, and others in between; some spaced near and some away from other cups; some facing right and some left; some with handles intact and some not. If you can't picture them all, decide on the placement of the first two cups. After cutting and gluing those into position, you can determine where the next should be placed.

2. Photocopy and enlarge the patterns on page 139. In graphite, transfer these motifs where you want them on the planter. Add enough to tie in the color theme and break up sections that would otherwise be nothing but solid white. Place some of the blossoms and leaves so they "run off" onto the top and bottom edges and behind the cups, as shown in the photo at left. When you have placed the motifs as desired, go over the graphite lines with permanent marking pen.

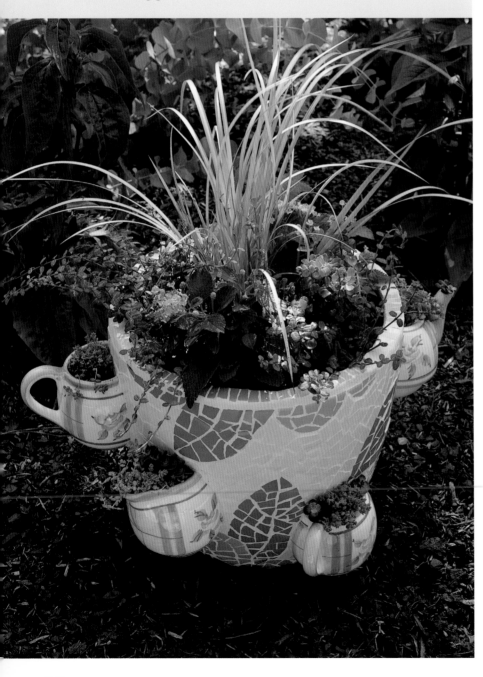

3. Using a hammer and wearing leather gloves, break up several each of the yellow, green, and white tiles, leaving some intact to be cut later into edge pieces or as needed. Use tile nippers to cut the broken tiles into irregular pieces small enough to lie flat on the planter's curving surface.

4. Hold the first cup up to the planter and determine how much to remove. You need at least enough to hold sufficient soil for a plant. With a permanent marking pen, draw a line where the cup is to be cut.

5. Place the wheels of the wheel glass cutters on the line at the mouth of the cup. Make sure the wheels are facing slightly outward toward the portion of the cup that will be removed.

*Note: If you are working with thick ceramic, you'll need to use tile nippers instead of wheel glass cutters. If you're lucky, the portion of the cup you wanted will still be intact.*

6. Hold the cup up to the wall of the planter again. Some space here and there between the cup and the wall of the planter is acceptable, but no more than the thickness of the ceramic tile you'll be placing around the cup. Nibble off any protruding areas, removing little bits at a time, until you get a proper fit. (See Figure 1 on page 136.)

## ATTACHING TESSERAE

1. Lay the planter on its side on an old cushion or towel, making sure it won't roll off. Have several foot-long pieces of masking tape ready within reach.

**Blossom and Leaf Design Patterns**

2. Squeeze a generous bead of silicone glue around the cut edge of the cup and press it in position on the planter's surface. Hold it in place with one hand while you add some additional glue to the joint, both inside and outside the cup.

3. Run a craft stick along the joint to remove any excess glue that could keep the ceramic tile you'll be placing later from fitting close to the cup.

4. While holding the cup in place, secure it with tape. Run lengths of masking tape from the planter wall, over the cup, and back down to the planter on the other side.

5. Let the glue dry thoroughly and make sure you have created a solid, clean joint at each cup before turning the planter and moving on to the next.

6. Repeat steps 2 through 5 until you have six cups attached.

*Note: After rotating the planter on its side a couple of times you won't be able to turn it again without hitting one of the glued cups. At this point, set the planter upright and use a lot of tape to hold each cup securely in position.*

7. Add extra tape where necessary, and use a craft stick to clean away oozing glue. If running glue leaves a gap in a joint, let the joint dry a bit and then fill the space with more glue. With all cups taped securely, let the glue dry overnight.

8. Mix the thin-set tile adhesive according to the manufacturer's instructions.

9. Using tile nippers to shape the yellow tile pieces as needed, fill in the flower blossom outlines on the planter's surface. Take care to nip pieces to match each blossom's edge contours, and fill the middles with irregular shards.

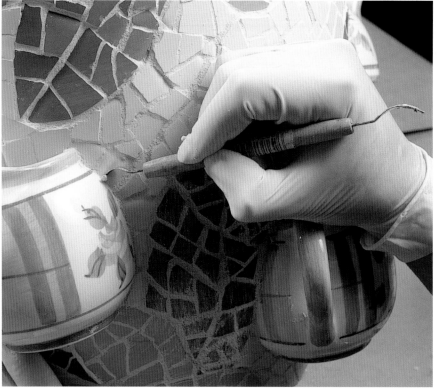

Photo 1

10. Use a craft stick to butter each piece with adhesive; then press it into position. Work from the bottom up so that the pieces you place on the planter's surface will support the ones you put above them.

11. With a craft stick, clean away any excess adhesive that comes up into the spaces between pieces, and wipe off the tiles with a damp cloth as you work. When tiling around a cup, place the tesserae flush up against the cup. Also, tile the planter's surface as far inside each cup's opening as you can easily reach.

12. Fill in the green leaf shapes. If you'd like the grout lines within a leaf to imitate leaf veins, draw the veins in pencil on the planter first, and then place tiles on either side of the lines, so the lines themselves become grout spaces.

13. After tiling all the flowers and leaves, cut, nip, and glue irregular pieces of white tile to the planter until you've completely filled in the background. Try to keep the spacing between tiles as uniform as possible.

14. When tiling the planter's top edge and inside rim, wherever a leaf or blossom runs off the top edge, use that same color to continue the design on that section of the rim. Measure the width of the planter's top edge and estimate how much of each color tile you'll need. Set the tile cutter to the edge width and cut the tiles into strips.

15. Tile the top edge, using tile nippers to cut the strips into narrow rectangular shapes as needed. Butter and press each piece into position as you go. Using irregular shards as you did on the planter's exterior, tile down at least 2" inside the rim. Wrap the planter in plastic and let the adhesive dry overnight.

## GROUTING

1. Put the planter on a lazy Susan if you have one; if you do not, set it up on some bricks or scrap wood for easier access. Use cleaning tools to remove any excess dried adhesive from the surface.

2. Mix the grout and acrylic fortifier. Start grouting the planter on the inside rim, then work grout into the edge pieces along the top. Use your gloved fingers to smooth the joints on both sides of the edge.

3. Work your way down and around the planter, pressing grout firmly into all the spaces. Take particular care to fill the joints along the inside and outside edges of the cups. Use a clay modeling tool to smooth those narrow joints.

4. Grout the planter's surface inside the cups as far as you can reach, and don't overlook the out-of-sight areas beneath the cups.

5. Grout the lower edge of the planter, carefully maneuvering it to work in the grout from underneath.

6. Wipe the grouted planter with a damp sponge. Allow time for the surface to haze over, then polish it with a soft cloth.

## FINISHING

1. Remove any stubborn excess dried grout with a razor blade or dental tools.

2. Carefully carve smooth any rough areas along the grout lines at the joints with a clay cleanup tool. (See Photo 1 on page .)

3. Wrap the planter in plastic or kraft paper and let it cure for three days.

# SECTION V

# Building Bases and Armatures

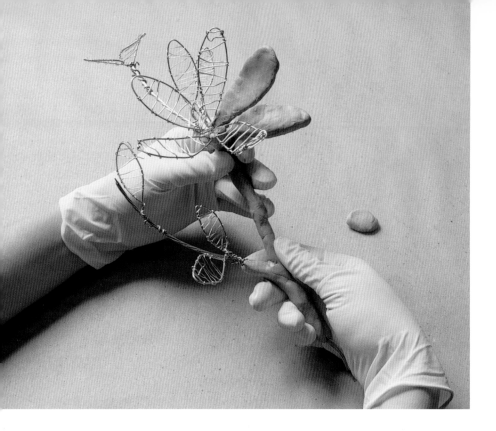

Photo 1

Photo 2

To level a rough edge on cut cement board, brush the edge with slurry, then smooth on a layer of fiber cement.

You can mosaic just about any solid surface, but you can also create from scratch your own bases or objects to mosaic. The projects in this section incorporate unique bases. The following instructions not only help you build the bases, but demonstrate techniques you can adapt when creating other works.

Sometimes building a base involves creating an armature, which is the internal structure that gives form to and supports sculptures and other formed bases. Armatures generally consist of two parts: a rigid skeleton that provides structural strength and holds the sculpture together, and a flexible "skin," such as wire screening, that provides contour and supports a covering material such as fiber cement or epoxy.

Depending on the project, materials for the skeleton can range from steel cable or wire to polystyrene or PVC pipe. Armatures can also be made from various found materials, too, such as leftover pieces of flexible metal tubing used for ventilating clothes dryers. Whatever material is used, an armature must be capable of supporting itself and everything to be added to it, including the surface coating, the mosaic tesserae, and the grout. The armature also needs to be either self-supporting or fastened to (or embedded in) something stable.

## MATERIALS FOR ARMATURES AND BASES

**Cement board** is sold in 4' x 8' sheets and various thicknesses in building-supply stores. Most kinds are made of cement mixed with cellulose or other fibers and are reinforced with synthetic mesh on either side. Look for the kind called tile backerboard, which is used primarily as a base for wall and floor tile installation, because it's waterproof. Most projects described in this section use the ½" thickness.

You can cut cement board into sections, much as you would a sheet of plywood. For straight cuts, a heavy-duty utility knife is all you will need. Just cut the board on one side, cutting through the mesh as well as the cement. Then snap the board along the cut line and cut the mesh on the other side with the utility knife to separate the pieces. For cutting complex shapes, the best tool is a power

spiral saw with a ceramic tile-cutting bit. You can also cut cement board with a conventional hand saw or jigsaw, but the material quickly dulls the blade. No matter what tool you use, wear a dust mask to keep from breathing in cement particles.

Cutting cement board leaves a rough edge. To level the edge for tiling, brush on a coating of cement slurry, then smooth a layer of fiber cement over the ragged surface. (See Photos 1 and 2.)

**Epoxy putty** is sold in the plumbing section of building-supply stores. It can be used both as an adhesive for joining sections of concrete board and as a sculptural material over wire armatures. The putty is packaged in a cylindrical plastic tube and consists of two parts: a dark gray center inside a

Photo 3

Photo 4

Photo 5 A base made from 6-gauge armature wire, 20-gauge aluminum wire, and woven wire mesh.

Photo 3 While wearing gloves, knead epoxy putty until the two layers are thoroughly combined.
Photo 4 Use epoxy putty to join sections of cement board.

white outer layer. Always wear latex gloves while working with this material. To use it, twist off the amount you want and knead the putty until the two layers are thoroughly combined and a uniform color. (See Photo 3.) The kneading activates the hardener—the putty will therefore become warm as the chemicals combine. Once the epoxy is mixed, you will have a working time of about 10 minutes; you must apply and smooth the putty and remove any excess before it hardens. After 10 minutes the material will become difficult to work, and within 20 minutes it will turn steel-hard. Some kinds of epoxy putty already come in rolls (they look like cinnamon rolls because of the layers) but they are not as easy to work as the tube putty.

To join sections of cement board with epoxy putty, knead the epoxy to activate it, then roll it to form a "snake" the length of the pieces you're joining. Press the snake along the edge of one piece of cement board, then push the other board's edge into the epoxy. Use a clay modeling tool to work the putty into the joint on both sides. Then roll another snake of putty and press it into the joint as needed to reinforce the bond. (See Photo 4.) Hold the pieces in place until the putty hardens.

Other types of epoxy are good for certain situations:

**Marine epoxy** comes in two parts and must be mixed. It is valuable for reinforcing areas on large wire armatures where two parts come together.

**Epoxy in a syringe** is good for small jobs when you need just a dab of epoxy.

**Wire and metal mesh** are flexible, strong, and can be adapted to a wide range of projects. Ordinary

steel cable, wire, metal lath, hardware cloth, window screening, and chicken wire can all be useful.

Art-supply stores sell wire and metal mesh made specifically for creating armatures. These materials are exceptionally easy to use and won't rust or create stains. Armature wire is sold in various gauges, both with and without plastic covering. Usually made of aluminum, wire and metal mesh are extremely pliable, so you can bend them into almost any shape. Form-holding woven wire mesh, also called modeler's mesh or sculptor's mesh, is available in various weaves, from a fine fabric-like material to more open square and diamond-shaped meshes. You can bend, stretch, and mold this particular mesh over structural skeletons to create complex contours and shapes. (See Photo 5.)

Wire and metal mesh also can be used to create armatures for extensions or additions to bases. Metal

mesh is ideal for making curving structures, such as the arch for the Garden Shrine project. (See page 000.) Needle-nose pliers, wire cutters, and scissors or metal-cutting shears are all you'll need for working with most wire and metal mesh.

**Wood** is a logical choice for bases that involve curving or complex contours because it's easy to cut. (See Photo 6.) Choose rot-resistant wood, either exterior-grade or marine-grade plywood, or a naturally resistant wood such as cedar. Use wood at least ¾" thick to minimize the possibility of warping.

To further reduce the chances of damage from rotting and warping, brush two coats of outdoor wood sealer onto the wood—including the edges—before tiling the surface. Use a nontoxic water-based sealer and allow drying time between coats. Some sealers leave a slick coating that keeps adhesive from sticking. If your sealer leaves such a finish, roughen it lightly with sandpaper.

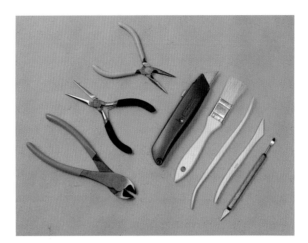

Photo 7  Armature and base-building tools. Clockwise from lower left: Wire cutters, needle-nose pliers, heavy-duty utility knife, slurry brush, clay modeling tools, clay cleanup tool.

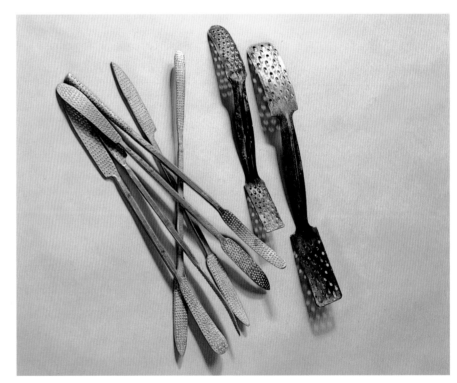

Photo 8  Steel rasps are helpful for smoothing and developing detail when working with fiber cement.

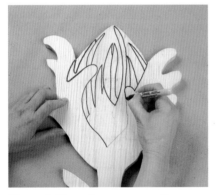

Photo 6  Use a jigsaw or scroll saw to cut curving contours in wood.

*Note: Watch the weather! For any mosaic that will be outdoors, be sure to use objects and materials that will withstand the weather, particularly freeze-thaw cycles. Ordinary terracotta, for example, is porous and will crack in a freeze-thaw climate; however, a high-fired ceramic pot won't crack. If your seasonal temperatures regularly dip below freezing, use only frost-hardy materials, or bring frost-susceptible projects indoors when the weather turns cold.*

144

# Basic Fiber Cement and Slurry

## MATERIALS

Bucket or other container for fiber cement

Container or cup for slurry

Paintbrush for slurry

Potter's rib or 3" x 4" rectangle cut from plastic milk jug

Small wire brush

Latex gloves

Dust mask

Safety goggles

**Fiber cement** is a mixture of Portland cement and acrylic fortifier with steel-wool fibers added for extra strength. When properly made, it has the feel and sculptural qualities of clay. Applied over an armature or base, it hardens into a solid and durable surface for mosaic.

Use your gloved fingers to press and smooth the material. The smoother the surface, the easier it will be to tile. Your hands are your most important tools when working with fiber cement—just be sure always to wear gloves to protect them from cement's caustic nature.

Use a potter's rib—or a home-made version, a 3" x 4" rectangle cut from a plastic milk jug—to evenly smooth wet fiber cement. A clay modeling tool is helpful for sculpting details. When the cement is nearly set up but still somewhat damp, use steel rasps to file away any lumps and bumps. You will also need a small wire brush to remove buildup in the rasp's teeth as you work, and to clean them when finished.

Mix just one batch of fiber cement at a time—if you mix too much at once, it will set before you can use it all. The following recipe makes enough for an initial layer for most projects.

## BASIC FIBER CEMENT

16 oz. acrylic grout fortifier

½ biscuit of medium fine (#0 or #1) steel wool

3¼ lbs. Portland cement, white or gray

1. Pull apart the steel wool to loosen and separate the fibers. Using scissors, snip the steel wool into the container in small bits. (See Photo 9.)

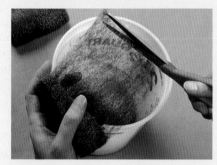

Photo 9

2. Add the acrylic grout fortifier. (See Photo 10.)

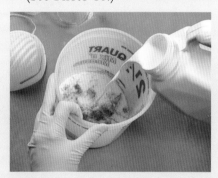

Photo 10

3. Add Portland cement, about 8 oz. at a time, mixing thoroughly after each addition. Be sure to wear gloves, dust mask, and goggles. (See Photo 11.)

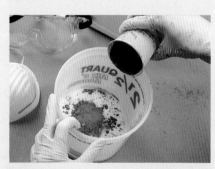

Photo 11

4. When completely mixed, the fiber cement should be smooth and have the consistency of wet clay. (See Photo 12.)

*Note: Like grout and other cement-based products, fiber cement must cure slowly, or go through the chemical process known as hydration, in order to attain maximum hardness. Cement or concrete left to dry in the open air loses moisture quickly and will reach only 30 to 40 percent of its potential hardness.*

5. Wrap freshly fiber-cemented work in plastic and keep it in a cool place for three to five days before tiling or otherwise working on it.

**Slurry** is a binder, a mixture of Portland cement and fortifier with a consistency similar to house paint. Before applying fiber cement, always brush on a coating of slurry to wet the surface and give the fiber cement something to bond to. If a slurried area dries before you can apply cement, brush it with slurry again, and then add the fiber cement. Likewise, always slurry over an existing layer of fiber cement before adding another layer.

## BASIC SLURRY

2 parts white or gray Portland cement

1 part acrylic grout fortifier

Mix the slurry thoroughly in a container, making between 1 and 2 cups at a time. Use an inexpensive paintbrush to apply the slurry.

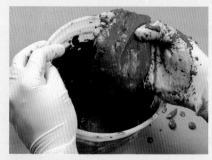

Photo 12

# Building a Simple Plant Surround Base

A simple conical armature made of window screen covered with fiber cement produces a versatile base you can mosaic any way you choose. Both the Spiraling Pebbles Plant Surround on pages 148–149 and the Ceramic Tile Plant Surround on page 150–152 start with this base.

## PREPARING THE ARMATURE

1. Photocopy and enlarge the pattern for the project of your choice and transfer the outer and inner circles to the poster board then proceed to step 5. Or, follow steps 2 through 4 to draw circles directly on the poster board.
2. To create a makeshift compass for drawing the large outer circle, tie one end of the string to the pencil. Measure 9½" out from the pencil, make a knot there, and stick a thumbtack through the knot at that point.
3. With the thumbtack in the middle of the poster board and the string extended, move the pencil 360°, drawing a circle 19" in diameter. (See Photo 1.)
4. Use a real compass to draw a circle 6¾" in diameter in the middle of the large circle; or, measure the string 3⅜" out from the pencil, reposition the thumbtack there and repeat the process you used for drawing the large circle.

5. Use a ruler and pencil to draw a vertical line through the middle of both circles. Then draw a horizontal line through the middle, forming crosshairs. (See Photo 2.)
6. Cut the large circle out of the poster board.
7. Place the circle on the wire mesh or screen. Trace around it with a permanent marking pen, and then cut around the mark to make a wire circle the same size. (See Photo 3.)
8. Cut along one line from the poster board circle's edge to the small inner circle. Then cut

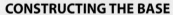

around the small circle and remove it. (See Photo 4.)
9. Place the poster board circle over the wire circle and trace around the inner hole with a permanent marking pen. Then, using a ruler, draw a line from the wire circle's outside edge to the marked inner circle.
10. Repeat step 8 with the wire circle; cut along the line to the inner circle, then cut and remove the small circle.
11. Lay the poster board circle in front of you with the cut to the center vertical, at the six o'clock position. Mark the inner circle ¾" below its intersection with the left horizontal line. (See Photo 5.)

## CONSTRUCTING THE BASE

1. Overlap the poster board circle's cut edge until it aligns with the mark, forming a cone. With the top and bottom edges even, staple in place. (See Photo 6.)

Photo 2

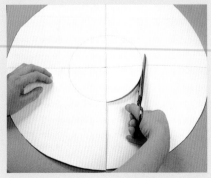

Photo 3

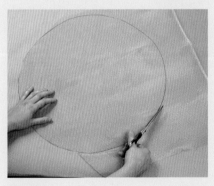

Photo 5

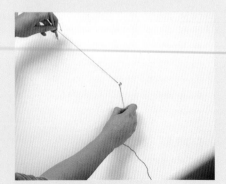

Photo 1

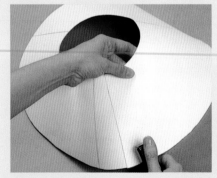

Photo 4

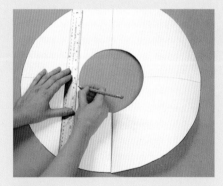

Photo 6

146

2. Place the wire mesh over the paper cone and overlap its cut edge to create the same size cone, fitting perfectly atop the poster board. Align the bottom and top edges, and staple the screen cone together. Do not staple it to the poster board cone, which is only a temporary form and not a part of the wire armature. (See Photo 7.)

3. Cover the paper cone with plastic sheeting or cling wrap. (See Photo 8.) Then place the screen cone atop the plastic. (See Photo 9.)

4. Paint a coating of cement slurry on the wire cone. (See Photo 10.)

5. Carefully press and smear a ⅜" layer of fiber cement on and into the screen. Reach inside the cone with one hand to support it as you work. (See Photo 11.)

6. Brush on more slurry, if necessary, to keep the area you're about to cement wet. Smooth the cement layer with the potter's rib or plastic rectangle. (See Photo 12.)

7. Make sure the top lip and lower edge also are smooth and of even thickness. No screen should be showing through in any spot. (See Photos 13 and 14.)

8. Cover the base with plastic and let it cure three to five days. (See Photo 15.)

Photo 7

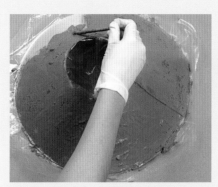
Photo 10

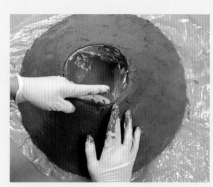
Photo 13

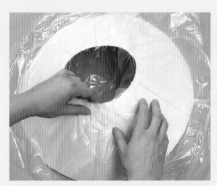
Photo 8

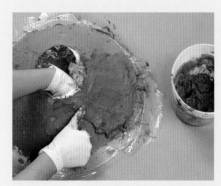
Photo 11

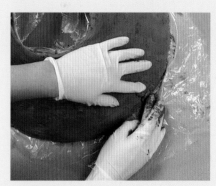
Photo 14

Photo 9

Photo 12

Photo 15

# Spiraling Pebbles Plant Surround

## MATERIALS

*For Base:*
Poster board, at least 20" x 20"
Wire window screen, 2' x 2'
Plastic sheeting or cling wrap
Cement slurry (See page 145.)
1½ batches of Basic Fiber
   Cement (See page 145.)
String, 15"
Pencil
Ruler
Thumbtack
Compass
Scissors
Permanent marking pen
Stapler

Potter's rib or 3" x 4" rectangle
   cut from plastic milk jug
Safety goggles
Rubber gloves
Plastic sheeting

*For Mosaic:*
3 lbs. mixed dark pebbles
   (black-brown-gray)
2 lbs. light turquoise pebbles
Silicone glue
Polyurethane spray
1½ lbs. sanded grout, dark gray
Acrylic grout fortifier
Craft sticks

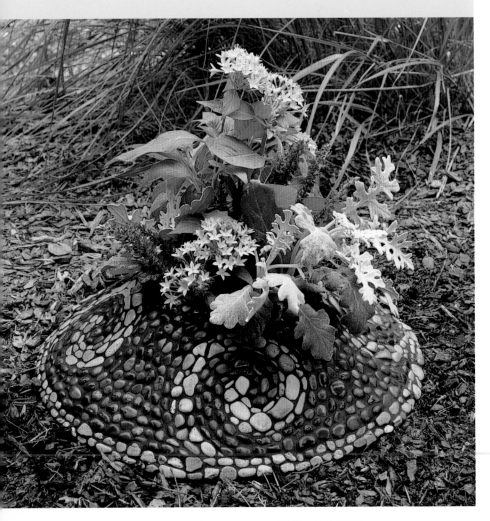

### SPIRALING PEBBLES MOSAIC

*Note: This project coordinates with the Pebble Mosaic Flowerpot on pages 129–131.*

### PREPARATION

1. Enlarge and photocopy one of the spirals from the pattern on page 149 and transfer it to the surface of the cement cone.

2. Position the spiral's open end ½" up from the cone's bottom edge. Transfer three more spirals onto the cone, also ½" up from the bottom edge and leaving 2⅜" of space between them, as indicated on the pattern.

3. Go over the graphite lines in permanent marking pen so they can't be smudged off.

### ATTACHING TESSERAE

1. Spread out all the dark pebbles and sort them by size and appearance, putting the nicest, flattest, and most uniform large, medium, and small pebbles on separate plates. Do the same with the turquoise pebbles.

2. Using a craft stick, spread glue on about a third of one spiral, starting at its innermost, or closed, end. Then begin positioning the turquoise pebbles. Remember that the direction in which you place each pebble influences the spiral's directional flow. Orient narrow or oblong pebbles lengthwise, in the direction of the spiral, rather than across. (See Photo 1.)

3. Finish tiling the spiral, working one third at a time. Then place a double row of turquoise pebbles along the lower border until you get to the next spiral. Glue and tile that spiral one third at a time, continue along the border to the next spiral, and so on until you've completed all the spirals and the entire border.

Photo 1

4. Use the dark pebbles to fill in the background space between and around the spirals. Don't worry about the direction in which you place the dark pebbles—their random positions will add contrast, emphasizing the spirals' flow. Do make sure, however, to keep the uppermost pebbles flush with the top edge.

5. Glue a band of the tiniest, roundest, turquoise pebbles around the top inside edge to give the surround a finished look. Let dry overnight.

## GROUTING

1. Outdoors or in a well-ventilated area, lightly spray the pebbles with polyurethane. Use just enough polyurethane to coat them, so the grout won't permanently adhere to the pebbles, but not enough to make them look glossy. Much of the beauty of pebbles is their natural, tactile quality. Let the polyurethane dry completely.

2. Mix the grout and fortifier to the desired consistency in one container and fill another with water for cleaning. Apply the grout with your gloved fingers, making sure to push grout up under the pebbles at the bottom edge and down over the pebbles on the top inner edge. Wipe the entire surface with a damp sponge, and let it dry for 10 to 15 minutes until it hazes over. Polish the pebbles with a soft cloth.

## FINISHING

Wrap the surround in plastic or kraft paper. Let cure for three days.

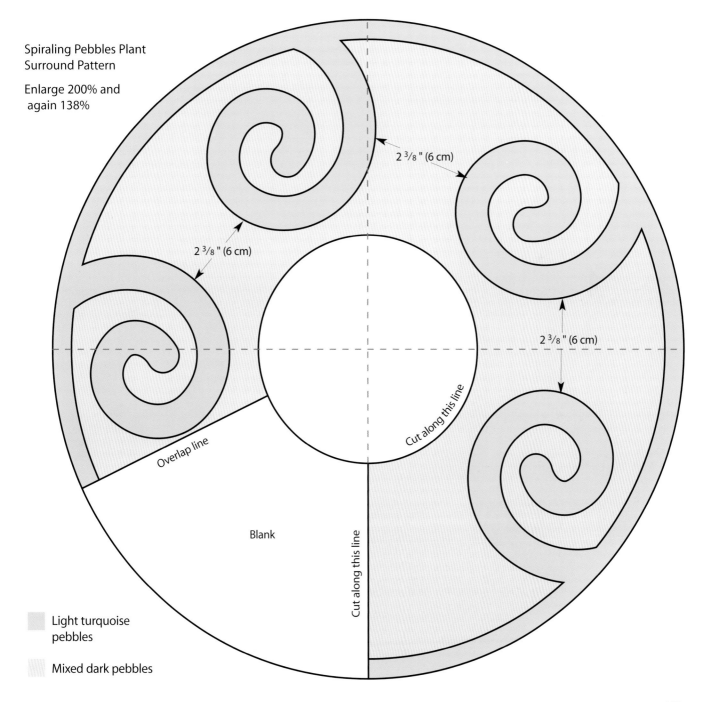

Spiraling Pebbles Plant
Surround Pattern

Enlarge 200% and
again 138%

2 3/8 " (6 cm)

2 3/8 " (6 cm)

2 3/8 " (6 cm)

Overlap line

Cut along this line

Cut along this line

Blank

Light turquoise
pebbles

Mixed dark pebbles

# Ceramic Tile Plant Surround

## MATERIALS

*For Base:*
Poster board, at least 20" x 20"
Wire window screen, 2' x 2'
Plastic sheeting or cling wrap
Cement slurry (See page 145.)
1½ batches of Basic Fiber
    Cement (See page 145.)
String, 15"
Pencil
Ruler
Thumbtack
Compass
Scissors
Permanent marking pen
Stapler
Potter's rib or 3" x 4" rectangle
    cut from plastic milk jug

Safety goggles
Rubber gloves
Plastic sheeting

*For Mosaic:*
Glazed ceramic tiles, 4" x 4";
    7 dark green, 5 decorative
    green, 15–16 light green
Silicone glue
2½ lbs. sanded grout, blue
1 oz. liquid pure pigment, yellow
Acrylic grout fortifier
Ceramic tile cutter
Ceramic tile nippers
Hammer
Leather work gloves
Craft sticks
Plastic sheeting or kraft paper

## PREPARATION

1. Make the plant surround base following the instructions on pages 146–147.
2. Using a tile cutter, cut one decorative tile (Tile A on the pattern) in half diagonally. You will use one half, and a corner portion from the other half, along the base's bottom edge.
3. For the tile placed along the inner circle (Tile B) use tile nippers to nip a curve into one corner that will align with the inner circle's curve.
4. One at a time, break all the decorative tiles (including the nipped Tile B and the two Tile A halves) into pieces. To do this, hold the tile face-down in a gloved hand and strike the tile's back with a hammer. (See Photo 1.)
5. Use tile nippers to nip the large pieces into smaller ones. As you break up each tile, reassemble the pieces on your work surface to keep from mixing them up with other tiles.

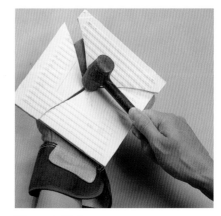

Photo 1 Make sure to wear protective glasses and a strong leather glove when breaking ceramic tile in this manner.

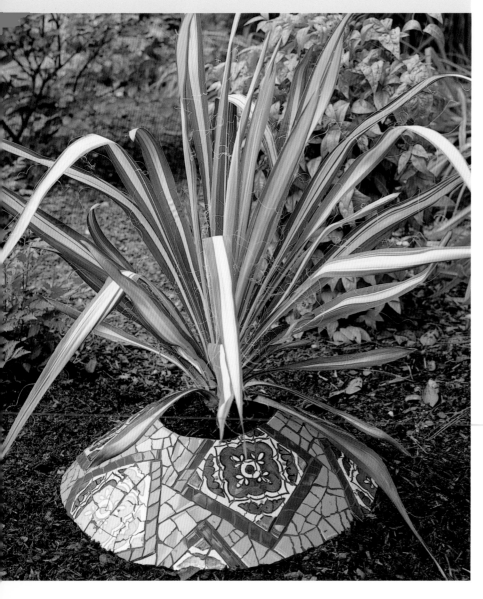

## ATTACHING TESSERAE

1. Use the pattern as a guide for the tile positions. With a craft stick, spread a layer of glue on the base the size of the decorative tile you will be laying. Carefully press the pieces into position, leaving ¹⁄₁₆" to ⅛" of space between them, recreating each tile or portion of tile as shown on the pattern. (See Photo 2.)

2. You may have to nip some pieces into even smaller pieces to keep the curving surface smooth, with no jagged edges sticking up. Be sure to keep the tiles along the inside and outside edges flush to the edge; do not let them extend over.

3. When all the decorative tiles are positioned, create their borders. With a tile cutter, slice the dark green tiles into ½" strips. You will probably be able to get only about five strips per tile before the piece gets too small to hold and cut.

4. Using tile nippers, nip each strip into ½" pieces, cutting on the diagonal. As you cut them, lay out the pieces in order, fitting them almost back together. This makes gluing the pieces on the base much easier and faster. Glue the strips of dark green around the outside edges of each of the decorative tiles.

5. Now break and nip the light green tiles into pieces. Fill in the spaces remaining between the bordered decorative tiles with light green. Place edge pieces flush to the top edge and, when necessary, cut large pieces smaller to make them fit to the curved surface and keep corners from jutting out. Let the surround dry overnight.

## GROUTING

1. Mix the yellow and green colorants into the dry grout and stir in 3 to 4 oz. of fortifier. If necessary, add more colorant until the color matches the dark border tiles. In this case, mix in enough additional fortifier to give the grout the desired consistency.

2. Grout the cone, taking particular care to create a smooth and even-looking grout line at the lower and upper edges. Sponge off any excess grout and let the surface dry for 15 minutes. Polish the surface with a soft, lint-free cloth.

## FINISHING

1. Use cleaning tools to remove any remaining excess grout.

2. Wrap the surround in plastic or kraft paper and allow to cure for three days.

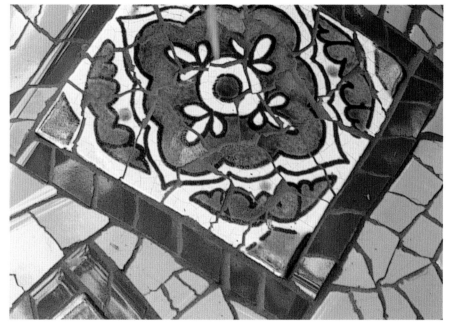

Photo 2  A wonderful effect is achieved when a decorative tile is fragmented and reassembled in a mosaic.

Ceramic Tile Plant Surround Pattern

Enlarge 200% and again 138%

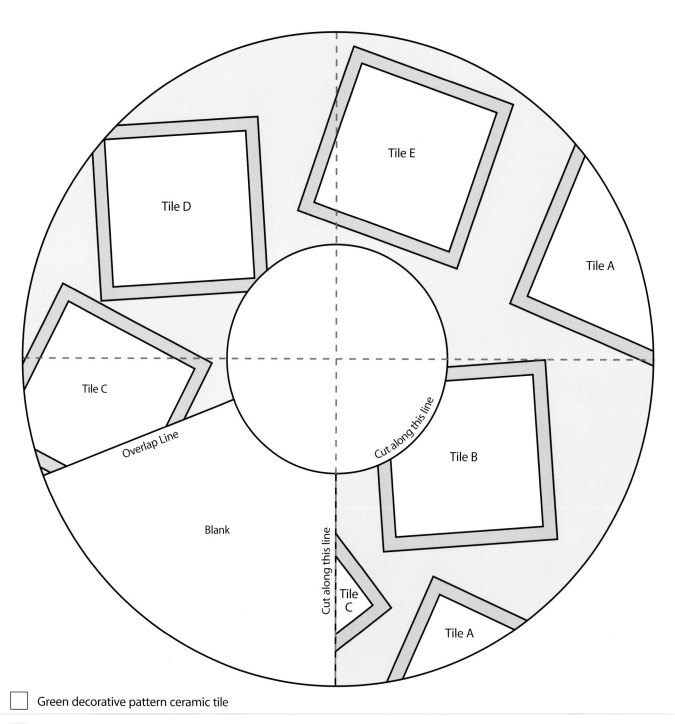

Tile E

Tile D

Tile A

Tile C

Overlap Line

Cut along this line

Tile B

Blank

Cut along this line

Tile C

Tile A

Green decorative pattern ceramic tile

Dark green ceramic tile

Light green ceramic tile

# Creating a Mold for Making Multiples

For some projects, you will want to make more than just one of a small base or sculpture. This technique allows you to use a single object to create a plaster mold for making multiples of the original.

## PREPARING THE BASE

1. Using clay and clay modeling tools, sculpt the base object, such as the Bold Beautiful Beetle on page 154. Keep the design simple, with gradual contours and a smooth surface, to make tiling easier.

2. Check the sides and underside of the sculpture. The sides should slope outward to the bottom. There must be no undercuts or indentations along the bottom edge or cast objects will become locked in the resulting mold. (See Figure 1.)

## MAKING THE CASTING

1. Spray the inside of the plastic food container with cooking oil. Place the sculpture bottom-side down in the container. The container should be at least 1" larger on all four sides than the sculpture, and about 2" deeper than the object's height. Press gently along the sculpture's bottom edge to seal off any gaps that might allow plaster to creep beneath the sculpture.

2. Mix the plaster of Paris according to the manufacturer's directions and pour it into a plastic container, filling it to a depth of 1" above the sculpture. (See Photo 1.)

3. Tap and shake the container lightly to get rid of trapped air bubbles. Let the plaster set overnight.

4. Cut away and discard the plastic container. Then remove the sculpture from the mold. If it's stuck, pry it out gently with a pencil or other tool, taking care not to scar the plaster. Wipe out any remaining clay sticking to the walls of the mold.

5. To cast a replica using the mold, spray the inside surface thoroughly with cooking oil. The oil will act as a release agent, allowing you to remove the cast beetle once it has hardened. Mix enough fiber cement to fill the mold and press the material into it, pushing out any trapped air. Wrap the cement-filled mold in plastic and leave it overnight. Then remove the cast object from the mold. (See Photo 2.)

6. Wrap the cast object in plastic or kraft paper and let the cement cure for three to five days.

**DO:**

Clay original

Slope sides outward

**DON'T:**

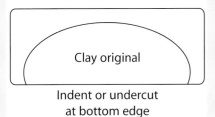

Clay original

Indent or undercut
at bottom edge

Figure 1

Photo 1

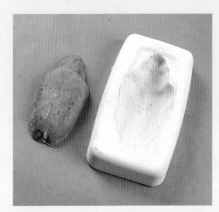

Photo 2

# Bold Beautiful Beetle

## MATERIALS

*For Base:*

3 to 5 lbs. natural clay, such as potter's clay

Plastic food storage container, 6" x 9"

6 lbs. plaster of Paris

Spray cooking oil

Clay modeling tool

Fiber cement

Plastic sheeting or kraft paper

*For Mosaic:*

Materials for ½ batch of Basic Fiber Cement (See page 145.)

Stained glass; 3" x 6" black opalescent, light blue opalescent; 5" x 6" ruby opalescent

Mirror, 3" x 3", blue

Silicone glue

2 lbs. sanded grout, black

Acrylic grout fortifier

20-gauge flexible wire, 10"

Wire coat hangers

Epoxy glue in syringe

Enamel paint or fingernail polish; black, gold, light blue, red

Round toothpick

Glass mosaic cutters

Wire cutters

Needle-nose pliers

Polystyrene foam cup

Small acrylic paintbrush

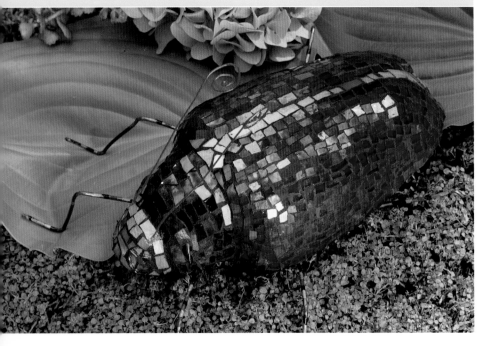

## PREPARATION

1. Sculpt a simple clay beetle 6" long, about 3¾" wide, and 1¼"-tall at its highest point (along the middle of the back), using the pattern on page 155 and the photos and description on page 153 as guides. Use a clay modeling tool to help shape the contours, but do not try for a lot of detail; a basic insect form will do. Slope the beetle outward along its bottom edge to create draft and avoid undercut. (See Figure 1.)

2. Follow steps 1 through 6 in Making the Casting on page 153.

3. Mix half a batch of fiber cement.

4. Spray cooking oil into the plaster mold, coating the inside thoroughly. The oil will act as a release agent, allowing you to remove the cast beetle.

5. Press fiber cement firmly into the mold, pushing out trapped air that can keep the cement from taking on the mold's shape.

Wrap the filled mold in plastic and leave it to set overnight.

6. Remove the cement beetle from the mold. If you have trouble getting it out, stick a pencil or dental tool part way into the center of the beetle and pry the insect loose. If this leaves the bottom of the beetle somewhat marred, just press and smooth any loose pieces back down.

7. With the beetle separated from the mold, use a toothpick to carefully make two holes ⅛" for the antennae, one behind each eye, as shown in the Beetle Pattern. If the cement has hardened too much for the toothpick to penetrate, use wire no thicker than a toothpick. Turn the beetle over and make holes—slightly wider and about 5/16" deep—for the six legs.

8. Wrap the beetle in plastic and let the cement cure for two to four days.

## ATTACHING TESSERAE

1. Cut the three colors of opalescent stained glass into strips approximately ¼" wide. (See pages 21–22.) Snip the strips into squarish tesserae, keeping the colors separate.

2. Following the color key in the Beetle pattern, glue the tesserae in place, using tweezers if necessary to hold the tiny tiles. Position the tiles lengthwise in rows along the wing sections and center of the back. Place the neck and head tiles widthwise. Be careful not to tile over the two antenna holes.

3. Cut two ½" squares from the blue mirror and nip these squares into circles. (See pages 22–23.) Nip the circles in half and then in half again. Glue the quarter-circle eye pieces in place. Let the beetle dry overnight.

Beetle Pattern

Leg Wire Bending Pattern

Antennae locations

Leg hole locations
(underside)

End that attaches to body

Light blue opalescent

Ruby opalescent

Black opalescent

Blue mirror

## GROUTING

1. Clean away any excess dried glue from the surface of the stained glass and mirror.
2. Mix the grout with the fortifier. Then grout the beetle, taking care to work the material with your gloved fingers into all the spaces between the tiles. Make sure you turn the beetle over and grout the bottom edge from underneath.
3. Wipe the surface with a damp sponge and let it haze over. Polish the surface with a soft cloth.
4. Use a toothpick to clean out any excess grout that may have filled the two antenna holes.

## FINISHING

1. Wrap the beetle in plastic or kraft paper and let cure for three days.
2. Cut the 20-gauge wire in half, creating two 5" antenna wires.
3. Using needle-nose pliers, grasp a wire ⅛" from one end and curl it into a tight loop. Then move the pliers up the wire ⅛" and curl the end inward again. Continue moving up and curling the wire by making many small bends every ⅛", until the first 1½" is spiraled. Repeat this on the second antenna wire.
4. Stick the uncurled ends of both antenna wires into the upturned end of a polystyrene foam cup, to hold them in place, and paint the wires with red enamel or nail polish. Allow to dry.

5. With wire cutters, snip six 5½" lengths of wire from coat hangers. Bend each of the lengths into the shape shown in the Leg Wire Bending Pattern above. Rest the beetle on its back on a towel or cloth, squeeze epoxy glue into each of the leg holes, and place a wire leg in each one. Leave the beetle with its feet in the air until the epoxy has hardened completely.
6. Paint bands of red, gold, blue, and black enamel down each leg. Allow paint to dry.
7. Turn the beetle upright and use epoxy glue to attach the two antennae. Wipe away any epoxy that overflows onto the glass. Let the epoxy set before handling.

# Forming a Contoured Armature and Modeled Face

To create complex three-dimensional sculpted forms to cover with mosaic, build a structural skeleton first, use wire mesh to define contours, then add surface material such as fiber cement.

## SHAPING THE WIRE ARMATURE

1. Photocopy and enlarge the Profile Wire Pattern on page 157.
2. Cut a 24" length of 6-gauge armature wire. Using needle-nose pliers, follow the profile pattern and bend the wire to create a facial profile. Leave at least 4" of extra wire at each end, measuring from the top of the face and from the chin. (See Photo 1.)
3. Bend the remaining 36" of 6-gauge armature wire into an 11"-long face-shaped oval measuring 8" across at its widest point, which is 5" down from the top of the head.
4. Wrap one end of the wire around the other at the base, or chin, to complete the oval. Trim off excess with wire cutters. Attach the profile wire to the oval, wrapping and trimming the wire at each end. (See Photo 2.)
5. Now wrap lengths of 20-gauge wire across the face and profile wire, creating a support structure. Start by wrapping one end of a piece of 20-gauge wire around the oval wire near the top of the head, about 2" to the

left of where the profile wire is attached.
6. Stretch the 20-gauge wire straight across to the profile wire, wrap it around a couple of times, pull it across to the right side, and wrap it around the oval wire. Now pull it back across to the profile wire 1" or so lower, wrap it around a couple of times, stretch it across to the other side of the oval wire, and so on.
7. Continue working from one side to the other, starting new lengths of 20-gauge wire as needed, until the entire face is criss-crossed. (See Photo 3.)

## MODELING THE FEATURES

1. Fold the wire mesh in half, doubling its thickness. Place the mesh over the wire face. Tuck the top edge over and behind the forehead. Press and form the mesh in place over the nose and the rest of the face. Fold the edges back over the oval wire, up inside the armature. (See Photo 4.)

2. Mix one batch of slurry and one batch of fiber cement. (See page 145.) Turn the wire armature face-side down and brush slurry onto the entire back side. (See Photo 5.)
3. Press and smooth a layer of fiber cement onto the slurried surface of the back of the face. (See Photo 6.)
4. Turn the armature face-side up. Brush it with slurry and begin smoothing on the first facial layer of fiber cement. (See Photo 7.)

Photo 4

Photo 5

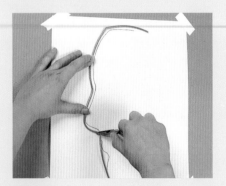
Photo 2

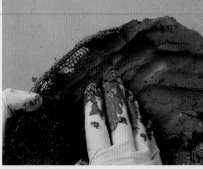
Photo 1

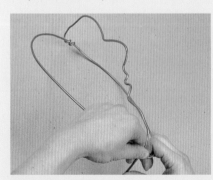
Photo 3

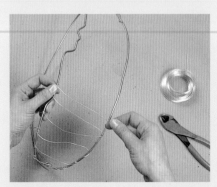
Photo 6

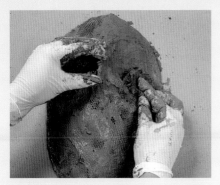

Photo 7

Photo 8

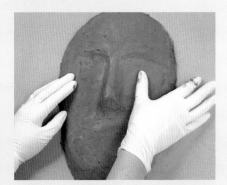

Photo 9

Photo 10

5. Create basic features by pressing and shaping with your gloved fingertips. (See Photo 8.)

Photo 11

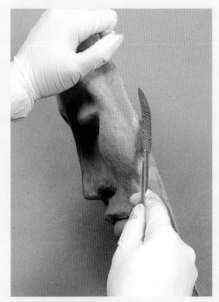

Photo 12

6. Look in the mirror at your own face for guidance and continue adding fiber cement and building up the beginnings of cheeks, lips, eyebrows, nose, and chin until you've used up the first batch of fiber cement. (See Photo 9.)

7. Wrap the face in plastic and let it set overnight.

8. Unwrap the face. Mix another batch of slurry and fiber cement.

9. Turn the face over, brush slurry on the surface, and fill the back-side to the level of the oval wire with more cement. Turn the face right-side up, brush slurry onto the surface, and add another layer of fiber cement, concentrating on building up facial details. (See Photo 10.)

10. Continue adding fiber cement and smoothing the surface nicely, creating a total thickness (both layers) of ½" to 1". Make sure no wire mesh or wires are showing. Use your gloved fingers and clay modeling tools to sculpt and refine the eyes, nose, and lips. (See Photo 11.)

11. Wrap the face in plastic and let the fiber cement cure for three to five days.

12. Unwrap the face and use a rasp to file away the edge created where the cement and work surface were in contact. (See Photo 12.)

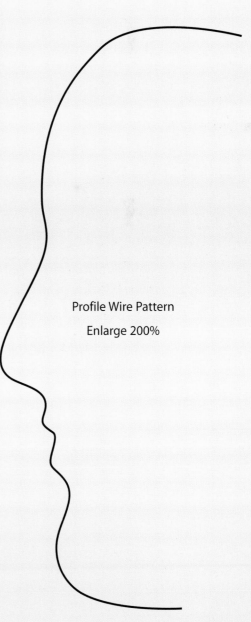

Profile Wire Pattern

Enlarge 200%

# Multi-Faceted Gazing Face

## MATERIALS

*For Base:*

6-gauge armature wire, 5'
20-gauge aluminum wire, 15'
Form-holding woven wire mesh,
    2½' x 2½'
Ingredients for 2 batches of
    Slurry and 2 batches of Basic
    Fiber Cement (See page 145.)
Needle-nose pliers
Wire cutters
Plastic sheeting

*For Mosaic:*

Enamel paint, metallic gold
Acrylic paint; cadmium red
    medium, cobalt teal, dark
    cerulean blue, iridescent gold,
light cerulean blue, purple,
    vivid lime green, yellow
Pearlescent powdered pigment,
    white
2 sheets double-thickness clear
    glass, 12" x 12"
Mirror, 5" x 5", silver
Composite gold leaf and adhesive
Silicone glue
Graphite paper
Pencil
Permanent marking pen
Sanded grout, 1½ lbs. blue
Liquid pure pigment, ¾ oz.
    yellow
Acrylic grout fortifier
Small pointed paintbrush
Small flat paintbrush
Glass mosaic cutters

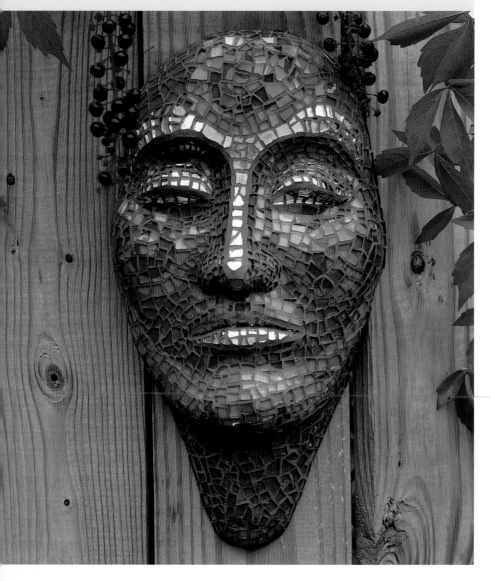

## PREPARATION

1. Photocopy and enlarge the pattern on page 159. Because of the face's contours, you won't be able to transfer the entire pattern easily. (See Transferring onto Three-Dimensional Objects on page 21.) Transfer as much as you can onto the flattest areas using graphite paper, then draw the rest of the pattern onto the face using pencil. Go over all the lines with permanent marking pen.

2. Carefully paint the lips, eyelids, eyebrows, and the bridge of the nose with metallic gold enamel, as indicated on the pattern. These areas will be tiled with homemade gold-leaf tesserae and the paint will hide any scratches in the gold leaf.

3. Paint the rest of the face with acrylic colors, following the key on the pattern. Start with any of the colors. Squeeze about a 1½"-diameter circle of paint onto a paper plate, add roughly ½ tsp. of pearlescent pigment powder, then mix in enough water to make the paint slightly thinner than its consistency directly from the tube. Use the pointed brush when working in small spaces and the flat brush when painting edges and filling in large areas. Refer to the photo at left for guidance when combining colors to produce the mixture called for on the pattern, or just trust your own color sense. Let all the paint dry completely.

## ATTACHING TESSERAE

1. See pages 21–24 for making gold-leaf glass and using a ruler, glass cutter, and running pliers to cut the gold-leaf glass into ¼" squares to tile the eyelids.

2. Spread glue on an eyelid and place the gold-leaf tesserae across the lid in horizontal rows. Repeat with the other eyelid.

3. With glass mosaic cutters, nip more gold-leaf glass into shards varying in size from small to smaller, some tiny and some larger as needed. Tile the eyebrows, the bridge of the nose, and the lips. Work carefully, maintaining consistent spacing between the pieces and using tweezers to place the tesserae.

4. Snip the silver mirror into small irregular pieces and glue them in place on the eyes.

5. Use a ruler, glass cutter, and running pliers to make a supply of ¼" clear-glass squares and glue them in rows under the eyebrows, along the sides of the nose, and above the lips. Nip and shape the pieces into even tinier squares to cover the nostrils.

6. Tile the rest of the face with irregular pieces of clear glass—cut and shaped to follow the direction of the face's design and contours—creating grout lines that emphasize that flow.

7. Spread glue over one small area at a time, then tile the area, pressing each piece firmly into the glue to eliminate air bubbles that would otherwise show through the clear glass. When you have completed tiling the face, let the glue dry overnight.

## GROUTING

1. Clean away any excess dried glue on the surface or in any grout spaces.

2. Mix the grout, pigment, and acrylic fortifier. With gloved hands, carefully spread and smooth the grout into all the spaces and crevices of the tiled face. Be sure to lift the face and apply grout from the underside to fill the gaps between the glass and the cement along the edge.

3. Wipe away excess grout with a damp sponge, and let the glass haze over. Polish the surface with a soft cloth.

## FINISHING

1. Use cleaning tools to remove any remaining grout residue.

2. Wrap the face in plastic or kraft paper and let cure for three days.

Multi-Faceted Gazing Face Pattern

Enlarge 200%

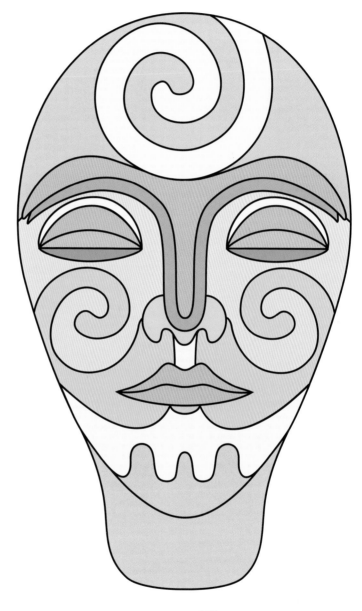

Light cerulean blue

Dark cerulean blue

Cadmium red medium

Vivid lime green

Purple

Cobalt teal

Metallic gold enamel

Iridescent gold and yellow mixture

Silver mirror

# Pillar Planter Under Glass

## MATERIALS

*For Base:*

Aluminum ventilation duct pipe, 6" diameter, 10" long

Form-holding woven wire mesh, 12" x 40"

Round-bodied flowerpot; approximately 6½" tall, 5" bottom diameter, 10" top diameter

Ingredients for Slurry and 2 batches of Basic Fiber Cement (See page 145.)

Acrylic paint; acra gold, brilliant blue, cerulean blue, chromium oxide green, cobalt teal, deep magenta, iridescent rich copper, medium cadmium red, vivid lime green

Pearlescent powdered pigment, white

*For Mosaic:*

2 sheets double-thickness clear glass, 12" x 16"

Glass cutter

Wheel glass cutters

Silicone glue

Craft sticks

6 lbs. sanded grout, black

4 oz. liquid pure pigment, phthalo blue

Acrylic grout fortifier

Scissors

Duct tape

Steel rasps

Artist's large, round paintbrush

Plastic sheeting or kraft paper

Masking tape

Lazy Susan *(optional)*

## BUILDING AND SHAPING THE PILLAR

1. Fold the wire mesh in half, creating a double thickness measuring 12" x 20". Wrap the mesh tightly around the duct pipe, leaving an extra 1" of mesh sticking out at each end. Fold the extra mesh in, over the ends of the pipe. Secure the edges of wire mesh on the interior of the pipe with small pieces of duct tape.

2. Make one batch of fiber cement and one batch of slurry following the directions on page 145. Brush on a layer of slurry, then smooth a first layer of fiber cement onto the pillar with your gloved fingers. Work on one section at a time, pressing the cement firmly into the mesh and onto the surface of the pipe. Keep the surface as smooth as possible and create an even ⅛" coating. Also work fiber cement into the wire mesh you folded in on both ends on the pipe's interior. Don't worry about the pipe's ridges—you will level out the surface with the second layer of cement.

3. When you have completely covered the pipe and used up your first batch of fiber cement, wrap the project in plastic and let it set overnight.

4. Mix a second batch of fiber cement and slurry. Work on building up the areas along the pipe's ridges, evening out the surface. Also, add fiber cement around the lower edge so that it flares out gently (about 1") giving the pillar a wider, more stable base. (See Figure 1.)

5. Turn the flowerpot upside down and cover its base and the next 3" to 4" with plastic cling wrap. Secure the plastic in several places with bits of masking tape.

6. Turn the flowerpot right side up and put it on top of the pillar. Step back and check to make sure the pot is resting level on the pillar; reposition if it is not.

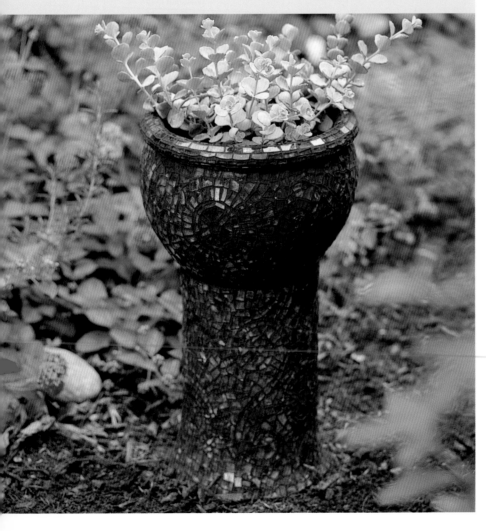

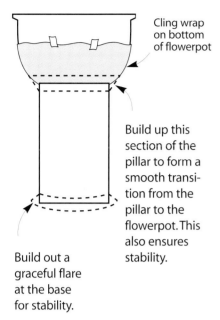

Cling wrap on bottom of flowerpot

Build up this section of the pillar to form a smooth transition from the pillar to the flowerpot. This also ensures stability.

Build out a graceful flare at the base for stability.

Figure 1  Building up the pillar with fiber cement.

7. Slurry then press on more fiber cement, building the pillar's top edge up slightly to form a gentle transition from the pillar to the flowerpot. This will also create a slightly wider area on which the flowerpot can rest. (See Figure 1.)

8. Remove the masking tape from the flowerpot and carefully lift the flowerpot straight up off the pillar. The cling wrap should stay behind on the pillar; some will be embedded in the cement. Carefully extract the wrap from the fresh fiber cement without destroying the built-up edge. Gently pull on a section that you can tell isn't embedded and then gradually ease your way around until you've removed all of the cling wrap. If a portion of the new edge breaks off in the process, apply a dab of slurry and add a few pinches of fiber cement to rebuild the area. Smooth the edge inside and out after rebuilding any sections.

9. Wrap the pillar in plastic and let it cure for three days. When you unwrap the pillar, use steel rasps to file away any protruding lumps or bumps, smoothing the surface of the pillar.

## PAINTING THE FLOWERPOT

1. While the pillar is curing, paint the flowerpot. There is no incorrect method, so here is your chance to be wildly creative. Start with any of the colors and squeeze about a 1½"-diameter circle of paint onto a paper plate or palette, and add roughly ½ tsp. pearlescent pigment powder to give the paint a shimmery look. Mix in enough water to make the paint slightly thinner than its consistency directly from the tube.

2. Put the flowerpot on a lazy Susan if you have one; if not, put the flowerpot on a raised surface that allows you access to all sides of the pot. Dab the paint here and there on the flowerpot, turning the pot as you work.

3. Mix another color with pearlescent pigment and water and dab it on. Then apply another color, and another, and so on until you have added all the paint colors and the flowerpot is covered. In the process you will end up with a widely varied palette of colors—some overlapping, some combining and blending to create even more colors. Just make sure that the entire flowerpot is covered, including the lip and the top 2" to 3" inside. Let the paint dry.

4. When the pillar has finished curing, paint it the same way you painted the flowerpot, using the same varied palette and dabbing and blending until the surface is covered with multiple colors. Let the paint dry.

## ATTACHING TESSERAE

1. Using a glass cutter, cut several strips of glass approximately ¼" wide. Nip the strips into lengths roughly ¾" long. Lay them out in the order that have you cut them.

2. Glue a row all around the bottom of the lip. Add another circling row above that, and so on, until the entire lip is tiled, including one row around the lip on the inside. To accommodate the contour and make tiling the lip easier, use narrow rectangles placed end-to-end in rows.

3. You can simply cover the surface of the pillar and flowerpot with irregular shards, or you can add design details—spirals, circles, leaves, or flowers—to your pillar planter. (See Figure 2.)

Figure 2  Sample design elements in clear glass.

4. If you decide to add details, cut several ¼" strips of double-thickness glass. Use wheel glass cutters to nip the strips into squares, rectangles, or other shapes needed for the designs you have chosen. (If your designs include leaf shapes or circles, see the instructions on pages 22–23.) Glue the pieces in place wherever you want to highlight design features.

5. Cut and glue random shapes of glass to cover the flowerpot and pillar's exterior. Use glass mosaic cutters to nip pieces of different sizes and shapes. Spread glue over a small area with a craft stick, then position the pieces.

6. When tiling the top of the pillar and the bottom of the flowerpot, put the flowerpot on top of the pillar first. Glue the glass pieces in place, but leave approximately ¹⁄₁₆" of space at the pillar's top edge and another ¹⁄₁₆" of space around the bottom edge of the flowerpot. This small gap will allow you to put the two finished pieces together without damaging the mosaic.

7. When you have finished tiling both pieces, let the glue dry overnight.

## GROUTING

1. Remove the flowerpot from the pillar and clean away any excess dried glue from the glass on both pieces.

2. Grout the pillar first. Mix half the grout and pigment with fortifier. Carefully—as the glass edges are sharp—press and smooth the grout over the surface of the pillar. Remember to grout both the lower and upper edges. Make sure there are no lumps of grout on the upper edge; smooth it nicely, taking care not to fill in the ¹⁄₁₆" gap you created, so that the flowerpot will sit evenly on the pillar.

3. Wipe any excess grout off the surface of the pillar with a damp sponge, and let the glass haze over. Polish with a soft cloth.

## FINISHING

1. Use a razor blade or dental tools to clean away any stubborn bits of grout.

2. Wrap the pillar in plastic or kraft paper and cure for three days.

3. Mix the remaining grout and pigment with fortifier and grout the flowerpot, beginning at the upper edge. Carefully work from inside the lip up over the top to the lower portion, creating smooth, even grout lines between all the narrow rectangles. Then work your way down and around the body of the flowerpot to the lower edge.

4. Gently turn the flowerpot over and cradle it on a cushion or folded towel. Grout and smooth the lower edge, again leaving the ¹⁄₁₆" gap intact.

5. Wipe the flowerpot with a damp sponge, and let the glass haze over. Polish the surface with a soft cloth. Clean away any excess dried grout residue.

6. Wrap the pot in plastic or kraft paper and let cure for three days.

# Reflecting Birdbath with Perch

## MATERIALS

*For Base:*

Tile backerboard, ½" x 24" x 36"

Epoxy putty

Ingredients for Slurry and 2
batches of Basic Fiber Cement
(See page 145.)

18-gauge flexible wire, 6'

26-gaugeflexible wire, 6'

11-gauge steel cable wire, 2'

Wire cutters

Needle-nose pliers

Rubber gloves

Permanent marking pen

*For Mosaic:*

Stained glass: 4" x 4", orange;
6" x 6", light blue; 12" x 12",
brown (2 sheets), dark
blue/ivory mix, honey opal
white, iridized dark green
(2 sheets), iridized pale
blue/white (2 sheets), light
and dark green/ivory mix,
teal/white mix

17 leaf-shaped glass jewels, 3¼",
green

Mirror, 12" x 12", light blue

Silicone glue

6 lbs. sanded grout, blue

Liquid pure pigment, yellow

Acrylic grout fortifier

Acrylic paint: 2 oz. blue, green;
4 oz. brown

Grout sealant

Spiral saw with ceramic tile
drill bit

Heavy-duty utility knife

Clay modeling tool

Wheel glass cutters

Lazy Susan *(optional)*

Masking tape

Plastic sheeting

## MAKING THE BIRDBATH STRUCTURE

1. Using a spiral saw or utility knife, cut the backerboard into the five section pieces on the cutting list.

2. Photocopy and enlarge the patterns on pages 168–169. Transfer the patterns onto section pieces A and B respectively. (See pages 20–21.) Go over the graphite lines with permanent marking pen. Then cut around the outlines to create the back and base sections.

3. Press a line of kneaded epoxy putty about ⅜" thick along the rear outside edge of the base, making sure the putty is sticking well. Then push the back flush up against the puttied edge, vertical and with the back's sides aligned to the base, so the two pieces form a 90° angle. (See Photos 3 and 4 on page 143.)

4. Use your gloved fingers and the clay tool to press the putty firmly into the entire joint so that it adheres to both boards. Keep the epoxy as smooth as possible. If necessary, knead and press in more putty to completely fill the joint. Then carefully lay the assembly on its back with the base board vertical. Stand bookends or bricks on end, on each side of the base to keep it from moving. Let the epoxy harden for at least 15 minutes.

5. Set the piece upright. Hold one of the side strips (Section C) on top of and along one side of the base. Mark the strip at the point where the base's front corner begins to curve. Draw a vertical line at that mark, another roughly 1" beyond it, and a third line 1" beyond the second. (See Figure 1.)

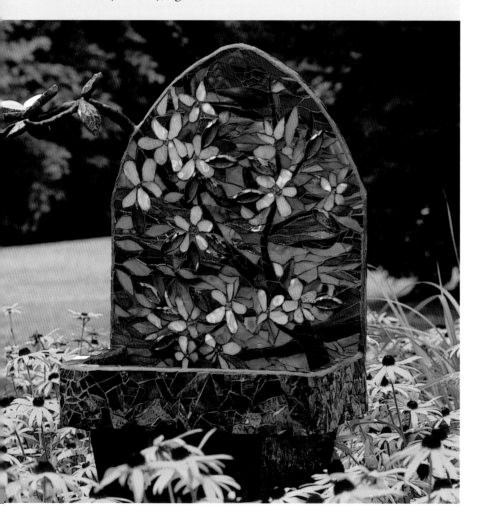

## CUTTING LIST FOR BACKERBOARD SECTION PIECES

| Code | Description | Qty | Dimensions |
|------|-------------|-----|------------|
| A | Back | 1 | 12" x 16" |
| B | Base | 1 | 10½" x 12" |
| C | Sides | 2 | 2" x 12" |
| D | Front | 1 | 2" x 7¾" |

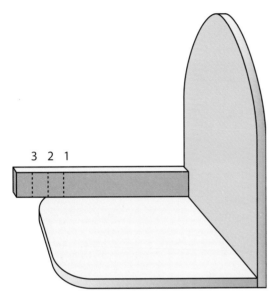

Figure 1 Mark side board at point where baseboard front begins to curve inward, then make two more marks, spacing the three marks 1" apart.

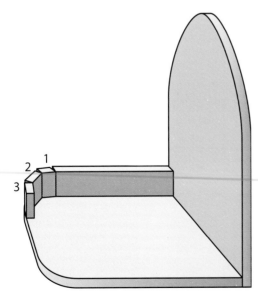

Figure 2 Score and snap the side board's outside surface along the marks, allowing the board to curve to the front.

6. Using a utility knife and ruler, score the outside surface of the cement board along each of the three marks. Align the first score with the edge of a table and gently apply pressure until the piece snaps; it will break, but will remain attached to the main piece by the mesh on the un-scored side. Snap the other two score lines, producing a side piece with three flexible sections at one end. Repeat these steps with the second side strip.

7. Position one of the side strips on top of the base, with the solid end butted up against the backboard and the flexible, scored section curving around the corner. (See Figure 2.) Mark the base front where the side strip ends. Repeat on the other side.

8. Press a line of kneaded epoxy along one side edge of the base, from the back to the mark you made near the front. Push the side strip onto the putty, making sure the strip is aligned with the outside edge of the base and butted up firmly against the back.

9. Support the strip with one hand, keeping it perfectly vertical, while you push the putty into the joint using your gloved fingers and the clay tool. Smooth the epoxy on both sides of the joint. Hold the piece in place until the epoxy hardens enough so that the side doesn't lean. Position and putty the other side strip in place.

10. Trim the front piece (Section D) with a utility knife, if necessary, to make it fit between the two side pieces. Use epoxy to set the front piece in place, making sure to fill and smooth the joint front and back. The basic birdbath structure is now complete.

## APPLYING FIBER CEMENT

1. Mix one batch of fiber cement and one batch of slurry. (See page 145.)

2. Start on the inside of the basin. Work on one small area at a time; first brush on a layer of slurry, then apply a smooth layer of fiber cement with your gloved fingers. Fill in gaps in the scored side pieces as evenly as you can, matching the thickness of the board plus about ⅛", brushing on slurry to keep the surface wet and applying about a half-handful of fiber cement at a time.

3. Press an even, ⅛" layer of fiber cement along all the inside joints, forming a gentle transition wherever two pieces meet. Dip your gloved fingers in water and use them to smooth the surface as you go.

4. Repeat steps 2 and 3 on the exterior, first filling in the large gaps in the scored side pieces plus about ⅛", then smoothing a ⅛" layer over all the joints, again working one small area at a time and always applying slurry first.

5. Apply a layer of cement over all the edges, to smooth them. (See Photos 1 and 2 on page 142.) Start at the top and work down the sides, then do the basin edges. Keep the edges as flat and uniform as possible to be a good base for mosaic.

6. If needed, cement over the joint on the back, where the back board and base meet. If you did a good job of joining them with epoxy, however, there may be no gaps and you could skip this step. In any case, if the epoxy work is bumpy, smooth on enough fiber cement to level the surface. Wrap the base in plastic and let it cure for three days. While waiting for the base to cure, make the wire branch and flower.

## BUILDING A WIRE BRANCH AND FLOWER

1. Cut one 9" and two 7" lengths of steel cable wire. At one end of each 7" piece, unwrap the first inch or so of cable wire and spread apart the smaller strands into two or three groups. (See Photo 1.)

2. Wrap the strands of one 7" cable around the 9" cable wire about 3" from one end, and the other 7" section about 7" from the same end, so the two smaller branches are 4" apart. Bend them so they are roughly parallel to each other, angling off from the main branch. (See Photo 2.)

3. Use the 18-gauge wire to fashion two 2"-long leaves, two 1½" leaves, and four 1¼" leaves. Also make five 1½" petals, making them appropriately wider and more rounded. Always keep some extra wire at the end of each petal and leaf, for attaching to the branch. (See Photo 3.)

4. Use the 26-gauge wire to wrap and criss-cross each leaf and petal, filling in some of the empty space in the centers to create small wire armatures that epoxy can grab. (See Photo 4.)

5. By wrapping the extra wire at the end of each leaf, attach a 1¼" leaf and a 1½" leaf an inch or so up the first small branch—the cable wire you attached 3" from the end of the main branch. Attach another 1¼" leaf at the tip of that branch. Wrap a 1¼" leaf near the tip of the other small branch, and a 1½" leaf just below that. (See Photo 5.)

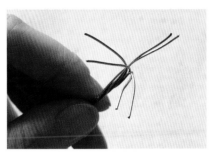

Photo 1

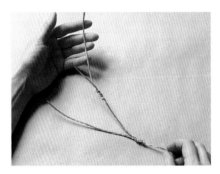

Photo 2

Photo 3

Photo 4

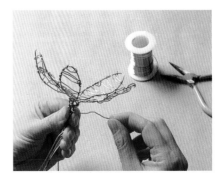

Photo 5

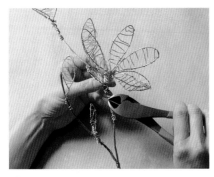

Photo 6

6. Wire the five flower petals together and secure the flower and the two 2" leaves at the juncture of the main branch and second, or outermost, small branch. Be sure all the branches, leaves, and petals are wrapped tightly to the main branch. Snip off any wire ends that are sticking up. (See Photo 6.)

## SCULPTING AND ATTACHING THE BRANCH

1. Wear latex gloves to protect your hands while handling the epoxy. Start by pulling off and kneading two ½" pieces of putty until they're a uniform color. Beginning at the base of the main branch, wrap and press the epoxy around the wire, creating a uniform ⅛"-thick layer. Sculpt the branches, leaves, and flower. (See Photo 7.)

2. Continue kneading and applying small batches of epoxy, keeping the surface as smooth as possible. Use a clay modeling tool to push the putty into hard-to-reach areas. (See Photo 8.)

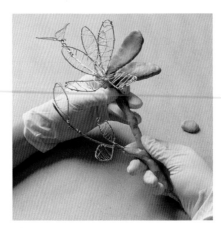

Photo 7

3. Work your way outward, covering everything—branches, leaves, and flower petals. Make sure no wires are showing or sticking up through the putty. If there is any play in the branches, or if one part cracks while you are working on another part, just reinforce the area with more epoxy. (See Photo 9.)

4. With the branch completed and the birdbath fully cured, secure the branch to the left side of the backboard edge, approximately 12" up from the base. Thoroughly knead together two ¼" pieces of epoxy. Press the putty around the lower inch or so of the main branch, and bring it down and around the edge surface, creating a smooth transition from wire to board. Add more putty, if necessary, to create a strong connection. Hold the branch in place until the epoxy hardens.

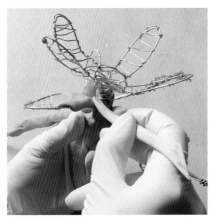

Photo 8

Photo 9

## ATTACHING TESSERAE

1. Use a black permanent marking pen to go over any portions of the backboard and base patterns that were covered up during epoxying and cementing.

2. Referring to the patterns on pages 168–169, use a glass cutter and wheel glass cutters to cut out the green leaf shapes and white flower petals for the backboard. (See pages 21–24 for the techniques.) Cut and nip each petal and leaf into shape and, with the birdbath flat on its back—preferably on a lazy Susan to make maneuvering easier—glue the petals and leaves in place. Cut, nip, and glue in position the tiny orange flower center pieces.

3. Position and glue the green glass jewel leaves. Although the jewels add dimension, they aren't absolutely necessary. If you can't find suitable leaf-shaped jewels, substitute pieces cut to shape from the same color glass you used for the other leaves.

4. Cut and glue tapered sections of brown glass for the limbs and branches.

5. The background mixes several glass colors and types—dark blue, blue mirror, and a random combination of pale blue and teal with white mixes. The pattern suggests where to place the mirror and the darkest shades of blue; but for the rest, follow your instincts in fitting the colors and shapes together. The intended effect is that of looking through a tree branch out over a river or lake; thus the direction of the background pattern (behind the branch) should be mainly horizontal. Shape the pieces accordingly, using the flow of colors in the glass and the grout lines between pieces to create the illusion.

6. Turn the birdbath upright and tile the floor of the basin. Again, cut and place the shapes indicated on the pattern first, then fill in the background in a horizontal direction. The floor pattern intends a rippling, watery reflection of the image on the backboard.

7. Cut and place random shapes of blue mirror around the basin's inner sides.

8. Use a glass cutter and ruler to cut seven 12" strips of dark brown glass, ½" wide to equal the thickness of the cement board. With wheel glass cutters, nip each strip on a slight angle into sections roughly ¾" wide. Lay the pieces out on your work surface as you cut, keeping them in order. These are to tile the edges of the birdbath.

9. Tile the edge of the backboard first. Start on one side at the base and work your way up to the center of the top, spreading glue on a few inches of edge at a time and placing the pieces. Repeat on the other side and again work upward. At the point where each side curves inward toward the top, you'll have to nip pieces into smaller strips to maintain a smooth curve. As always, keep the spacing between pieces uniform.

10. To tile the edge of the basin, start on one side where the basin meets the backboard and work around the edge to the backboard on the other side.

11. Finally, mosaic the entire exterior with dark green iridized glass. Nip small pieces for the rounded corners of the basin to keep them smooth, but use relatively large pieces for the flat surfaces, especially the back. Create visual interest by mixing and varying shapes, sizes, and shades.

12. For the wire branch, leaves, and flower, use the same glass colors as for the leaves and flowers on the backboard. Measure one of the epoxy flower petals and, with a glass cutter and wheel glass cutter, cut and nip a petal shape slightly smaller than the measured petal. Spread a bit of glue on the epoxy petal and position the cut glass. Then measure, cut, and place the remaining petals. Nip and glue a tiny orange circle for the blossom center.

13. Measure, cut, nip, and tile each branch leaf. Referring to Cutting a Simple Leaf Shape on page 23, create the basic leaf sections. Keep the pieces for each leaf loosely reconstructed on your work surface. Because the branch leaves are small and curved, nip the diagonal sections into tinier pieces to keep the tiled surface even. Work methodically, one leaf piece at a time, using tweezers if necessary and creating grout lines that resemble leaf veins.

14. Let all the glue dry for 24 hours. Use cleaning tools to remove any residual glue on the glass or in the grout lines.

## GROUTING

1. Tape a piece of plastic sheeting over the basin, covering all but the joints where the base and sides meet the backboard. Because there's so much surface area, you will need to grout the birdbath in two sections—the backboard first, then the basin. If you try to grout the entire piece at once, you won't be able to clean it all before the grout dries rock hard.

2. Mix 3 lbs. grout and apply it to the entire backboard. Work on the back and then the front. If you used glass jewels for some of the leaves, be sure you press grout firmly into all the spaces around the gems. Grout the backboard's edges last.

3. Sponge off the backboard, wait until the glass hazes over, then clean away any excess dried grout. Polish the surface.

*Note: If you used glass jewels, be careful not to dig or wipe away too much grout around them.*

4. If you have enough time to grout and clean the other half of the birdbath, go on to the next step. Otherwise, wrap the piece in plastic and wait until the next day.

5. Uncover the basin and sweep or vacuum out any bits of dried grout that may have fallen into it. Mix the remaining 3 lbs. of grout and apply it to the basin. Work on the interior first, then the exterior, then the edges. Also carefully grout the surface and edges of the flower on the extended branch. Sponge, clean, and polish the grouted surfaces.

6. Before you grout the branch leaves, mix a small quantity of the remaining blue grout with a drop of yellow liquid pigment— just enough to produce a suitably green color. Then, while supporting the branch with one hand, press the grout into the grout leaves and around their edges. Carefully sponge, clean, and polish the glass.

## FINISHING

1. Paint the branch brown, the backs of the leaves green, and the undersides of the petals blue. Let the paint dry.

2. Wrap the entire birdbath in plastic and let it cure at least three days.

3. After the grout has thoroughly cured, apply grout sealant to the basin, the basin's grouted joints, and its edges. Allow the sealant to dry for at least a day before filling the basin with water.

Reflecting Bird Bath Back Pattern

Enlarge 200% and again 109%

Light blue

Dark blue/ivory mix

Light blue mirror

Brown

Honey opal white

Green glass leaf jewels

Light and dark green/ivory mix

Random combination of iridized pale blue/white, plus teal/white mix

Orange

Reflecting Bird Bath BasinPattern

Enlarge 200% and again 109%

Light blue mirror

Brown

Honey opal white

Light and dark green/
ivory mix

Random combination
of iridized pale blue/white
plus teal/white mix

# Garden Shrine

## MATERIALS

*For Base:*
Cement board, ½"-thick
Epoxy putty
Form-holding woven-wire mesh
   or window screen
Ingredients for 2 batches of
   Slurry and 2½ batches of Basic
   Fiber Cement (See page 145)
Spiral saw with ceramic tile drill
   bit, or heavy-duty utility knife

*For Mosaic:*
Vitreous glass tiles, ¾"-square:
   beige, 10–12
   brick red, 10–12
   deep red, 14–16
   light baby blue, 70–80 or ½ lb.
   light blue-green, 22–24
   light grass green, 70–80 or ½ lb.
   medium teal, 70–80 or ½ lb.

metallic deep brown, 1 lb.
metallic grass green, 4 lbs.
metallic light purple, 22–24
metallic medium pink, 1½ lbs.
metallic turquoise, 8–10
olive green, 70–80 or ½ lb.
orange 26–28
Mirror, 12" x 12" silver
6 multicolored glass jewels, ½",
   tulip-shaped
Silicone glue
Sanded grout, 5 lbs. blue
Liquid pure pigment, 2½ oz.
   yellow
Acrylic grout fortifier
Clay modeling tool
Potter's rib or 3" x 4" rectangle
   cut from plastic milk jug
Wheel glass cutters
Lazy Susan *(optional, but highly
   recommended)*

## BUILDING THE SHRINE

1. Cut a 18" x 24" piece of
   cement board using a spiral saw
   or utility knife.

2. Photocopy and enlarge the pat-
   terns on pages 173–174. Transfer
   the outlines—just the outer
   lines—for the shrine backboard
   and shelf onto the cement
   board. Cut out the shapes for
   both sections, again using either
   a spiral saw or utility knife.

3. To bond the sections together,
   pinch off two pieces of epoxy
   roughly 1¼" long and knead
   them together until the putty is
   uniform in color. Roll out a
   snake of putty the length of the
   shelf and about ⅜"-thick. (See
   page 143.) Press the line of
   putty onto the surface of the
   shelf along the length of the
   back. Firmly press the bottom
   edge of the backboard into the
   bead of epoxy, making sure to
   align the sides flush with the
   side edges of the shelf. Use your
   fingers and the clay tool to push
   the putty firmly into the full
   length of the joint. Carefully tip
   the backboard flat on its back,
   with the shelf board sticking up,
   and place a brick or two up
   against the bottom of the shelf
   to hold it in place while the
   epoxy hardens for 15 minutes. If
   the joint seems weak, press more
   epoxy on both sides of the joint,
   wherever it needs strengthening.

4. On the enlarged backboard pat-
   tern, cut along the dotted line of
   the "arch armature outline."
   Center the pattern over the back-
   board and trace around the arch
   with a pencil; go over the line
   with permanent marking pen.

5. Cut a 7" x 20" piece from the
   wire mesh or window screen.
   Fold the piece in half lengthwise
   to create a double thickness
   measuring 3½" x 20".

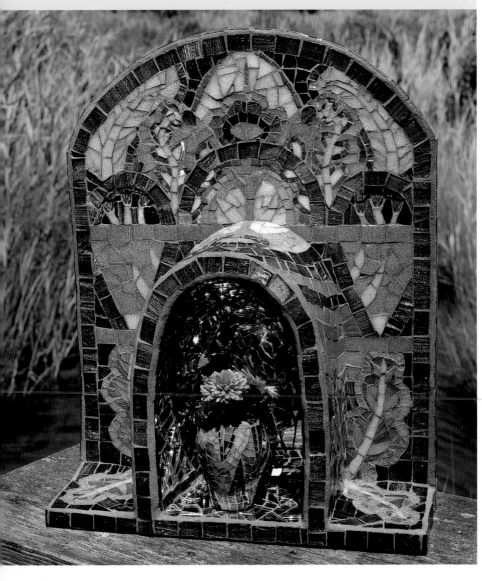

6. Mix one batch of slurry and one batch of fiber cement. (See page 145.) Lay the folded wire mesh out flat on a protected work surface, brush it with a coat of slurry, and then press and smooth fiber cement into both sides of the screen. Do not use a thick coat; press on just enough to cover the screen, and smooth both sides nicely.

7. Bend the cemented screen into an arch shape that matches the arch line on the backboard. With the screen in that position, put a brick on each side to hold the sides in place. You may also need to put a rock or piece of wood on the inside of the arch to keep the walls from sagging inward. Cover the arch with plastic and let the cement set overnight.

8. When the cemented mesh has hardened, epoxy the arch to the backboard. Knead two ½" pieces of epoxy putty together until the material is a uniform color. Position the arch along the outline on the backboard, then press and smooth a line of epoxy along the inside joints, where the arch meets the backboard and shelf. Let it harden for 15 minutes.

9. Knead and press more epoxy putty along the bottom outside edges of the arch, bonding the arch to the shelf. Use a clay modeling tool to smooth the epoxy. Let it harden 15 minutes.

10. Mix another batch each of slurry and fiber cement. With the shrine lying flat on its back, brush slurry over the joints along the inside of the arch where it meets the backboard and shelf. Press a layer of fiber cement along these areas, smoothing the joints. Repeat along the outside joints.

11. Add another layer of fiber cement to the entire arch. Remembering always to slurry the surface first, work your way from the backboard outward, covering the arch inside and out until you have created a total thickness (including the fiber cement on both sides of the mesh) of approximately ⅜". Use your gloved fingers and a potter's rib to smooth the surface, paying particular attention to the front edge of the arch, which should be level and a consistent ⅜" wide all around the opening. When you run out of the first batch of fiber cement, make another.

12. Once the walls are built up, add fiber cement to the arch interior so that the ceiling and walls slant inward, becoming much thicker toward the back, creating a vaulted look. (See Photos 1 and 2, below.)

Photo 1

Photo 2

13. Bring the fiber cement down onto the top and sides of the back wall until the shape at the back is about 5" high and 4" wide. Smooth the fiber cement along the sides and sloping ceiling. When you look into the arch, you should be able to see the entire ceiling because of the vaulting.

14. Finish the base by smoothing fiber cement onto all the rough outside edges of the backboard and shelf. Press fiber cement along all the joints, too, to smooth and reinforce them. Wrap the shrine in plastic and let the cement cure for three to five days.

## ASSEMBLING AND ATTACHING TESSERAE

1. Transfer the pattern for the backboard design to the cement board using graphite paper. With the pattern and graphite papers taped together (see Photo 1 on page 20), cut the arch shape out from the graphite paper, then position both over the arch and trace the design onto the backboard. Transfer the design patterns for the shelf and outer arch. Go over all the graphite lines with a permanent marking pen.

2. Lay the shrine on its back. Place metallic grass-green tiles around the perimeter of the back, creating a border. Cut, nip, and shape the glass tiles as needed, using glass mosaic cutters. To speed things up, cut several pieces to width first, then glue them in place. Make sure the tiles don't extend over an edge; they should be flush.

3. Cut and glue more metallic grass green tiles to fill in the three backboard loops—one over the arch and one on either side.

4. Cut and glue olive green tiles in the horizontal areas at the center of the design.

5. Follow the color chart and fill in the smallest details first, making these pieces as uniform in size as possible. Attach the six glass jewels. For the background, cut varied shapes and sizes to give the finished piece contrast and texture. Remember to cut and place your pieces so they follow the flow of the pattern. Use a craft stick to spread glue on one small area at a time, and use tweezers to place pieces too tiny to manage with fingers.

6. With the shrine still on its back, cut and glue metallic grass green tiles on the front edge of the arch. Work up from the bottom on each side, then across the top. Cut some pieces at an angle to tile the curve. Let the glue for these tiles dry at least 30 minutes.

7. Set the shrine upright to work on the exterior of the arch. Start by filling in the details of the flower on top of the arch and the leaf designs on each side. To fill in the color strips on the sides, use full-length tiles cut to a width of about ½".

8. Tile the leaf designs on the shelf and fill in the background, then tile the front and side edges of the shelf with metallic grass-green. Cut each tile just once to match the shelf width, and glue it with the finished side (instead of the cut side) facing up, to create a smoother, more uniform edge. Let the glue for these tiles dry.

9. To line the inside of the arch with silver mirror, use wheel glass cutters to nip the mirror into irregular shards. Shape as needed, and glue them in place, tiling the entire inner arch, floor, and ceiling.

10. Cut approximately 50 metallic grass green tiles down to the same width as the edge of the backboard. Begin at the bottom edge on one side of the backboard and work up the side to the top. Keep the spacing between tiles uniform. In order to keep the pieces lying flat and smooth, you will need to cut the tiles into smaller lengths at the point where the straight edge curves inward toward the top. Make sure no tiles slip out of position. Tile the edge on the other side the same way.

11. The back of the backboard can be almost entirely covered with whole tiles. Glue light grass green tiles in rows on the back, starting at the bottom and working upward. At least on the bottom rows, you will probably only need to cut one tile to fill out the space properly. Put this one cut tile in a different place in each row so it won't be noticeable. You will need to nip and shape pieces toward the top to keep them flush to the curving edge. With all the tiling complete, let the glue dry overnight.

## GROUTING

1. Grouting the shrine is a big job that will take an entire day; start early, and allow no interruptions. First, clean any excess dried glue from the surface of the tiles and mirror.

2. With ¾" masking tape, mask off around the outside of the arch, positioning the tape approximately ½" out from where the arch meets the backboard. Then run a second piece of tape outside the first, overlapping it slightly, making the taped area twice as wide. This will help keep the backboard clean but allow the grout to fill the joint.

3. Use the same technique to mask off the backboard where it meets the shelf on each side of the arch. Leave a ½" space between the joint and the edge of the tape and add a second piece of tape slightly overlapping the first for better coverage. The tape should extend over the outside edge on each side, too.

4. Mix 3 lbs. of grout with 1½ oz. of yellow pigment and enough acrylic grout fortifier to achieve the desired consistency. Grout the inside of the arch first, using gloved fingers to carefully push the material into all crevices and joints. Move to the front edge of the arch and the edges of the shelf. Position the shrine past the edge of your work surface in order to get grout up under its front and side edges. Smooth the edge grout lines. Then grout the shelf and the outer surface of the arch.

5. Clean the area you have grouted before the material hardens too much. Cover the grout container with plastic so the unused grout won't dry out. With a damp sponge, wipe off excess grout from the arch, shelf, and edges. Let the surface haze over, then polish it with a soft cloth and use cleaning tools to remove any dried grout residue. Remove all masking tape and clean away any grout that may have gotten up under the tape.

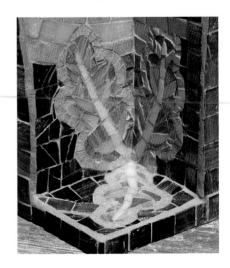

6. Put the shrine on its back and grout the front surface of the backboard. Wipe away excess grout using a damp sponge. Let the glass haze over, then polish it with a soft cloth and meticulously clean away any bits of dried grout using a razor blade and dental tools. This is a big job so take your time, and make sure to remove all the residue.

7. Mix the remaining 2 lbs. of grout with 1 oz. of yellow pigment and enough acrylic fortifier to produce the desired consistency. Set the shrine upright again and grout the edges of the backboard, starting at the bottom on one side and working to the top, then repeating the process on the other side. Grout the back side of the backboard. Wipe away excess grout with a damp sponge, polish the surface with a soft cloth, and use cleaning tools to remove dried grout residue.

8. Wrap the grouted shrine in plastic or kraft paper and let it cure for three days.

Garden Shrine
Arch and Shelf Patterns

Enlarge 200% and again 117%

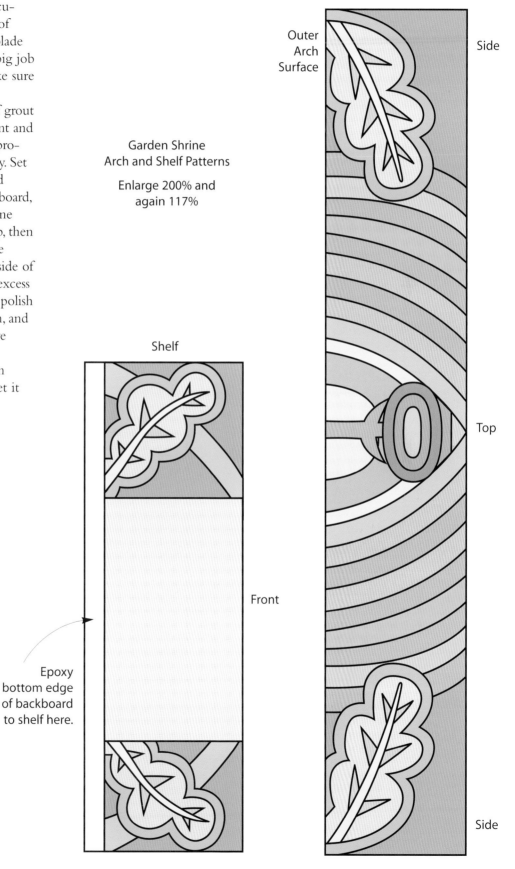

| | |
|---|---|
| | Metallic grass green |
| | Olive green |
| | Light grass green |
| | Deep red |
| | Light baby blue |
| | Metallic deep brown |
| | Metallic light purple |
| | Medium teal |
| | Light blue-green |
| | Orange |
| | Metallic medium pink |
| | Metallic turquoise |

Shelf

Epoxy bottom edge of backboard to shelf here.

Front

Outer Arch Surface

Side

Top

Side

Garden Shrine Backboard Pattern

Enlarge 200% and again 117%

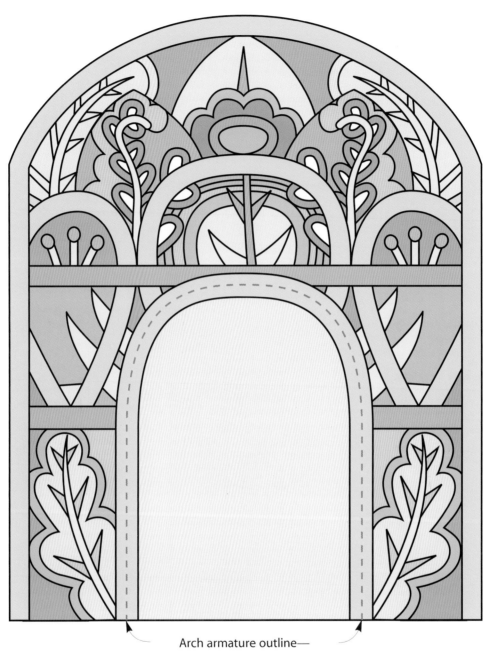

Arch armature outline—
trace on dotted line

Metallic grass green

Olive green

Light grass green

Brick red

Deep red

Light baby blue

Metallic deep
brown

Metallic light purple

Medium teal

Light blue-green

Orange

Metallic medium
pink

Silver mirror

Metallic turquoise

Beige

Glass jewel

# Roman Style Fragment Plaque

## MATERIALS

*For Base:*
Polystyrene foam
Wooden backing board
    (large enough to hold the
    form you want)
Plastic sheeting
Screws and washers
Sand
Portland cement, white
Trowel
Galvanized steel strapping or a
    piece of heavy galvanized
    wire mesh
Wire hanger

*For Mosaic:*
Unglazed porcelain tiles, 2" x 2":
    cream, gray, mottled cream/tan,
    slate gray, slate blue, taupe,
    terracotta, warm brown
Carbon paper
Dull pencil
Waterproof marking pen
Mortar
Cement-based, sanded grout,
    sand tan
Sponge
Tile stone or diamond file

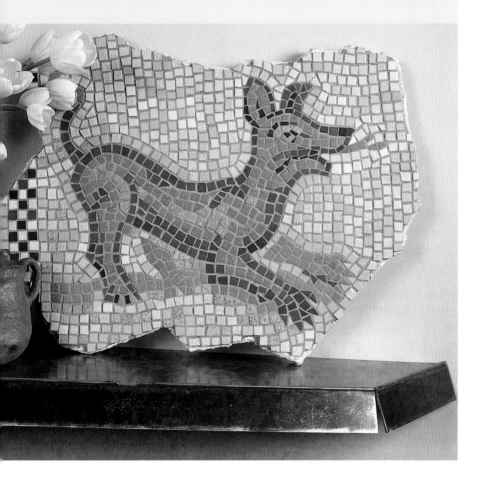

## CASTING A CONCRETE "FRAGMENT" BASE

1. Stretch the plastic sheeting taut over the backing board to ensure a smooth working surface.

2. Cut sheets of polystyrene foam into the appropriate shapes and piece them together to make a form. The overall shape should complement the design of your mosaic. Secure the foam in place with screws and washers on the plastic-covered wood board. (See Photo 1.)

Photo 1

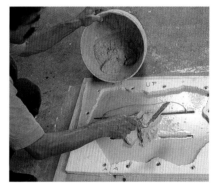

Photo 2

3. Cut two lengths of galvanized steel strapping or a piece of heavy galvanized wire mesh to reinforce the cast concrete. If desired, make a hanger by wrapping a length of wire onto one of the reinforcements.

4. Mix together three parts sand and one part Portland cement (either white, as used here, or gray). Add the dry ingredients to one part water; the consistency should be that of peanut butter.

5. Pour the concrete into the form, filling it half full. After smoothing the surface with a trowel, eliminate any air bubbles by jostling the form.

6. Add the steel reinforcements. (See Photo 2.)

7. Fill the form with the remaining material and jostle it again. Holding the wire hanger out of the wet concrete, smooth the surface with a trowel. Then allow the base to dry for 24 hours.

8. To remove the casting, simply unscrew the foam sections from the wood board—they shouldn't stick to the concrete and can be used again for another project.

## PREPARATION

1. Sketch your design on a piece of paper. This mosaic was inspired both by the artist's dog, who loves to play fetch, and by ancient Roman mosaic fragments. When designing your own mosaic, simplify the forms and don't include too many details. Keep in mind what is practical to achieve, based upon the sizes you intend to cut your materials. (See Photo 3.)

*Note: Notice the angular contours incorporated in design details—such as the paws—to accommodate tesserae.*

2. Use carbon paper and a dull pencil to transfer your mosaic design to the smooth face of the cast plaque. When the tracing is complete, go over the carbon marks with a waterproof marking pen so that your lines can be wiped with a damp sponge without smearing.

3. Cut a quantity of tesserae into unit sizes that feel comfortable for you. These porcelain tiles have been cut into quarters. For added convenience as you work, sort the tesserae by color.

Photo 3

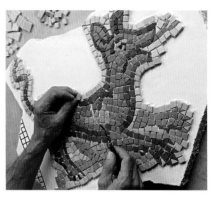
Photo 5

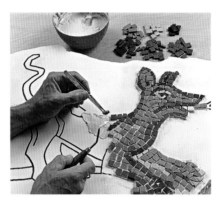
Photo 4

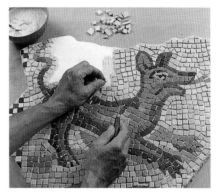
Photo 6

## ATTACHING THE TESSERAE

1. Using a commercial mix or starting from scratch (see pages 30–31), mix a batch of cement mortar.

*Note: If you used white cement for your plaque, you may want to make white mortar to match.) Make only as much as you can use in a couple of hours.*

2. While the mortar cures for about 15 minutes, wipe the plaque with a wet sponge to prevent it from drawing too much moisture from the mortar.

3. Apply a thin coating of mortar to a small area of the plaque and begin outlining the subject. Lightly butter the back of each tessera before placing it. Starting with the outline establishes the contours of your subject and allows you to vary the sizes of tesserae used to fit within these contours. If you start inside and work outward, you may run short of space and have to make do with a thin, less well-defined contour. (See Photo 4.)

4. Begin filling in the area just outlined, leaving small gaps between tesserae for the grout. When placing tesserae, choose a range of shades within color families to create shadow effects and add depth to your composition. If you want your mosaic to have a flatter, more uniform surface, gently beat each area as it's just completed, using a block of wood or a dry grout float.

5. Although every artist has a different style, classic mosaics often have a "halo" of background color that follows the contour of the subject to create a smooth transition between the central motif and the background. (See Photo 5.)

6. With the halo complete, fill in the background. This one is done in opus tessellatum, a rectilinear arrangement of the pieces. In ancient mosaics, opus tessellatum doesn't always consist of a single perfect grid. Some portions are angled slightly to "follow" the subject, and the grids blend where they meet. (See Photo 6.)

7. Complete the background as desired; then allow the mosaic to dry for 24 hours.

## GROUTING

1. Mix a small batch of dry grout, starting with about a cupful of cool water. Stirring continuously, add the dry powder until you have a thick, smooth consistency.

2. Apply the grout to the mosaic, using a hard rubber float to press it into the crevices. Around the perimeter of the mosaic, work the grout inward from the edges toward the center. The rough edges of the cast plaque need no finish unless one is desired.

3. Sprinkle some dry grout powder on the surface of the mosaic. This helps brighten the color of the grout and accelerates its drying time. If you notice some exposed edges of tile around the outside of the mosaic, don't be concerned. You needn't have grout everywhere to hold each piece in place; there should be sufficient bond from below and from the other sides.

## FINISHING

1. After the grout has set for about 10 or 15 minutes, wipe the surface with a damp nylon scouring pad. Rinse the pad frequently and use as little moisture as possible on the mosaic to avoid weakening the grout. Don't concentrate on one area, or the grout will skin over in others. Work the entire mosaic, going back over areas to remove successive layers of excess grout and moving in various directions to keep from dragging too much grout from some channels.

2. Complete the cleaning with a dry rag, frequently turning the rag to a clean area.

3. Allow grout to dry for 24 hours.

4. Smooth any sharp corners with a tile stone—an abrasive stone similar to a knife sharpening stone—or use a diamond file.

# Onion Dome Birdhouse

## MATERIALS

*For Base:*

Exterior grade ¾" plywood or other rot-resistant wood

Sandpaper, medium and coarse grits

Wood glue

Finish nails, 1¼"

Wooden ball finial, 4"-diameter with flared base

Dowel rod, ¼"-diameter

Polymer sculpting compound, 1 lb.

Wood sealer

Epoxy glue in syringe

Enamel paint, metallic gold

Flathead wood screws, ⅜" x 1"

Materials for making gold-leaf glass (See page 24.)

Circular, table, or hand saw

Hammer

Jigsaw

Electric drill with bits

Paintbrush

Baking sheet

*For Mosaic:*

Ceramic tiles, ⅜"-square: ¼ lb. dark teal, deep brown; ½ lb. black, metallic gold

1½ lbs. mixed light, medium, and dark teal

Ceramic tile leaf shapes, ¾"–1¼", 1 lb. assorted: blues, greens, and goldenrod

Silicone glue

Sanded grout; 1 lb. white, 3½ lbs. black

Liquid pure pigment, 4–5 drops yellow ochre; ¼ oz. yellow

Acrylic grout fortifier

Wheel glass cutters

Old towel or cushion

Tile nippers

Clay cleanup tool

Lazy Susan *(optional, but recommended)*

## CONSTRUCTING THE BIRDHOUSE

1. Saw the wood into the seven section pieces on the cutting list below. Sand all the surfaces and edges smooth, starting with coarse-grit sandpaper and finishing with medium-grit.
2. Measure and mark a line 1⅝" in from each edge of the base board.
3. Spread wood glue on one side of the base bracket and place the bracket on the base board, centered within the marked lines. Nail the bracket in place with a finish nail at each of the bracket's four corners.
4. Copy and transfer the patterns for the front and side sections on pages 183–185.onto their respective pieces. Go over the lines with permanent marking pen.
5. Drill a ⅜" pilot hole into the doorway area of the front board. Use a jigsaw to cut out the doorway opening.
6. Drill a ³⁄₁₆" hole for the perch, positioned as shown on the pattern.
7. Glue and nail the four walls together, with the smaller side boards positioned between the larger front and back boards. Be sure you have placed the side boards so the right and left patterns are facing outwards.
8. Center, glue, and nail the top board over the square shell of the birdhouse. When the top is properly positioned, ¼" of the top edge of all four walls will show around the perimeter of the top board. (See Figure 1.)

## ADDING THE DOME

1. Following the directions on the package of polymer sculpturing compound, knead and press pieces of sculpturing compound onto the ball finial, smoothing it as you go and working upward from the "equator" to create an onion dome shape. Build the material up around the finial

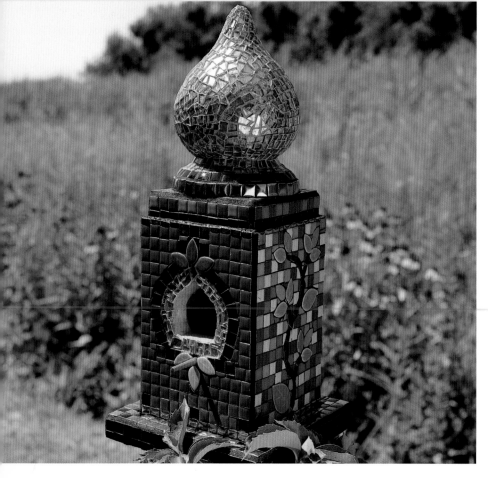

## CUTTING LIST FOR BIRDHOUSE SECTIONS

| Code | Description | Qty | Dimensions |
| --- | --- | --- | --- |
| A | Front | 1 | 4⅝" x 7" |
| B | Back | 1 | 4⅝" x 7" |
| C | Sides | 2 | 3⅛" x 7" |
| D | Base | 1 | 6½" x 6½" |
| E | Base Bracket | 1 | 3⅛" x 3⅛" |
| F | Top | 1 | 4¼" x 4¼" |

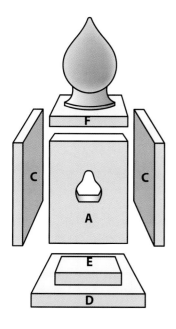

Figure 1

Birdhouse assembly—
exploded view

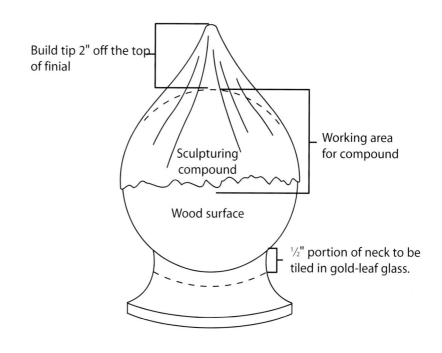

Build tip 2" off the top of finial

Working area for compound

Sculpturing compound

Wood surface

½" portion of neck to be tiled in gold-leaf glass.

Figure 2

Building up finial with sculpting compound to create onion dome.

gradually, increasing the thickness of polymer compound from very thin at the middle to a rounded point that rises 2" above the top of the ball. (See Figure 2.)

2. Turn the finial frequently as you work, checking from various angles to make sure the dome is symmetrical. If your finial's base has ridges, fill in and smooth the ridges with compound after you've sculpted the dome. The entire surface needs to be smooth to accommodate tiling.

3. Read the instructions and precautions on page 186 for baking polymer. Put the modified finial on a baking sheet on the center rack in an oven preheated to 225°F (126°C). Bake for approximately 45 minutes in a well-ventilated room, checking after 30 minutes to make sure the clay isn't burning. Remove the finial from the oven after it has cooled.

4. Spread epoxy glue on the base of the finial. Center and press the dome firmly onto the top of the birdhouse. Let the glue dry completely.

5. Brush wood sealer onto the onion dome and exterior of all the birdhouse components, including the base. Make sure to cover the edges thoroughly.

Allow to dry completely.

6. Apply a second coat of wood sealer and allow to dry overnight.

7. Slip the bottom of the birdhouse over the base bracket and onto the base. Drill a ⅛"-diameter hole, centered ¼" up from the bottom of one side board, boring through the side board and into the bracket. Repeat on the other side. Sink a wood screw into each of the two holes.

*Note: This will allow you to remove the birdhouse from its base each year to clean out last year's nest.*

8. Paint the dome and the upper ½" of its neck with metallic gold enamel paint. Also paint the doorway area, referring to the Front Pattern.

## ATTACHING TESSERAE TO THE DOME

1. Follow the directions on page 24 for Making Gold-leaf Glass. Make at least two 5" x 5" sheets. Use wheel glass cutters to nip the glass (foil-side up to minimize scratching the gold leaf) into small irregular shards.

2. To tile the dome, start at the base of the ball (not the neck). Work around the ball and upward, spreading glue on one small area at a time and cutting and positioning pieces. Make sure the glass shards are small enough to keep the surface smooth despite the ball's rounded contour. Snip the glass into especially tiny pieces and use tweezers to place them when tiling the dome's top and tip.

3. Glue gold leaf shards around the painted upper ½" of the neck, where it meets the ball. Let the glue dry completely.

4. Carefully place the birdhouse on its back, supported by a towel or cushion. Again using shards of gold-leaf glass nipped and shaped to fit, tile the painted

area around the doorway, as indicated on the pattern.

## ATTACHING TESSERAE TO THE HOUSE

1. Use tile nippers to nip 10 black tiles into halves. Glue the halves in a row on the front-facing edge of the top board (piece F), along the bottom. Position each tile's cut side down and the finished edge facing up. Then glue mixed-color teal tiles in a row above the black tile pieces, flush to the top of the wood's edge (use the photo on page 178 for reference).

2. Glue a row of whole metallic gold tiles along the bottom of the front. For the top row, place a single black tile in the middle, put one whole metallic gold tile on each side of the black tile, then fill in the remainder of the row with metallic gold tiles cut into thirds. Be sure to position the rough cut edges facing down, so only the smooth finished edges of the tiles face up.

3. Glue three whole black tiles above the bottom row of gold tiles. (See main photo and Front Pattern.)

4. Glue the green leaves in place, then use black tiles to fill the space around the doorway and leaves. Add one metallic gold tile at each corner of the doorway, and nip a third into two small triangles, one straddling either side of the lowest leaf.

5. Fill in the rest of the front with dark teal tiles. Keep the tiles whole except where you have to nip and shape them around the doorway's decorative trim. Let the entire front side dry for at least 45 minutes.

6. Carefully turn the birdhouse so that one of its sides is facing up. Tile the top board's edge on this side, using the same

materials and procedure described in step 1.

7. Glue a row of whole metallic gold tiles across the side board's bottom, taking care not to tile over the screw. Then cut and glue a row of one-third-size metallic gold tiles across the top, much as you did in step 2.

8. Following the pattern and color chart, fill in the details, tiling the brown vine first and then adding the leaves.

9. Tile the background with mixed teal, varying the placement of the light, medium, and dark hues and using whole tiles as much as possible. Nip the tiles where necessary to shape them around the vine and leaves. Let the glue on the tiled side dry for at least 45 minutes.

10. Carefully turn the birdhouse so the back is facing up. Tile the top board's edge on the back side using the same materials and procedure described in step 1.

11. Repeat step 2, adding a thin strip of metallic gold at the back's upper facing edge and a whole-tile strip along the lower facing edge.

12. Fill the remainder of the back with mixed teal, again varying the placement of the hues and using whole tiles as much as possible. Let the glue dry for at least 45 minutes before turning the birdhouse to the remaining untiled side.

13. Repeat steps 6 through 9. When you've finished tiling the last side, let the glue dry for at least 45 minutes before turning the birdhouse upright. Put the birdhouse on a lazy Susan or a raised surface that allows you to turn the project and reach the bottom edge.

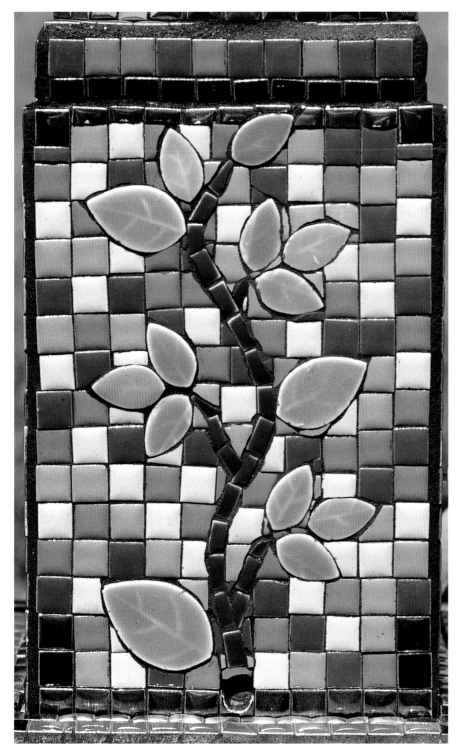

Detail of left side of Onion Dome Birdhouse. See main photo for right side.

## ATTACHING TESSERAE TO THE BASE

1. Use the photo on page 178 as a guide. Line the edge of the base with two rows of black tiles, starting with a row of whole tiles along the top portion of the edge. Cut some black tiles to about two-thirds width to fit along the bottom. Place these pieces cut side downwards.

2. On the top surface of the base board, glue a metallic gold tile in each corner. Place a black tile on each of the open sides next to the corner pieces. Cut another metallic gold tile to fit (if necessary) in the space flanking the two black tiles.

3. Fill in the remainder of the base with dark teal tile, using whole tiles as much as possible. To be able to take the birdhouse apart for cleaning, be sure to leave a $\frac{1}{16}$" space along the inner edge on all four sides, where the base meets the birdhouse's walls. Position the tiles on these inner rows with their cut sides facing toward the wall.

4. Glue a row of whole metallic gold tiles around the dome's base. Fill the gap between the metallic gold tile and the gold-leaf shards with a row of black tile, cutting them to whatever width is necessary. Let the glue dry overnight.

## GROUTING

1. Use a razor blade and/or dental picks to carefully remove any excess dried glue from the surface of the tile and glass.
2. Mask off the ceramic tile on the neck under the dome with masking tape. Also mask off the ceramic tiles that border the gold-leaf section of the doorway. Then cover the entire body of the birdhouse—everything below the dome—with plastic sheeting secured in place with tape.
3. Mix the white grout, pigments, and acrylic fortifier and carefully grout the dome and the portion of the neck tiled in gold-leaf shards. Wipe off excess grout with a damp sponge. Allow the surface to haze over, then polish it with a soft cloth.
4. Unwrap just enough of the body to give you access to the doorway trim. Grout that section of gold-leaf glass. Sponge off excess grout. Allow to haze, then polish the surface. Re-cover that section and allow the grout to set overnight.
5. Unwrap the birdhouse and carefully peel off all the masking tape.

6. Carefully run masking tape around the neck of the dome, along the lower edge of the gold-leaf glass, leaving the black and metallic gold tile exposed. Drape the rest of the dome with plastic and tape it down loosely. Tape off the gold-leaf glass around the doorway, also covering the hole you drilled for the perch.
7. Unscrew and separate the bird-house body from the base.
8. Mix the black grout and acrylic fortifier. Grout the body, first filling the joints around the top edges and the neck of the dome, and along the edges where the walls meet. Then grout the front, side, and back surfaces. Be sure to grout along the lower edge from underneath.

*Note: Take care not to leave any lumps of grout on the underside, or the bird-house won't sit level on the base.*

9. Wipe away all excess grout from the birdhouse with a damp sponge. Use the clay cleanup tool to clear grout out of the screw hole on each of the two sides.

10. While the grout on the bird-house hazes over, grout the base. Fill all the joints along the outer edges first, then grout the surface. Be careful not to leave too much grout along the inside edges of the tile, or you will have trouble reassembling the birdhouse. Use a damp sponge to wipe along these inside edges and to remove any excess grout from the rest of the base.
11. While the base hazes over, use cleaning tools to remove any excess dried grout from the birdhouse body, then polish the surface with a soft cloth.
12. Clean and polish the base in the same manner.

## FINISHING

1. Reassemble the birdhouse. Wrap it in plastic or kraft paper and let it cure for three days.
2. Cut a piece of dowel rod 3"–4" long for the birdhouse perch.
3. Apply wood sealer and let dry.
4. Give the dowel a coat of metallic gold enamel paint.
5. Apply a dab of wood glue to one end of the perch. Use a hammer to lightly tap the glued end about ½" into the hole.

**Onion Dome Birdhouse Pattern**

**Left Side**

Actual size

Deep brown

Goldenrod small ceramic leaf

Baby blue ceramic leaf (size on pattern)
S = small
M = medium
L = large

Periwinkle small ceramic leaf

Teal blend

Metallic gold

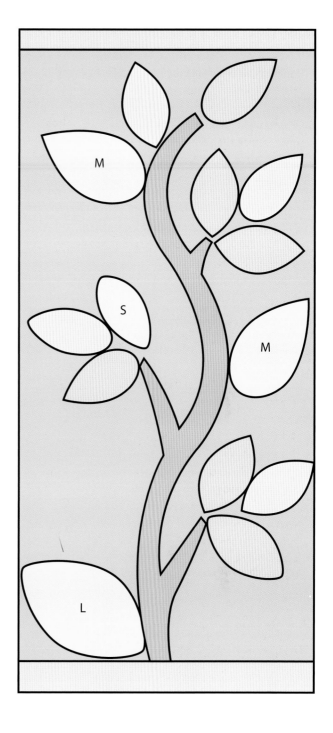

**Onion Dome Birdhouse/pattern**

**Right side**

Actual size

Deep brown

Olive green small ceramic leaf

Baby blue ceramic leaf (size on pattern)
S = small
M = medium

Periwinkle small ceramic leaf
S = small
L = large

Teal blend

Metallic gold

**Onion Dome Birdhouse Pattern**

**Front**

Actual size

■ Cutout area/perch hole

Metallic gold

Black

Dark teal

Dark green small ceramic leaf

Light green small ceramic leaf

Gold-leaf glass

# GUIDELINES AND PRECAUTIONS FOR USING POLYMER COMPOUND

Polymer sculpting compound is a pliable material that can be molded and shaped like clay, but is easier to use and exceptionally durable. Unlike natural clay, which consists of mineral particles suspended in water, polymer compound is made from finely pulverized polyvinyl chloride (PVC) mixed with a plasticizer. It can be fired in an ordinary oven.

For outdoor mosaic projects, avoid the polymer compound that is sold in many colors and small square portions (usually called polymer clay). Look for the type that is widely sold in craft stores in 1-lb. packages. It can also be purchased by mail or over the Internet in 8- and 24-lb. packages. The material is skin-colored and is often described as "ceramic-like." It is workable right out of the box, and when baked is shatter- and chip-resistant and so hard you can sand it, drill it—and mosaic it.

- Polymer compound is synthetic and must not be ingested. Do not snack while working with it, and be careful that a child or pet doesn't eat it.

- Knead the material thoroughly before shaping it, to ensure the plasticizer is distributed evenly.

- Scrub your hands thoroughly after using the material.

- Bake the compound on a baking sheet reserved only for this purpose. Never use the same baking sheet for food. This also goes for any utensils you may use.

- Follow the manufacturer's instructions for firing temperatures and times. Most recommend firing at 250°–275°F (121°–135°C) for 20 minutes for every ¼" of thickness. You need not preheat the oven, just make sure that the material bakes for the full time at the right temperature.

- Keep a window open and the room ventilated during baking.

- If polymer exceeds 300°F (149°C), the PVC burns and gives off toxic fumes. Do not bake it too long or at too high a temperature. For this reason, always use an oven thermometer to make sure your oven isn't hotter than the temperature set on the dial.

- After baking, turn off the oven, open the door, and let the items cool gradually before removing them.

- When the pieces have cooled enough to be handled, if there is any give or flexibility at all, reheat the oven and return the pieces to bake for 15 minutes more, or until they are properly hardened.

- After baking, wash the inside of your oven thoroughly with water and baking soda to remove any residue. If you will be working with polymer on a regular basis, consider buying a toaster oven especially for this purpose.

- Always wear a dust mask when sanding fired polymer compound.

# Glossary

**Acrylic paint** Water-based paint; used to paint bases and color cement-based grout.

**Andamento** The "flow" or pattern in which tesserae are placed; the direction or movement of the tesserae and grout lines that make up a mosaic picture.

**Backerboard** Cement- or fiberglass-based panels used as a base for mosaic work when a water-resistant underlayment is necessary.

**Buff** The practice of removing the haze or residue left on glass after initial removal of excess grout.

**Butter** The practice of applying adhesive to each tessera before placing it, or spreading adhesive on a small area of the base.

**Cure** The setting process of cement, grout, mortar, and adhesive; a chemical change that makes these substances gain strength.

**Direct method** The process of adhering tesserae facing up directly onto a base to create a mosaic. This is a more spontaneous approach than the Indirect method, and it results in a mosaic with slight variations in the surface texture.

**Filati** Rods of glass made in Italy, manufactured for and used specifically in miniature mosaics.

**Float** Tool used to spread grout or smooth out cement.

**Grout** A mixture of sand, cement, and water used to fill spaces between tesserae; available in powdered or premixed form.

**Gum Arabic/gum mucilage** Water-based adhesive used to attach tesserae to paper for the Reverse, or Indirect, mosaic method.

**Hammer and hardi** A hammer and a type of anvil traditionally used to cut smalti and stone.

**Indirect method** A technique for assembling mosaics on temporary surfaces, such as kraft paper, clear adhesive film, or plastic mesh. The tesserae are stuck facing down using a water-soluble adhesive (or the temporary adhesive on the film) and can be rearranged as desired to create a design. The back of the completed mosaic is then adhered to its permanent base and the temporary surface is removed from its face.

**Key** Causing the roughness of a surface; to key a surface, one roughens it to provide a better grip between adhesive and tesserae.

**Mastic** A premixed tile adhesive with a latex or petrochemical base.

**MDF** Medium-Density Fiberboard.

**Millefiori** Small round glass pieces with designs in the "face," cut from glass rods (similar to a polymer clay cane).

**Micro mosaic** A miniature mosaic traditionally made with smalti filati, but can also refer to a mosaic made with beads or other small pieces.

**Mortar** A mixture of sand and cement.

**Nibbling** The act of cutting, or nipping, small pieces away from the edges of tesserae to achieve a usually curved shape.

**Opus circumactum** Circular or fan-shaped design; can be used to cover large expanses without the need for a "picture."

**Opus musivum** In this pattern you outline the focal point, then continue to outline the outline, over and over until you fill in the whole background—this results in a very lively look. It is essentially opus vermiculatum continued for the entire background.

**Opus palladianum** Irregular tesserae laid out in the "crazy paving" tradition. The trick is to keep the spaces relatively equal between the tesserae. It is a great way to use up bits and pieces.

**Opus regulatum** To lay out the tesserae in a grid; very plain yet dramatic when used properly.

**Opus sectile** More common among stained-glass artists, this opus uses pieces cut individually into shapes specifically fitted to each other.

**Opus Spicatum** A weave or herringbone effect.

**Opus tessellatum** A Latin term meaning "set with small cubes." It refers to an arrangement of tesserae in a rectilinear pattern, most often applied to background areas, where rows of the tesserae are laid in a staggered way, similar to brickwork.

**Opus vermiculatum** A Latin term meaning "wormlike." Arranging tesserae in curving lines outlining a focal point or design to emphasize the form of the design. The rest of the background can be completed using opus regulatum or opus tessellatum.

**Picasiette or pique assiette** The process of making mosaics using broken pieces of crockery, tiles, and various found objects. The designs using this method may be abstract or representational, or contain elements of humor.

**Pizze** Round or oval slabs of molten glass from which smalti are cut.

**Plywood** A relatively inexpensive material made of thin layers of wood glued together.

**PVA** (polyvinyl acetate) Water-soluble craft glue used most often in the Indirect, or Reverse, mosaic method. When diluted 5:1 with water, it can be used as a base sealant—especially for wood surfaces.

**Sealant** A protective coating.

**Slaking** Allowing grout mixture to interact for at least 15 minutes before use in order to give the polymers time to strengthen and bind.

**Smalti** Italian-made traditional mosaic tesserae made from molten glass.

**Spatula** A wooden or plastic spreading tool; can also be used to mix grout.

**Stiff grout** The less water you add to grout the drier, or "stiffer," it is.

**Tessera (plural, tesserae)** Latin term for the basic units that together make up a mosaic, originally used to describe a square or cupped piece of stone. Although the word tessera literally means "cube," it can be applied to any type of material, from square glass tiles to irregular pieces of broken pottery, and now refers to all "pieces" used to make a mosaic.

**Vitreous tile** A mass-produced glass tile that is less expensive than smalti for use in mosaics. It is strong and durable, but not as vividly colored as smalti.

# Metric Conversions

**MM-MILLIMETRES    CM-CENTIMETRES**
**INCHES TO MILLIMETRES AND CENTIMETRES**

| INCHES | MM | CM | INCHES | CM | INCHES | CM |
|--------|-----|------|--------|------|--------|-------|
| ⅛ | 3 | 0.3 | 9 | 22.9 | 30 | 76.2 |
| ¼ | 6 | 0.6 | 10 | 25.4 | 31 | 78.7 |
| ⅜ | 10 | 1.0 | 11 | 27.9 | 32 | 81.3 |
| ½ | 13 | 1.3 | 12 | 30.5 | 33 | 83.8 |
| ⅝ | 16 | 1.6 | 13 | 33.0 | 34 | 86.4 |
| ¾ | 19 | 1.9 | 14 | 35.6 | 35 | 88.9 |
| ⅞ | 22 | 2.2 | 15 | 38.1 | 36 | 91.4 |
| 1 | 25 | 2.5 | 16 | 40.6 | 37 | 94.0 |
| 1 ¼ | 32 | 3.2 | 17 | 43.2 | 38 | 96.5 |
| 1 ½ | 38 | 3.8 | 18 | 45.7 | 39 | 99.1 |
| 1 ¾ | 44 | 4.4 | 19 | 48.3 | 40 | 101.6 |
| 2 | 51 | 5.1 | 20 | 50.8 | 41 | 104.1 |
| 2 ½ | 64 | 6.4 | 21 | 53.3 | 42 | 106.7 |
| 3 | 76 | 7.6 | 22 | 55.9 | 43 | 109.2 |
| 3 ½ | 89 | 8.9 | 23 | 58.4 | 44 | 111.8 |
| 4 | 102 | 10.2 | 24 | 61.0 | 45 | 114.3 |
| 4 ½ | 114 | 11.4 | 25 | 63.5 | 46 | 116.8 |
| 5 | 127 | 12.7 | 26 | 66.0 | 47 | 119.4 |
| 6 | 152 | 15.2 | 27 | 68.6 | 48 | 121.9 |
| 7 | 178 | 17.8 | 28 | 71.1 | 49 | 124.5 |
| 8 | 203 | 20.3 | 29 | 73.7 | 50 | 127.0 |

# Resources

## Supplies

**Craft stores:** Project-oriented and good places to browse.

**Dollar stores:** For affordable grouting supplies like bowls, sponges, and spatulas.

**Flea markets:** Wonderful for finding old dishes and bases.

**Hardware/lumber store:** Where you will find all sorts of things that would make great bases or tesserae. Also check out different adhesives—manufacturers come out with new types all the time. Most stores will do simple wood cuts for you, and may also offer a selection of precut smaller pieces.

**Salvage stores:** Terrific sources for old tile, bases (furniture), and interesting found objects.

**Specialty stores:** Stained-glass suppliers, tile outlets, frame shops, etc. are excellent resources for hard-to-find tools and materials.

**Thrift shops:** Great places to look for old dishes and unusual bases.

## A Note about Suppliers

Usually, the supplies you need for making mosaic projects can be found at your local craft supply store, discount mart, home improvement center, or retail shop. If you need to buy materials or tools from specialty suppliers, a list of suppliers (updated on a regular basis) can be found on the following Web site: www.larkbooks.com

Click on "Craft Supply Sources," and then select the relevant topic. You will find numerous companies listed with their Web address and/or mailing address and phone number.

## Organizations

### Society for American Mosaic Artists (SAMA)

The Society of American Mosaic Artists (SAMA) is a nonprofit organization dedicated to the promotion of mosaic art and the advancement of mosaic artists through research, education, and networking. The organization's Web site includes links to many individual member's sites.

SAMA
P.O. Box 428
Orangeburg, SC 29166
www.americanmosaics.org

### Axis

Axis in the UK provides information that champions the work of contemporary artists and makers, nationally and internationally, and that stimulates opportunities for the creation, presentation, and purchase of artists' work.

Axis
Leeds Metropolitan University
8 Queen Square
Leeds LS2 8AJ
West Yorkshire
United Kingdom
www.axisartists.org.uk
Telephone: (+44) 0870 443 0701
Fax: (+44) 0870 443 0703
Information service:
  (+44) 0870 443 0702

### British Association for Modern Mosaic (BAMM)

The aim of this association is to promote, encourage, and support excellence in contemporary mosaic art. Membership is open to all, including those who live outside of the United Kingdom.

BAMM
23 Lovelace Crescent
Exmouth, Devon
EX8 3PP
www.bamm.org.uk

## Internet Resources

Cole Sonafrank's Internet Links to Mosaic Artists & Studios Lists hundred of hyperlinks to other mosaic artists: www.elvesofester.com/MosaicStudios.html

### Mosaico Network

A fabulous resource with links to many mosaic-related sites, including those that showcase the work of modern masters from all over the world: www.mosaico.net

### Email Lists

There are many mosaic email discussion groups on the Internet where people share techniques, tips, and photos. Check the available groups via any of the popular search engines.

# Index

---

## Credits and Rights Information
*(continued from p. 4)*

The publishers of *The Pattern Companion: Mosaics* gratefully acknowledge permission
for the use of material from the following previously published works:

*Making Mosaics,* by Leslie Dierks © 1997 by Altamont Press; information, illustration, and/or projects from the following pages in that book: 18, 20–22, 25–27, 30–33, 36, 38, 41, 43, 46–49, 51–52, 55–56, 76–79, 83–84, 87, 94–103, 107–109, 112–121, 124–126. In-process photography on those pages by Evan Bracken

**Specific credits**—projects from *Making Mosaics* appear on these pages in *Pattern Companion: Mosaics*:
Jeni Stewart-Smith designs: *Fish Tile,* p. 41 (photography, John Stewart-Smith) and *Zodiac Bowls,* p. 43 (photography, Evan Bracken). Joanna Dewfall designs: *Seaside Treasures,* p. 49 (photography Derek Magrath) and *Two Doves,* p. 77 (and photography). Vanessa Benson design: *Tree & Maze,* p. 81,(and photography). George Fishman designs: *Mister Mooch,* p. 92 and *Roman Style Fragment Plaque,* p. 175 (and photography). Martin Cheek designs: *Flamingo,* p. 47 (and photography) and *Fire Salamander,* p. 79 (photography, Ruskin Crafts Gallery). Terry Taylor designs: *Picasiette Stepping Stone,* p. 117 and *Many-Handled Lamp,* p. 112 (photography Evan Bracken)

*Mosaics in an Afternoon,* by Connie Sheerin © 1999 by Prolific Impressions, Inc.; information, illustration, and/or projects from the following pages in that book: 24–31, 54–56, 60–63, 73, 78–82, 88–97, 102–103, 111. Photography on those pages by Greg Wright

**Specific credits**—projects from *Mosaics in an Afternoon* (all Connie Sheerin design, Greg Wright photography) appear on these pages in *Pattern Companion: Mosaics*:
*Geometric Picture Frame,* p. 36; *Hearts & Circles trivets,* p. 39; *Rooster Art,* p. 45; *Timely Beauty Clock,* p. 51; *Sea Treasures Mirror,* p. 55; *Aquarium Backsplash,* p. 57; *Deco Dream Table,* p. 63; *Clear Delight Bottles & Mirror,* p. 72; *Sparkle & Shimmer Candle Holders,* p. 115; *Tiled Gem Mosaic Egg,* p. 116

*Creative Garden Mosaics,* by Jill MacKay © 2003, by Jill MacKay; information, illustration, and/or projects from the following pages in that book: 13–15, 17–19, 21–36, 40–66, 69–70, 74–80, 83–90, 95–112, 116–155. Photography on those pages by Evan Bracken; Illustrations by Orrin Lundgren and Shannon Yokely

**Specific credits**—projects from *Creative Garden Mosaics* (all Jill MacKay design, Evan Bracken photography) appear on these pages in *Pattern Companion: Mosaics*:
*Spirited Tabletop,* p. 60; *Starburst Applique,* p. 84; *No Ordinary House Number,* p. 120; *Mosaic Accent Brick,* p. 124; *Looking Glass Garden Stake,* p. 126; *Pebble Mosaic Flowerpot,* p. 129; *Night and Day Flowerpot,* p. 132; *Cascading Planter,* p. 135; *Sugar-and-Cream Planter,* p. 138; *Spiraling Pebbles Plant Surround,* p. 148; *Ceramic Tile plant Surround,* p. 150; *Bold Beautiful Beetle,* p. 154; *Multi-Faceted Gazing Face,* p. 158; *Pillar Planter Under Glass,* p. 160; *Reflecting Birdbath with Perch,* p. 163; *Garden Shrine,* p. 170; *Onion Dome Birdhouse,* p. 178

From: *Beyond the Basics Mosaics,* by Elizabeth DuVal © 2003, by Elizabeth DuVal; information, illustration, and/or projects from the following pages in that book: 15–35, 46–49, 55–60, 63–66, 74–79. Photography on those pages by Ryne Hazen for Hazen Photography; David Fowler for Talent Group, Inc.

**Specific credits**—projects from *Beyond the Basics Mosaics* (all Elizabeth DuVal designs) appear on these pages in *Pattern Companion: Mosaics*:
*Picture Frame,* p. 96; *Cross,* p. 98; *Boudoir Mirror,* p. 100; *Nightstand,* p. 102; *Blue Transferware Backsplash,* p. 105; *Blue Willow Coffee Table,* p. 107; *Patio Table,* p. 109

From: *Mosaics for the First Time,* by Reham Aarti Jacobsen © 2003, by Reham Aarti Jacobsen; information, illustration, and/or projects from the following pages in that book: 8, 12–34, 44–46, 50–51, 54–56, 65–67, 70–85, 109–110. Photography on those pages by Kevin Dilley for Hazen Photography

**Specific credits**—projects from *Mosaics for the First Time* (all photography Kevin Dilley for Hazen Photography) appear on these pages in *Pattern Companion: Mosaics*:
Reham Aarti Jacobsen designs: *Jeweled Mirror,* p. 53; *Stained Glass Lampshade,* p. 69; *Cake Stand,* p. 70; *Wall Clock,* p. 74; *Sun/Moon Applique,* p. 87; *Greenhouse Side Table,* p. 89. James Turner design: *Daisies Tile Picture,* p. 65. Suzy Skadburg design: *Pictures-Under-Glass Mosaic,* p. 67